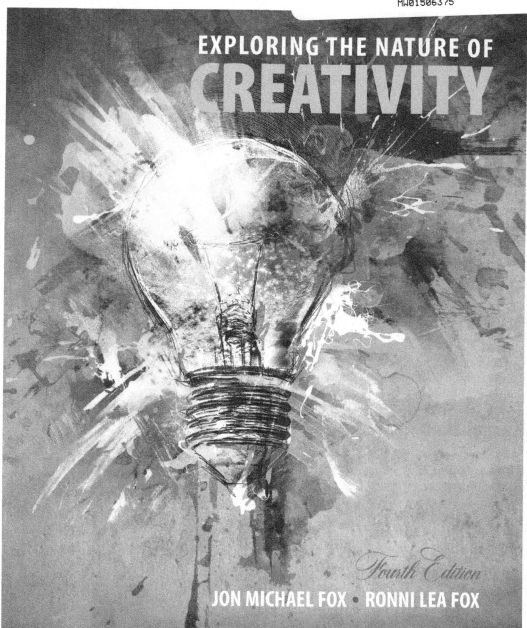

EXPLORING THE NATURE OF
CREATIVITY

Fourth Edition

JON MICHAEL FOX • RONNI LEA FOX

Kendall Hunt
publishing company

Cover image © Shutterstock.com
Cartoons throughout interior courtesy of Allen Cowert. Copyright © Kendall Hunt
Publishing Company.

Kendall Hunt
publishing company

www.kendallhunt.com
Send all inquiries to:
4050 Westmark Drive
Dubuque, IA 52004-1840

Copyright © 2000, 2004, 2010, 2019 by Kendall Hunt Publishing Company

ISBN 978-1-5249-8624-7

Dedication

For Mary Murdock, Ruth Noller, and Sid Parnes—It is an honor to stand in their shadows.

Mary C. Murdock was my friend, my colleague, the senior faculty member at the Center, and the smartest woman I have ever known. Mary died just before this book went to the publisher. I miss my friend.

Sid Parnes and Ruth Noller were the principal players that brought Alex Osborn's dream of creativity into the educational mainstream. They manifested the Creative Education Foundation. Such an easy statement to write. Such a difficult task to achieve.

Without these three giants, the Creative Studies Department and the International Center for Studies in Creativity at SUNY Buffalo State would not exist. They leave a legacy of scholarship, vision, success, and just plain hard work. So many owe so much to so few.

One of the first questions we get when we tell our students and friends we are writing another book is "Do you make a lot of money writing a book?" The short answer is *no*. This has been a labor of love. In fact, if one looks at the number of hours it takes to write, rewrite, rewrite again, make promises, get permissions, plead for students to submit those promised vignettes, arrange for illustrations, talk to the editor who lovingly but firmly asks, "And just where is the draft?"—well, the answer is you would make about 38 cents an hour. If your motivation isn't intrinsic, you might want to rethink the idea.

As with the first and second editions of this book, all the proceeds go to the International Center for Studies in Creativity. The proceeds help to fund things like the Mary C. Murdock Scholarship, and the Sidney Parnes and Ruth Noller Scholarship—for students who want to study the nature and nurture of creativity.

—Mike Fox

Contents

Preface *vii*

Acknowledgments *ix*

Chapter 1 Introduction to Creativity 1

Chapter 2 The Creative Person 39

Chapter 3 The Creative Process 113

Chapter 4 The Creative Press 185

Chapter 5 The Creative Product 233

Dictionary of Common Creativity Terms *255*

References *299*

Index *301*

Preface

The authors set out to write this book to provide an introduction to creativity for the curious, the uninitiated, the students of our beginning classes, and all other interested persons beginning their inquiry into the field of creativity research. We are deeply indebted to all the brave individuals past and present who were or are actively engaged in furthering the field. We know they are far too numerous to mention here. We have worked hard to acknowledge them all within the text and apologize profusely if we have inadvertently failed to mention someone.

One of the problems we have had with past introductory texts is that students found them difficult to read. Conversational knowledge is not easily gleaned from formal research writing and academic formats. We have attempted to simplify and condense the research available in the field so that the average freshman student will feel comfortable in exploring it further. This has led, we hope, to no distortion of any information presented. Our intent was simply to make the information more understandable to the layperson. We acknowledge that much more useful and complete information is available in the actual articles we used as resources, and encourage the readers of this book to avail themselves of the original articles. We have listed them in the text.

Creativity is a growing field of study. There are, unfortunately, a lot of myths associated with creativity. This book is an attempt to separate the implicit from the explicit, the fiction from the facts. We know that creativity is a broad field— *transdisciplinary* in fact—and there are numerous ways to define it. We have chosen to look at an accepted structure of creativity. In this text, we present creativity in four main areas of focus: the creative person, the creative processes they use, the creative products or outcomes they produce, and the creative press (the environment or climate that helps or hinders). It is our belief that knowledge of these basic areas is vital to any understanding of the larger issues. One cannot be a great painter, for instance, without knowledge of anatomy, color, and perspective.

We also chose to concentrate our focus on the "little c" of creativity. Most people think of the "big C" issues when they consider creativity. They give importance to the Mozart symphonies rather than the invention of the paperclip. Great examples of creative outcomes abound. We want to emphasize the everyday importance of creativity. What would we do without the paperclip? As Maslow said, "A first-rate soup is more creative than a second-rate painting." We want to give importance to the concept that everyone possesses creativity in some degree. It is as integral a part of human nature as the heart or the brain. We differ only in the degree of creativity, and *that* is changeable. The most important point we try to emphasize is that creativity can be learned, renewed, and increased by the use of specific tools. It is teachable. It is learnable. It is not the province of magic, mystery, genius, or genetics.

We are most interested in applied creativity. We believe that anyone reading this book and using the techniques detailed in the text can learn to apply creativity in both personal and business applications.

Creativity has a long history, but only in the most recent decades has there been any attempt to study it scientifically and hold it to the strict scholarly standards of research. It is our deepest hope that you, the readers of this book, will become the new pioneers pushing the boundaries of knowledge ever wider. We want you to become future colleagues in the field of creative studies. For all we have learned, there is so much we have yet to discover.

Acknowledgments

The authors wish to give sincere and heartfelt thanks to our colleagues at the International Center for Studies in Creativity at SUNY Buffalo State.

Nick Strascina did the page layout for the first edition. We liked it so much that we continue to use it in this edition.

The illustrations were done by Allen Cowart. Allen has worked for many years as a creativity professional. He has worked in creativity workshops, conferences, and classrooms for DuPont creating the illustrations that add depth and character to the event. Allen is a visual storyteller, skilled at getting at the core connection between the "visual" and the "data." Allen has done graphic facilitations, brainstorming sessions capturing the essence graphically, and he is particularly adept at mind mapping. Allen Cowart can be reached at (251) 666-4723.

Contact Information

The International Center for Studies in Creativity is a center of distinction located at SUNY Buffalo State, Buffalo, New York. The Creative Studies Department is the academic department offering a 33 credit-hour Master of Science degree in Creativity and an 18 credit-hour Graduate Certificate. We also offer an 18 credit-hour undergraduate minor degree with the same title. The faculty and staff at the Center and the department are the same people at the same place. We just wear two hats!

For those who wish to contact the International Center for Studies in Creativity, you can reach us at (716) 878-6223 or online at www.creativity .buffalostate.edu.

Our mailing address is 248 Chase Hall, SUNY Buffalo State, 1300 Elmwood Avenue, Buffalo, NY 14222. Come visit us.

Chapter 1

Introduction to Creativity

History, Background, and Development of Creativity

Although the subject of creativity has interested—and baffled—humanity since the dawn of time, its serious study as a field is relatively recent. Alex Osborn, an executive and partner in the advertising firm of Baton, Barton, Durstine and Osborn (BBD&O) in New York City, is generally credited with doing seminal work in the 1930s, 1940s, and 1950s. He is most well known as the originator and a developer of modern brainstorming. He saw a need for a more creative trend in education and business. As a member of the Board of Trustees of the University of Buffalo (in the 1950s while it was still a private university), he was able to develop this vision into the Creative Education Foundation in 1954.

The efforts of the Creative Education Foundation are widely acknowledged to be the first efforts to both study what defined *creativity* and to assess its "learn-ability." In 1967, the Creative Education Foundation moved to SUNY Buffalo State. Dr. Sidney Parnes and Dr. Ruth Noller became the first academic staff. The first graduate courses teaching the Creative Problem Solving process were offered, the Creative Studies collection was instituted at E. H. Butler Library, and the first issue of the *Journal of*

Creative Behavior was published. Two years later, they initiated the Creative Studies Project, a comprehensive experimental study on the impact of a sequence of undergraduate creativity courses in which most of the current tools of creativity were developed. This led, in 1975, to the establishment of approved and fully accredited undergraduate minor degree and a master of science degree in creative studies.

Ten years later, in 1985, Osborn's dream of a formal academic learning center was completely realized as the Center for Studies in Creativity. The Creative Education Foundation relocated off campus to concentrate on continued application of creative thinking skills in a constantly expanding field. In the 1990s, the Center officially became an academic department as well, known as the Creative Studies Department. The faculty and staff wear two hats: one of a conventional department providing courses leading to academic degrees, and one of an academic center of excellence providing information, research, and scholarship in the emerging discipline of creativity.

Digital Commons

For PDFs of Theses and Projects see https://digitalcommons.buffalostate.edu/

The International Center for Studies in Creativity was the first school in the world to offer a master of science degree in creativity and has achieved an international reputation for scholarly research and teaching that focuses on developing creativity, leadership, and decision-making and problem-solving skills. In many academic and business circles, our programs are known simply as "The Buffalo Technique." The reach of the Center has been worldwide for many years. In 2002, we

changed our name to the International Center for Studies in Creativity to reflect our international influence.

The Creative Studies Department currently offers students three general academic options: an undergraduate minor degree, a graduate certificate in creativity and change leadership and a master of science degree in creativity. These programs provide students with experience using the Creative Problem Solving process, small group facilitation and leadership, decision making, and how to nurture, develop, and support creative behavior in themselves and others. The masters program requirements include a thesis or project that builds on previous experiences and/or provides additional depth and knowledge in the field of creativity and problem solving. The graduate program focuses on applications of creativity as they relate to an individual's professional context.

In addition to actual courses, the International Center for Studies in Creativity serves as a meeting place for a variety of practitioners, scholars, and students from around the world to discuss common research interests, provide colloquia. Visitors from around the world come to SUNY Buffalo State to examine the Creative Studies Library collection of over 6,000 books, dissertations, and rare archival material relating to creativity. Ours is the largest known collection of creativity-related literature in the world. Visitors also attend a variety of Center-sponsored domestic and international conferences and seminars on creativity. Many former alumni join the *Creative Connections* group that supports networking and interaction in the creativity field. By acquiring this book and pursuing your studies of creativity, either formally or informally, you have joined the International

You can't use up creativity. The more you use , the more you have.—Maya Angelou

Center for Studies in Creativity family. Welcome home.

According to Puccio and Murdock (2001), creativity is an essential life skill. We agree. Creativity is a way of turning challenges into opportunities, seeing new solutions to old problems, seeing old problems in new ways, and anticipating the future. We all have the capacity to think creatively. We have developed creative problem-solving skills we use in various ways. As the authors are fond of saying, "The locus of creativity is in the individual." The purpose of this book is to introduce you to a framework to study both the nature of creativity (What is it?) and the nurture of creativity (How might I apply this knowledge to enhance my own creativity?). The understanding of the creative process goes beyond the mere talent-oriented definition (i.e., artists, musicians, writers) to the more global orientation of creativity as techniques, thought processes, and results.

In the old tradition, creativity was studied and taught more as simply developing and applying a specific set of techniques to a situation. While effective in producing creative products and outcomes, it was too narrow a scope for the field. In this book you not only will learn useful tools and techniques, but you will also learn to use them in a myriad of creative ways, encompassing what you will learn to recognize as the "4 P's" of person, process, product, and press.

Framework of Person, Process, Product, and Press

Rhodes (1961) in his seminal article *An Analysis of Creativity* was in search of, as perhaps you are, the "universal definition" of creativity. He did not

*Creative thinking—a purposeful set of skills.—*Unknown

find it. Instead he developed a classification system that allows us to look at creativity one piece at a time. The system he devised to study creativity is broken into four basis elements: the creative Person, the creative Process, the creative Product, and the creative Press. Hence, to study creativity, first you take a "P."

Person, as used in the four P's classification scheme, covers personality, intelligence, temperament, physical characteristics, personal traits, habits, attitudes, self-concepts, value systems, defense mechanisms, cognitive styles, and behavior. Each of these strands of your makeup affects your creativity, your approaches to problems and opportunities, and your comfort or discomfort with change and challenge.

Process applies to motivation, perception, learning styles, thinking, and communicating. Process is how you go about being creative.

Product is how an idea has been communicated to other people usually in a tangible form: words, paint, clay, fabric, or other material source. It is the artifact that has been produced. It can also be intangible such

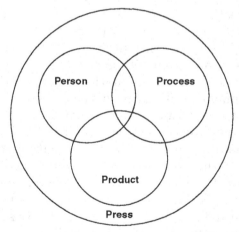

4 P's of Creativity (Rhodes, 1961)

as a concept or theory—again, so long as it has been produced or communicated in some way.

Press may be the most important element for the great majority of us. Press refers to the relationship between you and your environment. What in your physical day-to-day world affects you? What working environment do you need to be creative? What support systems are—or are not—in place to nurture your creative self? Press includes physical, psychological, and emotional safety and comfort in your environment—those things pressing on you that help or hinder your creativity.

We will deal with these concepts and issues more fully a bit later. Let us first explore a few common conceptions and misconceptions of creativity.

Conceptions of Creativity

Throughout history there have been questions posed that baffle the mind. What is the sound of one hand clapping? Which came first, the chicken or the egg? What is the meaning of life? If a tree falls in the forest and there is no one around to hear it, does it make a sound? What is creativity?

It might be more productive for our purposes to focus on what creativity is not. Isaksen (1987) introduced the concept of myths about creativity: mystery, magic, and madness. Each myth holds us back from a serious study of creativity and its applications. One of the recurring frustrations of the field is the question, "What is creativity?" Those who hold to the myth of mystery would have the rest of us believe this question to be unanswerable. This myth arises because everyone seems to have a different definition. "How can you study such a broad and personal topic?" they will ask.

Creative thinking must be practiced. It is not a spectator sport.—Mike Fox

In *Creativity Assessment: Readings and Resources* (Puccio & Murdock, 1999), over 400 different measures of creativity were listed. Among them were measures of fluency, flexibility, originality of thought, sensitivity to problems, and elaboration of ideas. If a subject can be measured, it loses its mystery. Believing in the mystery myth can be a way for a person to avoid developing the ability to productively use his or her own creativity and avoid the topic of creativity as a serious concept at all. Many, if not the majority, of us at the International Center for Studies in Creativity have had to deal with a smirking or condescending individual who has said, "It's not a real science." When you get this response—and you will—remember the public conception of the study of psychiatry and the human mind in the early part of the 1900s!

An equally unproductive myth is that creativity is just magic. You are born with it or you are not. It is the eerie domain of a very select few. If it is inherently magic, then you can neither develop it in yourself nor nurture it in others. The myth places "the divine gift" externally, from a source beyond explanation, over which there is no control. You may have yourself produced some marvelous creative product in your life—a winning argument, a glorious painting, an unexpected home run and someone may have exclaimed, "How on earth did you do that!" You probably sheepishly said, "I don't know. It was just magic." Was it? If creativity is magic, it can be neither taught nor learned.

Still another widely encountered myth is the creative person as a madman: the brilliant but doomed Dr. Frankenstein creating life in his laboratory, Vincent van Gogh cutting off his ear, Einstein and his eccentric behavior. The examples

If we don't change our direction, we're likely to end up where we're headed. —Chinese Proverb

go on and on. This myth has encouraged people to be afraid of, or at least skeptical about, creativity and creative people. If in order to develop your personal creativity you must be weird, nerdish, quirky, or just plain abnormal, what is the attraction? Television assails us constantly with this potent myth. Think of shows with characters that are presented as highly ingenious and creative. How often are they presented as well-rounded, average, normal people? The kind you would be proud to have show up at the family picnic. How often are they portrayed as evil geniuses or comic bumpkins with great inventions? You begin to see the pervasiveness of this myth.

Less damaging on the surface is a fourth myth, the myth of merriment. Creativity is only for fun and play. We smile benignly on children playing dress-up. Look how creative they are being! Remember in school that wonderful period between the "serious studies" when the art supplies were pulled out and you could now engage in something "creative?" As a consultant in creativity, I am not infrequently asked to plan some kind of fun activities for business retreats because "our people deserve a reward for working so hard." These business people have bought the myth of creativity as merriment.

Is there any truth to these myths? Of course—a scant amount and none of it helpful. Many creative persons have been a little mad, overly merry, a bit magical, and somewhat mysterious. On the average these behaviors are just as common in the noncreative person.

It is amazing that anyone has had the courage and faith to objectively study creativity at all. Fortunately, "the truth will set us free" as the Rev. Dr. Martin Luther King said in the 1960s. Creativity is complex. Creativity seems elusive. How can such a profound topic be presented

as also a science? Can it be defined, analyzed, studied, researched, catalogued, labeled, reduced to formulas and abstractions? Can it be taught and learned? Creativity is understandable. It is natural. I have it. You have it. Children, old people, teenagers, students, everybody has it. It is healthy to be creative. It is enjoyable to be creative. It is important to be creative. It is necessary to be creative.

Creativity is seen as complex and challenging because, like the field of psychiatry, it defies a simple and universally accepted single definition.

The problem of creativity is not that it is un-definable; it is that it has so many definitions. As Hamlet would say, "Ah! There's the rub!" What indeed is creativity? Is it that "divine spark" arcing from the fingers of God to the finger of Adam portrayed on the ceiling of the Sistine Chapel? An elusive magical mystery possessed only by artists, madmen, and geniuses? This would seem true if we slipped easily into the four creativity myths. The myths are just too easy.

Some people prefer to define creativity by its terminology. This can be more damaging to the field of serious research than the preceding myths. Creativity is not brainstorming, right-brain thinking, thinking outside the box, problem-solving, personal empowerment, whack packs, or any other of myriad terms used by both serious scholars of creativity and the infinite numbers of "consultants" professing to teach it all in one easy lesson. Although there are many qualified creativity consultants, there are many more self-taught ones. Much like unlicensed mental health "counselors," they have adopted little more besides the jargon. This has led to serious misuse and abuse of legitimate terminology. Any perusal of your daily comic strips will turn up examples. Although we at the International Center for Studies in

Every new idea looks crazy, at first.—Abraham Maslow

Creativity love "Dilbert" and post the relevant ones on each other's doors, it also makes us wince. We congratulate ourselves that our concepts have become so widely known that they can become targets of satire. We wince, as psychiatrists do, when we hear serious terms blithely tossed around with most of their real meanings absent.

"Creativity is an essential life skill. It is a way of turning challenges into opportunities, seeing new solutions to old problems, seeing old problems in new ways and anticipating the future. We all have the capacity to think creatively, and in various ways we are called on to use our creative problem-solving skills" (Puccio & Murdock, 2001).

So let's make an attempt at debunking those myths and misconceptions.

© worker/Shutterstock.com

First, the **myth of mystery**. While certainly a complex subject, it is not incomprehensible. People have been studying, researching, documenting, and reporting on creativity for over 50 years. In 1950, American Psychological Association president, J. P. Guilford, gave his inaugural address. He presented the emerging field of creativity with its first big challenge when he stated, "If you're going in search of something, it helps to define what it is you're looking for." That question will be your first big question,

too. Creativity, like psychology or music, may resist definition but it is not undefinable. On the contrary, it seems that creativity has definitions to spare.

One of the authors puts it this way when he addresses his students in their first undergraduate classes: What the heck is this creativity stuff anyway? You have, by entering into this field, accepted the responsibility of contributing to the answer. You are an important pioneer in an emerging discipline. In the scientific world there is usually no single right answer to a problem. There are usually multiple right answers. Moreover, in creative studies particularly, there is a reasonable possibility that the best answer has not yet been found. Perhaps the field has been waiting precisely for now and precisely for you.

Creativity is a rewarding yet frequently frustrating field of study. Like the field of psychology, it is not cut and dried. One clear concise definition is elusive. Some scholars (and lay persons alike) will never accept it as a legitimate field of research, let alone a true science. Creativity came first. Whether you call it the "Big Bang" or "God Created the Heavens and the Earth," creativity came first. It has been here from the start. It is so thoroughly a part of our world that it is almost transparent. Creativity defines us. Creativity is a move to self-reliance. Creativity is not the spice of life; it is the very stuff of it.

If we can remove the mystery, we can certainly remove the **myth of magic.** Creativity is not just the realm of a few geniuses. It is universal. Everybody possesses it. The baby in the crib discovering he can use his foot to push a mobile and make it spin is using creativity. The hungry person standing in front of the refrigerator perusing the choices and deciding how to combine them into a meal is being creative. Life is a continuous stream of *little c* creativity.

People do possess creativity in different degrees and express it in different ways. Degree

Magic

© JuliRose/Shutterstock.com

of creativity does not equal magic. Mozart is a frequently cited example both for creative genius and for the myth of magic. He was composing at the age of three it is reported. Innate ability? So it appears. Magic? No. Magic implies that it is unlearnable. Can creativity be learned? Of course creativity can be learned. Let us continue with the comparison of creativity to music. It is true that there are the occasional precocious savants like Mozart, possessed seemingly from birth with innate talent. We know and recognize Mozart as a creative prodigy, a genius. Are Mozart and the like the only producers of beautiful music? Of course not. The vast majority of music is produced by those who have moved slowly, and often laboriously, from experimentation, through trial and learn, to technical masters. Most of us banged joyfully upon a piano as young children, happy with the musical chaos we produced. Some of us yearned (or had parents who yearned for us) for more control and more knowledge of music. We took lessons. We learned the symbols of music: notes, chords, etc. We learned the mechanics of the instrument—push that pedal, strike that key, etc. We practiced scales over and over to perfect our skill in the rudiments

You have to get in the activity of creative thinking. You can't learn to swim by the lecture method.—M Fox

of music. We finally attained enough skills to entertain others. We learned to use whatever degree of creativity we possessed to master the problems presented in making music. Learn what the magician knows and it's not magic anymore.

In studying creativity, you enter a new discipline. Like music you will learn to "pound joyously" in unlocking your creativity. Many of you will be content with that. A few of you will be inspired to dig deeper. In this book, you will learn the language of creativity. You will learn the mechanics of how it operates. You will be given several tools to master the skills. You will be required to practice, practice, and practice. Finally, you will have the skill, the comfort, and the confidence to use these skills in public and private settings. You will be a creativity Mozart.

Creativity is not magic. It is a challenging discipline. You learn to recognize what level of creativity you inherently possess and the natural style in which you choose to express it. You are creative. You can learn to develop it further. You will learn to define it for yourself. You will learn to increase your creativity by using a unique collection of "tools" in a variety of fun but challenging situations. You will be given boundless opportunities to practice and master creativity and to bring it out in others.

© marcogarrincha/Shutterstock.com

Like intelligence, curiosity is one of the things you never have to fix.—Mike Fox

The **myth of madness:** you have to be crazy to be creative. In actuality, creativity is healthy, not destructive. Unless you are already mentally unbalanced, creativity will not make you so. Understanding your creativity will bring you a rewarding sense of completeness. You will feel more satisfaction with your accomplishments both professionally and personally. The myth arose from the popular stories about unusual yet creative artists, scientists, and public figures. We all know about examples. It is more important to focus on the fact that their high degree of creativity is what enabled them to overcome and subdue their eccentricities long enough for them to accomplish the creative products we admire them for. What healthy perspectives they had were because of this creativity. Creativity did not cause their madness; it enabled them to function within it. We remember Nikola Tesla not for his peculiar obsession with cleanliness (his need for everything he handled to first be sterilized and that a minimum of twenty-four napkins be placed by his table with each meal) but for his overwhelming contributions to modern scientific knowledge.

The **myth of merriment** lies not with the concept that creativity is fun and playful. It lies with the concept that it is only that. The myth is that there is no serious purpose for it. On the contrary, corporations, such a Proctor and Gamble and IBM, have long recognized that creativity and creative persons are not only important to their commercial growth but that they are vital to their survival. Creativity produces measurable and marketable outcomes. The consequences of using creativity produce positive benefits whether for individuals, organizations, or businesses. It is a bonus that it is also fun.

Creativity is not the spice of life. It is the very stuff of it.—Mike Fox

Dancer
vector illustration
EPS 10

Defining Creativity

It will be helpful to remember these positive and productive conceptions in your study of the field of creativity. It will help you in finding the answer to these three important questions: Are you a creative person? How creative are you? In what ways are you creative? This gets us back to our original question: "What the heck is this creativity stuff anyway?"

Dr. Ruth Noller, an early pioneer in the field, and a mathematician, presented it as a simple yet elegant equation: Creativity equals the function of an attitude multiplied by knowledge, imagination, and evaluation.

$$C = fA\ (K, I, E)$$

Where: C—the "size" of creativity
f—the *function of*
A—attitude—the driver of creativity
K—knowledge
I—imagination
E—evaluation

You miss 100% of the chances you don't take.— Unknown

We have demonstrated the effects of myth versus facts, positive versus negative attitudes in studying creativity so let us function on the remaining three parts of the equation: knowledge, imagination, and evaluation.

It cannot be knowledge alone. As David Page stated, "If to be educated is to possess knowledge, then an encyclopedia is better educated than a man." Substitute "creative" for "educated" and you will agree. You can make even a cursory study of any field: business, art, education, etc., and find numerous examples of leaders with a thorough knowledge of their field and yet no creativity. Contrast the current "big glass block" school of architectural design with, say, Frank Lloyd Wright and the "Prairie School" of architecture.

Albert Einstein was quoted as saying, "Imagination is more important that knowledge." Still, can imagination alone equal creativity? Someone imagined polyester pants and pet rocks once. I can imagine climbing a mountain peak in the Himalayas, but if I lack a knowledge base of climbing, is my *imagining* creative?

Being aware of the need for creativity is not enough. One needs to be able to recognize creative elements, when presented. George Perkins Marsh once said, "Sight is a faculty of the senses; seeing is an art." You possess the ability to "see" but you may lack the skills or training to do it habitually. Think of the wonderful Sherlock Holmes and his Dr. Watson. Both had access to the same facts. Both had powers of imagination in constructing scenarios based on that knowledge. Only Holmes possessed the "seeing," the analytical abilities to come to the creative conclusions. He possessed Noller's third part of the creativity equation, evaluation—the ability to use his imagination in conjunction with his knowledge to reach a solution. For us, as well as Dr. Watson, this is usually far from "elementary."

If you never change your mind, why have one?—Edward deBono

> ## Definitions of Creativity
>
> *I believe creativity is the source of all life. I believe it is found in everyone and everything. Creativity has no boundaries; it is fluid, and it will always have its place. To survive one must have creativity. It is just as important as water or air. Without creativity, nothing can be defined. Your feelings, your ideas, actions, your styles, all are organized to represent your being in this world. Therefore, without creativity one cannot exist. To me, existence is creativity because to exist we must be different. To be different we must first change. And to change we must be creative.*
>
> —Juan Valle (undergraduate student minoring in creative studies, BSC)
>
> *Creativity is boldness when I'm timid, courage when I'm fearful, free-wheeling when I'm thoughtfully confined, but most of all, imaginative when I'm unseeing.*
>
> —Kathy Sealover (grad student, master of science program in creative studies, BSC)
>
> *When you are able to think in a way that is completely out of the norm, process information in a manner that is out of the ordinary, and when you can find multiple solutions to different situations and problems, then you are a creative person.*
>
> —Julio G. Urrutia (undergraduate student, BSC)

Noller (1997) mentioned three areas of creativity: personal creativity, recognized creativity, and transformative creativity.

Personal creativity is that form which is new and useful only to, or primarily to, the individual creator. For me, it might mean a style of expressing myself or a way of dealing with stress. A friend of mine makes arts and crafts from recycled materials. A neighbor sings opera. What do you do— unique to yourself—that you value?

When hiring key employees, there are only two qualities to look for, judgment and taste. Almost everything else can be bought by the yard.—John W. Gardner

Recognized creativity is a form that is new and valuable to a group, community, or society as a whole. The washing machine, powered flight, the telephone, are all good examples of this concept. The public recognizes the value and uniqueness of the creative endeavor.

Transformative creativity are the outcomes, products, and acts that transform society or produce sustained and meaningful shifts in the way things are done or experienced. Think of the Industrial Revolution, the Renaissance, and the development of nuclear power. Transformative creativity changes our relationship to our world so profoundly that there is no going back.

Your creativity, in whatever degree you possess or develop it, can be expressed in any or all of those ways depending upon the situation or purpose you use it in or for.

Certainly creativity has many facets. However, Gryskiewicz (1987) conducted a study of business leaders, executives, and managers for the Center for Creative Leadership in Greensboro, North Carolina. He asked these managers to describe what made a product or process creative. Two themes consistently emerged: novelty and usefulness. Newness alone was not useful. Usefulness alone was not as marketable. The product had to meet a perceived need, be relevant to a particular purpose, and yet not be seen as duplicating something currently available. There had to be that element of novelty. The simplest definition of creativity is a couplet: ideas or outcomes that are both novel and useful.

4 P's of Creativity

Rhodes (1961) in his article *An Analysis of Creativity* related fifty-six definitions of creativity. He divided them into four main areas of focus: understanding the traits, characteristics, and

attributes of creativity within a person; describing the processes, operations or stages of thinking a person uses; identifying the qualities of the products or outcomes the individual produces; examining the nature of the environment, situation or context in which a person expressed this creativity.

These focus areas are not independent but overlap each other. They intertwine and weave together. These focus areas have come to be called person, process, press, and product, the 4 P's we mentioned earlier in this introduction. We will briefly enlarge upon them now.

Creative Person

Early studies in the field centered on persons. The majority of the work focused on determining the level, capacity, or degree of creative characteristics a person possessed. We began with the simple question *How creative are you?* and moved to the more complex issue of *How are you creative?*

Continued research has contributed to the development of twelve major creative characteristics. These are the fluency of ideas the person can generate, the person's ability to be flexible, originality of conceptual ideas, the ability to elaborate on new or old ideas, an openness to new patterns of thought, the capacity to bring order to chaos, a level of comfort with risk taking, an abundance of curiosity, complexity of thought process, boundless imagination, independence of thought and action, and, finally, a tolerance of ambiguity.

Creative Process

These individual traits allow a person to enter into the creative process. Graham Wallas (1926) proposed that a researcher could ". . . take a single achievement or thought—the making of a

new generalization or invention, or the potential expressions of a new idea—and ask how it was brought about. We can then roughly dissect out a continuous process, with a beginning, a middle and an end of its own" (p. 79). He broke this down into a simplified four-step thought process: preparation, incubation, illumination, and verification.

Preparation entailed investigating the problem in all directions. The International Center for Studies in Creativity poses this to students and clients by asking, "What's the problem you are trying to solve?" The expressed problem, e.g. "My boss never listens to me," might not be the real problem, if what is really going on is "I feel undervalued."

Incubation deals with thinking about the problem in an unconscious, non-deliberate way. Much as when you can't remember a person's name, forget about it, and wake up at 4 a.m. shouting, "Quincy Jones!"

Illumination is when an idea surfaces in a new way. The "Ah Hah!" of thought when the incubator warms up. Many creative people, in explaining a new product or endeavor, have stated "It just came to me!" Illumination is the light bulb above the inventors' head.

The final step is *verification*. This involves testing the validity of the idea and reducing it to an exact form. Verification leads to a creative product.

Creative Press

Before the creative person can effectively enter the creative process, the creative environment or "press" must be present. Press means the situation, physical and/or emotional, that pushes or pulls on an individual, and the individual's acceptance of or resistance to these factors. These factors "press" on the individual and have either a positive or negative effect on that person's ability to be creative.

Göran Ekvall (1987, 1991) of the Swedish Council for Management and Work Life Issues researched companies with high degrees of productivity, innovation, and creativity. He identified ten major dimensions that created a climate that both encouraged and allowed for creativity in the workers and management of a company. These ten attributes were: challenge, freedom, dynamism, trust and openness, idea time, playfulness and humor, idea support, debates, risk taking, and conflict. The higher the levels in each area, except conflict, the generally higher are the measurable levels of creativity. Conflict, it is not surprising, suppressed creativity if it rose beyond a level where the individual felt comfortable.

Blocks and Barriers to Creativity

Blocks and barriers are anything that get in the way of being creative. Consider blocks and barriers as a function of the press. Many of these are internal—in addition to the external environmental dimensions mentioned above. Les Jones (1987) of the University of Manchester, UK, posited he could identify four major categories or barriers to individual creativity: strategic barriers, value barriers, perceptual barriers, and self-image barriers. These categories are not a complete set of every block there is. Jones offers these as a way to think about those things that get in the way.

The strategic barriers are those that limit our personal ability to see solutions or solve problems. These include resistance to using our imagination to stimulate new ideas, the inability to tolerate uncertainty or to keep an open mind about ideas suggested by others.

Value barriers are those we bring with us based on our own senses of right and wrong, good or bad. They may limit our flexibility. We may have a

strong desire to conform or a strong sense of loyalty to the way "we've always done it." We may have strongly negative ideas about change, innovation, or similar creative concepts.

A perceptual barrier relates to our reluctance to see familiar things in a new light, failing to use our senses fully or engaging in stereotyping of information. When one of the authors was a student at the University of Washington, she was part of a psychology department experiment in critical thinking. Adults were put in a room with a table that was missing a leg. A box containing an assortment of tools (but excluding a hammer, nails, saw, or wood) was in the room as well. She was given thirty minutes to achieve the stated goal, "Make this table usable for a meal." Her attempts to solve the problem were futile—and filmed. Later, she and the other participants were questioned as to what made the problem difficult and what emotions were felt. Most participants felt frustrated, annoyed, humiliated, or fearful. Most quoted the cause of failure as the lack of useful or proper tools to solve the problem and achieve the goal.

Interestingly, the same experiment was conducted with a group of kindergarten students from the university-sponsored day care. The author's five-year-old child was part of that group. After dumping the box over and looking at all the tools available, the child slid the box under the portion of the table missing the leg and propped up one corner with a monkey-wrench. Objective achieved. He did not possess the same barriers perceptually as the parent. He could use these tools objectively. The majority of the children involved solved the problem. One imaginative child simply used the tools to break off the other three legs of the table and turned it right side up. It was indeed usable for a meal. When questioned about the experiment, all of the children said it was fun and many wanted to do it again.

I have no special talents. I am only passionately curious.—Albert Einstein, 1952

Self-image barriers are those we set up to maintain emotional comfort. We may be afraid of rejection or humiliation. We may be "too polite" to assert ourselves or request resources available or additional resources. We may have an intense fear of failure. We might be reluctant to exert our influence for fear we will be seen as "pushy."

These barriers to creativity can lead to reduced creativity. If we then find ourselves in an environment that is not supportive of creativity, it may leave us just going "through the motions" at work or in our personal lives.

Product

The final "P" of the creative equation is product. Product focuses on the results and characteristics produced as the outcome of creative thinking. These outcomes can be the results of individuals or groups. The product can be tangible, as is the case for marketable inventions or intangible, such as the development of a new method for delivering a service. MacKinnon (1978) believed that it was the most important of the four P's. He stated, ". . . the study of creative products is the basis upon which all research on creativity rests and, until this foundation is more solidly built than it is at present, all creativity research will leave something to be desired" (p. 187).

What's in it for me?

What does all this mean to you, the reader? Why should you study creativity? Why is it important?

It is interesting to note that prior to 1950 there were 121,000 psychological studies indexed about human motivations and behaviors in the main

The reluctance to put away childlike things may be a requirement of being creative. — Mike Fox

source of psychological reporting, the *Psychological Abstracts*. Of these, a mere 186 articles dealt in any substantive way with creativity (Guilford, 1950). By 1994, there were over 5,600 entries in creativity. By 2018, there were many thousands of articles in over 30 refereed journals on creativity.

No doubt our expanding global views after World War II, our rapidly sophisticated technological and scientific advances, our interest and entry into the space exploration age, and our growing concern about our physical environment motivated this interest in creativity.

Old approaches for problem solving simply didn't, couldn't, or wouldn't work with the new problems arising from our advancements. Individuals, as well as businesses and governments, felt frustrated by the growing demands for effective actions, effective systems, effective solutions, and effective products. In short, we were at a loss for creativity.

Vignette from Jesse Roberts

During the Creative Studies 625 "Mock Trial", we had a time to answer questions from the class at the end. The team I was on had to defend that creativity is domain specific. A question directed toward me, from a fellow class member, regarding a statement I had made during my section of the presentation, made me come up with the following (philosophical/ theoretical) statement. He asked me why I said (and did I really say) "creativity is logical."

My (directional) response to many questions is "All things being equal, I am allowed to think creativity is logical." (It also helped sum up the point of our argument.)

What I say to those who feel they are not creative is, "Every fear has a wish. Fear not the world, for it is where you create *you*."

—Jesse Roberts

creative studies master's student

You can judge your age by the amount of pain you feel when you come in contact with a new idea.—Pearl S. Buck

We have much in common now with our earliest ancestors. Motivated by survival, our Neanderthal cousins realized that they needed something better to bring down the mastodon than one guy throwing a sharp rock attached to a long stick. Without development of creative thinking and design, early humans could not have developed new survival skills. We now face a global and computerized society. Old ways of thinking can't keep up. We must learn to become more creative, to think more creatively, and to recognize and use the creativity we all possess to both anticipate and solve increasingly complex problems and situations. Like that Neanderthal society, we must become creative for survival.

Laughter is an altered state of consciousness.—M Fox

Why Study Creativity?

Why should you bother to study creativity? Is there a payoff? In his article *Why Study Creativity?* Puccio (1989) listed twelve reasons commonly cited in research studies:

1. Develop human potential beyond the IQ
2. Rapid growth of competition in business and industry
3. Effective use of human resources
4. Contributes to effective leadership
5. Discover new and better ways to solve problems
6. Development of society
7. Builds on all disciplines
8. Builds on the nature of knowledge
9. Natural human phenomenon
10. Important aspect of mental health
11. Enhance learning process
12. Growing body of interest

Of course, Puccio did not mean this to be a complete and final list of reasons to study creativity. He envisioned it as a sampling of common reasons cited—a "jumping off" place to make creative studies more personally valuable to an individual's own research into the subject. He understood the need for the individual to build a bridge between "content knowledge" (an understanding of the basic facts in a situation) and creativity.

Let's explore Puccio's twelve reasons for studying creativity a bit closer.

1. Developing Human Potential Beyond the I.Q.

Many "lay people" are confused about the concept of I.Q. It is only a measure of certain

Creativity is a different kind of smart.—M Fox

limited areas of intelligence. It is not the measure of intelligence or intelligence itself. It is not a measure of creative ability. Intelligence is a broad and extremely complex issue. One of the more creative individuals I have worked with was a bright, vivacious female singer in a rock band. She composed both beautiful music and wonderful gatherings. She was, and is, compassionate, warm, funny, and a great sharer of ideas. She once took the standard IQ test and received a rating of 65— high functioning mental retardation. The test did not measure her creativity or her personal abilities, nor did it take into account certain life-long learning disabilities for which she had found creative ways to cope. Nevertheless, she became for a time depressed and confused. She temporarily lost her creative skills because she doubted them. After much counseling, she was able to accept that her assigned IQ was not her functioning IQ. Taylor (1988) in his article *The Nature of Creativity* summed it up when he wrote, "The general public has been misled and still readily believes that IQ is the 'total intelligence' that encompasses all the dimensions of the mind, including all creative factors (and possibly all other dimensions not yet discovered and measured in the total mind-power)" (p. 100).

This unfortunate view of IQ has stifled many of us in our personal and professional lives. Reviews of most studies that measure the relationship between IQ and creativity and creative achievements show zero to slight effective correlation. These studies have concluded that creativity is distinct from general intelligence. A person can be quite intelligent but have a low "CQ" or "creativity quotient." The opposite is also true. My friend with the low IQ had developed a high measure of creativity and creative tools to help her reach a real-world success well beyond what her measurable IQ would have predicted.

It is important to study research so that each one of us can understand and develop our full personal and professional abilities as well.

2. *Rapid Growth of Competition in Business and Industry*

The technological developments in our society are a tribute to our creativity and our innovation. The computer age with the development of the Internet has been the most evolutionary event since the Industrial Revolution. Companies develop, expand, dissolve, and disappear in record numbers. Rapid developments in communication and transportation have led to exciting advances in every area of business. They have also led to such increased and immediate competition that there is an enormous pressure on organizations to continually improve on old systems and products. New problems constantly arise. Think of the "Y2K" panic just before the turn of the century, when businesses realized that their entire operations were jeopardized by a technology that did not and was not designed to adapt to the changing of the century. In the mere forty years or so since the first computers were introduced into the mainstream of our lives, we neglected to realize how important they had become to our economic and personal survival. We wonder now how those early programmers could have been so shortsighted in their thinking.

Being thrust into an age of global competition forces us to become more creative. No longer can we rely on old patterns of competitive thought. My business is no longer competing with the business across the street or even across town. It is now competing with businesses across the world. We have seen, in a few short years, this concept affecting not only large corporations but also small,

A snake uses his tongue to explore his world. We use our curiosity.—Ronni Fox

local, individual businesses. People can and do buy products over the Internet. The motivation and need to go to a physical business are decreased. A business that cannot embrace the technology cannot survive. Here are some examples:

"The horse is here to stay, but the automobile is only a novelty—a fad."

> *– Advice from a president of the Michigan Savings Bank to Henry Ford's lawyer Horace Rackham.* Rackham ignored the advice and invested $5,000 in Ford stock, selling it later for $12.5 million

"[Television] won't be able to hold on to any market it captures after the first six months. People will soon get tired of staring at a plywood box every night."

> *– Darryl F. Zanuck, head of 20th Century-Fox, 1946*

There is no reason for any individual to have a computer in their home."

> *– Kenneth Olsen, president and founder of Digital Equipment Corp, 1977*

The business that cannot consistently develop new products and promote them creatively cannot and will not survive. All companies, all businesses are basically just collections and teams of people. The more creative the team, the more creative are the outcomes. The more creative the individual, the more creative is the team. This leads naturally to:

3. Effective Use of Human Resources

To stay effective and competitive, business must nurture creativity. Innovation can only occur when creativity is recognized, rewarded, and encouraged. Contributions must be encouraged and accepted from all levels of the company, corporations, facility, or other areas of industry

and government. It cannot come from just the bottom up. It cannot come only from the top down. There must be an environment and policy in place to encourage and allow for the creative thought process. Barron (1988) did not mince words when he stated, "Established organizations in government, industry, and education do not take creativity as a value and consequently do not make provisions for the creative use of the creative individuals they employ" (p. 96). This mind-set has led to such current cliches as "downsizing," "hostile take-overs," and the loss of local businesses to global competitors.

Developing our knowledge of creativity, learning to recognize it in ourselves and in others, and learning what environments and techniques support its development are crucial to our economic survival in a rapidly changing world.

4. Contributes to Effective Leadership

A creative leader must do more than just maintain everything at the current level (Puccio, Murdock, & Mance, 2007). A leader does not practice the old business maxim, "if it ain't broke, don't fix it" or the concept, "it's always worked before so it will work on this problem too!" A creative leader must anticipate problems before they develop and have a plan and a team in place to solve them. Leadership involves recognizing the strength in novelty and diversity. A leader must develop a creative vision and have the ability to inspire her team to realize it. Leaders enjoy a challenge. Instead of seeing the liabilities, they see the possibilities. Bennis and Nanus (1985) conducted their research into the field of leadership and what strategies leaders used to motivate. They contacted company managers and company leaders. Their elegant finding was, "Managers are

Breaking the law of gravity is usually a capital offense.—Angela Rhoads

people who do things right and leaders are people who do the right things" (p. 21). A leader must do more than just accomplish current objectives but always have future concepts in mind. The leader must consistently share a creative vision. Not only does a leader acknowledge the importance of creativity in the team—a leader demands it.

5. *Discover New and Better Ways to Solve Problems*

Everyone now living must face the modern threats of global competition, limited resources, and increased demands for good and services. Add to these stresses the environmental threats of global pollution, overpopulation, mass starvation, and all forms of political, religious, and personal terrorism in our world today and one is forced to acknowledge we have survival-threatening problems. We must develop and use survival-enhancing creative problem-solving skills. Our Neanderthal cousins could not anticipate or solve the problems of their age as well as their more creative peers, the Cro-Magnons. They lost out to people more adept at using resources, combining strengths, and adapting to changing environments. Both early groups had similar initial tools and strategies. The Cro-Magnon learned to build on them, refine them, adapt them, and combine them. Not just invent the spear, but the spear thrower—to build from one innovation to another. If one could throw a spear farther, how about throwing it harder and faster? Thus they invented the bow and arrow. Neanderthal could not compete and died out. Cro-Magnon advanced and became the dominant survivalist. We also must not rely merely on conventional and useful skills and knowledge. We need to develop the creative skills that will allow us to combine them in ways that are adaptable to changing needs.

6. *Development of Society*

Civilization can neither survive nor advance without an ability to adapt and problem solve. Rome was the creative empire of the world during the times of Julius and Augustus Caesar. All levels of society benefited. Rome fell when it became rigid, when the belief in the "Roman way" of conquest and subjugation grew too large to be managed by a tradition-bound centralized government. At the advance of Roman civilization, foreign ideas, innovations, religions, and individuals were cherished additions to a growing society. Each adapted concept was viewed as a positive influence for Roman advancement. By the fall of Rome, change was seen as heretical, a universal conspiracy against the government itself. New ideas—such as Christianity—were ruthlessly quailed. The "glory that was Rome" faded into the reality of just a nice city in Italy. A nation that ignores the creative potential of its people will flounder as surely as will a business corporation. The glory that was "Ma Bell" is now just a series of regional telephone companies.

7. *Builds on All Disciplines*

No matter what field you are in—business, education, the arts, science, or industry—the successful ones are those possessing a creative environment and embracing creative staffs. Creativity is, by its nature, a transdisciplinary concept. Even at the International Center for Studies in Creativity, the researchers come from widely differing backgrounds. One comes from the field of education and another from psychology. Mike Fox, one of the authors, has been a practicing landscape architect, professional pilot, corporate executive, and teacher. His co-author and wife, Ronni, is a

Good taste is the enemy of creativity.—Pablo Picasso

well known cheese expert, writer, executive, and chef. One staff researcher is a librarian. Another is a farmer. There are no fields from the military to computer science that have not been involved in building research and discovering new applications for creativity. No matter who you are, what you do, or what you plan to do, studying creativity will give you a vital edge over the competition.

8. *Builds on the Nature of Knowledge*

Creativity builds on knowledge. It develops the imagination and enables us to use our existing knowledge productively. Creativity is a knowledge-enhancing skill keeping us from being overwhelmed by the facts, data, statistics, and awareness of our personal, social, and economic problems. Creativity enables us to adopt, adapt, and adjust our knowledge to any given situation. Without creative thinking and problem-solving skills, our resources are limited to the "tried and true" that worked for simpler problems that have now become complex. Creativity allows us to experiment with the known in new, novel, and useful ways. We develop, as the Cro-Magnon did, new tools from modification of old ones. We contribute to our own survival.

9. *Natural Human Phenomenon*

By studying creativity, we learn to what degree and level we possess it. We learn to recognize it in others. We learn our preferred style of creativity, how we choose to use it, and in what ways we manifest it. We learn to acknowledge that everyone is creative and has the ability to become more so. It is not a rare asset; it is our most common bond. We are inspired to learn more and to share this knowledge with others. It is natural, it is positive, and it is in everyone.

The most interesting questions are the ones for which we do not have the answers. —
Marvin Lazerson (University of Pennsylvania)

10. *Important Aspect of Mental Health*

Knowledge of ourselves as creative beings is essential to our sense of self-worth. As we discover (or rediscover) our creativity, we learn to discover and develop all our personal and professional talents. We cope better with change, challenge, and other daily stresses. We learn to value our friends, family, and colleagues not for limitations but for contributions. Our shared creativity allows us to interact based on our similarities and with respect for our differences. An increased awareness of creativity and creative styles enables us to make allowances for and use the creative styles of persons who are different than ourselves. They become interesting instead of irritating. Creativity and our acceptance and recognition of it allow us to redefine the negative as a positive force. It gives us the freedom to "march to a different drummer" instead of numbly conforming. We develop an "interior view" less reliant on outside approval. It enables us to achieve our full, healthy potential for personal growth.

11. *Enhance the Learning Process*

Most of us packed away our creativity when we were around nine or ten years old. This phenomenon is known in educational circles as the "fourth grade slump" (Torrance, 1968). This is the general age when facts are promoted over imagination and we are beginning to be told "act your age—be serious!" by our parents and other authority figures. We learn to diagram sentences instead of create them. We are encouraged to be "scholarly" to the exclusion of being "artistic." We learn to conform. We raise our hands and wait our turn. We learn there are right answers and wrong ones. We learn not to take risks. We take tests that "prove" we learned or failed to learn.

Our greatest fear should not be that we won't succeed, but we will succeed at something that doesn't matter.—D.L. Moody

There is a wonderful little song called *Flowers Are Red* by Harry Chapin. In it, a little boy is told to draw flowers during a first-grade art project. He enthusiastically uses every color in his crayon box in drawing imaginative flowers. He is happy and feels good about himself and proudly shows it to his teacher. She humiliates him and criticizes his work by saying, "Flowers are red, green leaves are green." The little boy tries to explain that there are lots of color possibilities. The teacher becomes angry at his "stubbornness" and "sassiness." She forces him to stand in a corner until he conforms to her popular beliefs. Finally, mournfully, he complies and only draws red flowers with green leaves. Years later, he has another teacher who assigns a similar project. He produces his "normal" picture. She joyfully instructs him to draw "rainbow" flowers with all the colors in his crayon box. Alas like us, he has been forced to pack up his natural creativity too long and can do nothing except repeat "flowers are red, green leaves are green." He has lost the key to his creativity.

But you can get your creativity back. Creativity is a skill as teachable and learnable as reading or writing. Studying creativity and applying the concepts of creative thinking help us rediscover that key to unlocking our creative potential. When we become freer in our creative ability, we develop more flexibility and become more actively involved in lifelong learning processes. When students receive early exposure and training in creative thinking and in creative problem solving, they use these skills well beyond their formal educational years.

12. Growing Body of Interest

Finally, we come to Puccio's twelfth reason for studying creativity: the growing body of interest in the creative studies field. The fact that there

We Need These Higher-Level Thinking Skills

I began studying creativity in September 1995 and, like many of you, I wondered what this "stuff" was all about. I soon discovered that creativity is very much a part of our daily lives. To share a quote with you from Dr. E. Paul Torrance in his book *The Manifesto for Children*, "Don't be afraid to fall in love with something and pursue it with intensity." When I first read this quote, I realized then that I had fallen in love with this stuff, the discipline of creativity, and that I wanted to learn as much as I could.

Since my first undergraduate course, I have grown to appreciate the many aspects of creativity and why it is necessary. The undergraduate courses taught by the International Center for Studies in Creativity at Buffalo State College enhanced both my creative and critical thinking skills. Since I was a business major, a creativity minor would not only complement my studies but also provide me with a competitive advantage over others in the classroom and beyond. Using these skills would of course help me in my future career, but they also enriched my understanding of who I am. Not many courses can do this!

This personal enrichment is what caused me to fall in love with creativity and to continue studying from the program offered at Buffalo State College at the graduate level. I now have a career where I teach and nurture creativity in others. People in any organization, regardless of the purpose of the organization, *need* skills that will teach them to think creatively and critically in an efficient manner. So if you are at that point in this introductory class where you are saying to yourself, "I wish I would have had learned this stuff years ago," then don't let the opportunity pass you by!

—Russell A. Wheeler

In the real world there is usually no single right answer to a problem. There are usually multiple right answers. Moreover, there is a reasonable possibility that the best answer has not yet been found!—Mike Fox

has been such an increased interest in creativity and creative research since 1950 is reason alone to study it. The body of serious—and not so serious—research is growing annually. The Creative Problem Solving Institute is a celebration of creativity, sponsored by the Creative Education Foundation, and it has held annual summer conferences for nearly fifty years. The American Creativity Association, the European Creativity Conference (CREA), and Creativity Expert Exchange (CEE, the annual conference sponsored by the International Center for Studies in Creativity) are just a few venues for serious conversations about creativity and creativity research. Numerous individuals are offering their services as "creativity consultants" and being well paid for it. Creativity study is seen as "cutting edge." It is a rapidly growing field of study that is only gathering more momentum as it gathers more acceptance. The more individuals are actively involved in the study of creativity, the quicker it will become accepted as a topic of serious exploration.

There is a new book available *Why Study Creativity?* by Fox and Fox (2016). That illuminates reasons for studying as noted by alumni from the ICSC. They reflect on the value of having gone through the process of getting a degree in creativity. *Transformative. It changed my life. I use this as an educator. I use this in my business. My company has profited from my creativity skills*. These are typical comments in each chapter of the book.

Be careful what you wish for. When you get your creativity back there is no going back.!

Chapter 2

The Creative Person

Introduction to the Creative Person

How do we determine a person is creative? Are there concrete measurable elements that can be consistently observed and evaluated? Can a person who is labeled "noncreative" become creative?

These questions have been asked and re-asked for generations. They are about as useful as asking, "How do we determine a person is crazy?" Well, we can. Sometimes, sort of. Depending on the personal definition of "crazy."

We know that personal creativity is not based solely on educational skills. Thomas Edison's grades placed him dead last in his graduating class, yet he produced highly creative products throughout his long inventive life. The playwright George Bernard Shaw was known to be a very bad speller. William Butler Yeats, the great Irish poet, was labeled an idiot by his teachers. Benjamin Franklin, inventor of bifocal glasses and the wood stove and discoverer of modern-day electricity, was very poor at math. Albert Einstein, one of the greatest scientists of all, was so educationally slow in his early grade school years that his teachers had him labeled mentally retarded. His parents were advised to remove him from school and put him in an institution.

The creative person cannot be judged solely on output either. Nora Roberts has written more than 223 books including more best sellers than anyone in the world. John Steinbeck published

only 43 works in his entire lifetime. If we go on output alone, Roberts is definitely the more creative writer. However, although highly readable and usually enjoyable, it can be argued that Nora Roberts produces her books by predictable formats and does it on purpose. They are byproducts of literary formula. There is a certain sameness and predictability about them. John Steinbeck, although producing fewer works, produced greater ones. His were fresh, touched universal themes, and had complex characters. We are transformed by reading them. They not only entertained but also inspired us.

Nor can creativity be measured by intelligence alone. Many highly intelligent people produce nothing creative and many people with low IQs consistently operate on a high level of creativity.

No wonder the *Creative Person* has generated so much attention. It does make a great deal of sense to study creativity by going directly to the source. By studying creative people, we can begin to understand creativity as an abstract idea.

Modern scientific inquiry into the study of the creative person has tended to center on four basic areas:

1. What individual traits do highly creative people have in common that are distinctly different from those of individuals who show less creativity?
2. Do highly creative people possess and use unique thinking skills, or do they use patterns of thinking in different ways than the majority population?
3. Are highly creative people the same; do they exhibit creativity in similar or different ways?
4. Can the degree of knowledge, intelligence, and skill predict an individual's displayed level of creativity?

Critical thinking should be used in service to creative thinking.—Aaron Podolefsky, past president of SUNY Buffalo State.

Serious scientific study of the creative person was begun in 1950 by J. P. Guilford (1950) in his address to the American Psychological Association, in which he asked the crucial question, "What is creativity?" He continued to explore the creative person his entire life, designing rigorous, controlled studies of creative individuals. He focused on identifying what made certain people creative.

D. W. MacKinnon began assessing creative people in 1967. MacKinnon (1978) and his fellow researchers at the Institute of Personality Assessment and Research (IPAR), located at the University of California, Berkeley, began an intensive study of creative people in a wide variety of occupations; architecture, mathematics, science, education, arts, and business. They were interested in personality traits. Much of what we know now about characteristics of creativity is based on these early studies. Guilford (1977) and E. Paul Torrance (1972, 1979) were mainly concerned with the investigation of thinking skills used by "high creatives."

In this chapter, you will begin your own investigation into the nature of personal creativity. You will use yourself as a subject in the study of the creative person.

Many modern researchers believe we will move beyond the skeptics' view that creativity can never be understood. They believe that a comprehensive view of the psychology of creativity will result in the same breakthroughs as did the studies of the psychology of mental health. Most of us in the creativity field believe finding solutions to our serious global problems lie in expanding our creative potential. If, as individuals, we can develop new applications for our creativity, we can develop new problem-solving skills as well.

"Project Zero," a research project at Harvard University, studies cognitive skills among scientist and artists. The researchers have set out to debunk

I really am tolerant of ambiguity. I just want it to be consistent.—Ronni Fox

the myth of the "magic moment" of creativity. They are finding that creativity in their study groups is rarely the mighty burst of inspiration bringing forth genius. Instead, they have found that creativity is a combination of the personality and personal values that shaped the individual's intentional and continued efforts, combined with the use of imagery. As the oft-quoted expression states, "What the mind can conceive, the mind can achieve." If the person believes in his/her level of creativity, that individual will be creative to that degree. The creative person works hard to increase his or her creative output.

Genius Does Not Equal Creativity

Creativity has little, by itself, to do with genius, although the two have become linked together in the common mind. Frank Barron, a psychologist at IPAR, has studied the connection between IQ and creativity for more than forty years (Barron, 1988; Barron, & Harrington, 1981). He has concluded that intuition is much more important than was previously thought. He observed that the main measures of the standard IQ test are the functions of reasoning and verbal comprehension. In his opinion, this command of rational thinking and the ability to understand spoken vocabulary are less important to creativity than is intuition.

Characteristics of the Creative Person

What are the characteristics of a creative person? How many do I need to have to be creative?

Below we will show below some of the most commonly reported characteristics of the creative person. These traits, and how they relate to each other, make up the creative person. Two notes of interest: First, we do not absolutely know how

A discovery is said to be an accident meeting a prepared mind.—Albert Szent-Gyorgyi

many characteristics of a creative person are necessary, but it certainly takes at least one. Second, in a conversation with Gary Davis in about 1988, he noted that his research at the University of Wisconsin, Madison, showed that if you want to know if someone is creative, just ask them! The responses will likely fall into one of three categories: No, I'm not; Yes, I am; or Yes, I am—in some context such as art, writing, interpersonal skills, and so on. Apparently creative people know they are creative. There are of course many more characteristics. Torrance (1979, 1974), MacKinnon (1978), Davis (1986), and Csikszentmihalyi (2003, 1996) are good sources for characteristics of the creative person. Some of these are shown below. The question for you is, "Which one characterizes you?"

Fluency (also known as Ideational Fluency)
Flexibility
Originality
Elaboration
Tolerance for ambiguity
Ability to defer judgment
Concentration
Willingness to test assumptions
Openness to ideas
Willingness to take risks
Self-confidence
Ability to excel in defining problems
Capacity to make order from chaos
Ability to toy with problems and ideas
Ability to use imagery
Intrinsic motivation
Curiosity
Optimism
Humor
Persistence
Independence
Self-awareness
Commitment
Self-discipline
Impulsiveness
Objectivity
Flow

From Torrance (1974) we find the four characteristics that are measured by the Torrance Test of Creative Thinking (TTCT): fluency, flexibility,

originality, and elaboration. These are the basic four that, when using the TTCT, give a good indication of some basic thinking skills of the creative person.

© nuvolanevicata/Shutterstock.com

Fluency (also Known as Ideational Fluency)

This is the cognitive skill that lets a person generate many options. (Options include ideas.) Nobel Prize winner and scientist Linus Pauling was asked how he found good ideas. His humorous and true response was, "You have a lot of ideas and then you throw away all the bad ones." Moreover, creative people know how to weed out ideas that are not as useful by applying critical judgment. This judgment can be emotionally charged and intensely personal.

Flexibility

Creative people have limber minds. They stay cool. They can give and take. A person needs to be

able to listen to all ideas and perspectives, not just the ones he or she find agreeable. This ability to flex the thinking muscle allows one to see all sides to an issue, develop fresh views on it, and generate different types of solutions.

Flexibility is what allows the creative person to find new ways of looking at a problem—to view all the angles, to change course when faced with a barrier. "Janusian Thinking" is an example of this mental mobility. Janus was a Roman god with two faces, each looking in a different direction, at the same time. Creative people are like Janus. They tend to think in terms of opposites and contrary views. This process of thought is what allows most women to enjoy a magazine that lists both dieting tips and recipes for chocolate. Flexibility also allows the creative person to challenge the "status quo." A creative person can see beyond assumptions. The scientific assumption, based upon the accepted principles of flight, is that the bumblebee cannot fly. His body is too heavy and his wings are too short to become airborne. The bee, of course, does not accept these assumptions and flies anyway. Rather than accepting a situation at face value, the creative person asks, "What if?"

Watch elementary school children work together at problem solving and you will see endless examples of flexibility. I once tried an experiment on a group of third-grade students and a group of third-grade teachers. The problem centered around removing a ping-pong ball from a narrow three-foot-tall pipe without touching the pipe or the ball. The teachers immediately started analyzing the problem and shooting down ideas. They seemed overwhelmed by the elimination of the quickest and most obvious solutions. They tended to focus on what they could not do. Very few efforts were made at doing anything active. After less than twenty

Play is training for the unexpected.—Marc Bekoff, Univ of Colorado

minutes, the teachers gave up and asked for "the answer." They made the assumption there was one.

The children simply accepted the conditions of the problem eagerly. There were no complaints or cries of protests. They excitedly entered upon the "game" they were playing. Quickly idea after idea was proposed, talked about, and acted upon. One child suggested they jump up and down to knock the ball out. They joyfully and energetically tried for several minutes. "Well, that didn't work!" one boy said laughing. Someone else suggested they stand on chairs and blow down the pipe. That wasn't successful either. This group did not seem to be discouraged at their many failed attempts to achieve the solution. Instead, they seemed to become more inspired and creative. They continued to work on the problem for three days, breaking only for class time. Every recess and lunch hour, the group met resolved to solve the problem. Finally, the group came up with a working solution. They poured cups of water from the hall drinking fountain down the pipe and floated the ball to the surface and over.

They used their mental mobility—their cognitive flexibility—to preserve, try new ideas, and meet the challenge of the task.

Originality

When we speak of originality, we use words like *the first, distinctive, fresh, novel, new, unique, unusual, not seen before,* and so on. We know it when we see it because some concept of "newness" has been introduced. For many, originality springs from the capacity to think independently. Keep this in mind: you are the locus of creativity. You get to decide. If an idea or outcome is original to you, it is original. Others with a different history may have a different opinion.

The most important thing about being creative is to be constantly curious. Be curious about how and why things work and how and why things didn't work. Go out and look for the things that aren't working and find a way to solve that problem.—Wilson Greatbatch

Elaboration

The details have been filled in to develop it to its highest possible level for that time. The idea or outcome is expressed in a refined, understandable way. Perhaps there is a sense of elegance or a complexity that communicates the idea most clearly.

Tolerance for Ambiguity

Most people are uncomfortable with the "gray" areas of life. We want the comfort of knowing "this is good, that is bad." We have been schooled to believe in the right answer, the right solution. Many of the problems we face in our personal and business lives are not so clear. The labels do not fit quite so nicely. We do not know how to feel about something.

Imagine you have a friend in a bad marriage. Imagine she just told you she is pregnant. You "know" this is a bad idea but she is happy about it. You have mixed feelings. You feel ambiguous about it.

Creative people are more comfortable with ambiguity. They tend not to see things as simply black or white but rather as different shades of gray. They rarely stereotype people or situations. In the case of your pregnant friend, the creative person could offer sincere congratulations while privately planning what assistance she can offer when the marriage breaks up.

Creative people accept the pros and cons of an unknown situation. They refuse to make assumptions until they weigh all the options.

Ability to Defer Judgment

We are taught from an early age to be judgmental. Traditional games children play have a right and wrong way to play. A child who

improvises is "cheating." In school, there are correct answers and wrong ones. An idea is good or bad. When I was in school, we were required to give a short speech every Friday on a prepared topic. Our fellow students then "critiqued" it—usually by emphasizing the flaws we needed to improve. Most of us are used to using *critique* and *criticism* as if they were the same. We react quickly with all the negative reactions. We see the things that are "wrong" with this picture. Do you remember the cartoons called "What's wrong with this picture"? Two cartoons would be drawn side by side. On the surface they would appear to be identical. Closer study would show there were slight changes—a red hat for a blue one. You won by discovering all the "wrong" things in the picture. We have learned to seen anything different as being wrong. We are quick to offer negative opinions. Creative people are able to defer this judgment. They have learned to give new ideas a chance to come alive, to breath, and to grow. Deferring judgment does not mean the creative person accepts every idea as ideal. It is just that there is no need to decide strengths or weaknesses immediately.

Concentration

Most creative people become so involved in a problem or project that concentration is not a problem. Intense periods of concentration are required for the off-the-wall, hard-to-solve problems. Many creative people have learned to "switch the problem off" and use their concentration onto another area when they hit a snag. This allows them to return to the difficult problem with fresh energy.

A diamond cutter for one of the largest diamond firms in the world was selected to cut a record-setting ten-pound raw diamond. In an

Intuition is the highest form of knowledge – a characteristic unique to humans.—Unknown

interview, he explained his thought processes:
". . . I studied the diamond for three years before I
did anything else. I just looked at it, measured it,
mapped it. I explored it till I knew every atom of
it. When I picked it up, my hands married it and
it became part of me. Only after such close and
intimate awareness of it did I dare to imagine the
ways I could cut it. I spent two more years drawing
every conceivable way it could be cut. In the sixth
year, I selected the way that would best suit the
needs of the diamond. I could have cut in a way
that would produce more stones to be sold, but they
would not have been so beautiful or so unique."

Willingness to Test Assumptions

Every problem comes with certain assumptions.
The ancient scientific world assumed the earth was
flat. A flat earth limits exploration in that you explore
too far and you fall off one of the four sides. The
creative person is willing to test these assumptions.
Early sailors kept sailing closer and closer to the edge
of the world according to their sailing charts. Each
time they sailed on, they charted new territory to add
to the map. The sides of the world began to curve.
Creative problem-solvers know the most important
part of the process is just defining the problem by
testing all possible assumptions about the problem
itself. They redesign the map.

Openness to Ideas

Creative people are aware that creativity
does not take place in a vacuum. Creativity is a
vibrant, dynamic, ongoing process of growth and
development. Creative people search for new
ideas they can use and build on. They ask for
other opinions and add them to the creative soup.
A major toothpaste company was faced with the

Never trust an atom. They make up everything.—Unknown

dilemma of how to increase sales by 10%. They knew how many individual "doses" there were in a tube. They discussed ways to decrease the amount of toothpaste in each tube but decided the costs involved outweighed the benefits. A cleaning woman, emptying the trash baskets, was listening. She said, "Why don't you just make the hole 10% bigger so more squeezes out?" This company had an openness to ideas and took it. Sales increased.

Willingness to Take Risks

Creative people like to work on the very edge of potential failure. By working to the extreme limits of their creative possibilities, they are most likely to produce creative results. For the creative risk-taker, risks are unexplored territory. They are like our pioneer ancestors, pushing the envelope into the great unknown. Columbus expected to discover a new route to India and was willing to gamble his very life to achieve it. The creative individual may not enjoy failure but is willing to accept it as part of the way to reach creative goals. They are driven by the need to discover a new horizon.

Creative people exhibiting this trait are able to accept failure when it comes as part of the creative process. They are able to view failure as part of a learning cycle. It is a consistent myth that creative "geniuses" are always coming up with great ideas that work perfectly. Trial and learn, not trial and error.

If we believe that every idea must be earth-shakingly successful, we will never feel free to "play," to fail, to experiment again. We will inhibit our own ability to use our creativity.

If a person plays it safe all the time, there will be no creative breakthroughs. We must be prepared to take on certain risks, to gamble on new ideas, in the quest for creative solutions and products. A person with a low tolerance for risk will limit the

The past, present and future walked into a bar. It was tense.—Unknown

number of options that a problem might offer. They will stick with the known, even if it is not working, rather than take a chance. They believe it is better to go with the sure thing.

Self-Confidence

Being creative requires a certain amount of belief in yourself and your abilities. Creative people know they can use their talents, skills, knowledge, and creative imagination to tackle any problem. They believe all problems to be solvable. Self-confidence allows the creative people to influence, convert, and inspire less creative individuals. Being creative is not enough. Self-confidence is what allows us to follow through.

Ability to Excel in Defining Problems

Creative people spend time just thinking about a presented problem. They then proceeded to generate and explore a large number of options for problem solving. Creative people know how to ask the right questions. It is important to determine exactly what is the real, or core, problem.

For example, you may have a roommate or neighbor who plays loud music that prevents you from working on a project. What is the core problem for you—the loudness of the music or the inability to concentrate? Which problem are you trying to solve? By asking the right questions, the creative person is led to discoveries and creative solutions to solve the right problem.

Capacity to Make Order from Chaos

Creative individuals enjoy taking on complexity, disorganization, chaos, and ambiguity and then attempting to make order from it. Creative

Men are born to succeed, not fail.—Mike Fox

individuals thrive on approaching difficult situations with an open mind and a keen sense of the challenge involved. They enjoy taking mixed messages and less-than-clear goals and struggling toward changes and new resolutions. They have a drive to establish order and meaning to their life— to work toward simplifying everything.

Ability to Toy with Problems and Ideas

Playing with a toy or other object helps a child understand it better. The same can be true when we deal with ideas. Creative people are not afraid to play. When we toy around with our problems and solve them as part of a game, we enjoy the challenges. We must work hard to overcome the prejudices and fears instilled in us by well-meaning parents, teachers, and bosses who have repeatedly said, "Okay, it's time to quit fooling around and get to work." Maybe "fooling around" is the real work of creativity. Most of us can remember coming up with a brilliant idea, solution, or project when we were just fooling around. Our creativity expands when we allow ourselves to experience the work of wonderment and play. Toying with an idea gives us the time to truly understand and appreciate all the complex possibilities it presents.

Ability to Use Imagery

"What the mind can conceive, the mind can achieve." We are taught that rational thought is the highest form of intelligence. We like to analyze things. Imagination is considered a lesser thinking skill. Frivolous. Not serious. Childish. These negative images of imagination are unfortunate. They keep us from asking those wonderful "what if" questions. We need to use our imaginations like we did when we were creative children. What if

I do this? What if I do that? Imagination allows us to play with a problem. Imagery, pure and simple, is the ability to "see" a situation without having to experience it. By developing a mental image of a problem, a person can often produce unique solutions with less effort than analyzing it.

How many times have you used imagery to deal with a problem? Imagine you are breaking up with a long-time love interest. Imagine the different ways you could do it. Imagine the different reactions your sweetie has. Imagine your reactions. Imagine choosing a solution. Imagine a positive outcome.

Using imagery can help us deal with a potential problem situation safely. Imagery can provide us with material for the more analytical trial and error. It prepares us for potential obstacles and offers us conceivable solutions. Most important, the creative use of imagery plants the idea of success.

Intrinsic Motivation

Intrinsic motivation may be the most important indicator of creative success. What is our personal attachment or involvement? This must be more that just financial, like a paycheck. There must be some compelling personal reason we want to achieve the goal or solve the problem. There must be an internal reason. The challenge must contribute, in some measure, to our personal enjoyment or satisfaction. The creative person must feel a "grand passion" in the pursuit of the goal.

Albert Einstein once wrote a friend about his enthusiasm about a new theory he was working on, "The emotional state which leads to such achievements resembles that of a worshipper or a lover. . . . The daily struggle does not arise from a purpose or a program but from an immediate need."

Creativity has been here from the start. It is so thoroughly part of our world it is almost transparent.—Ronni Fox

A person who has no intrinsic motivation may be coerced into a certain degree of creativity by external motivation. Competition for prizes, positive work evaluations or the threat of negative ones, salary increases, and promotions can all be motivators. However, if there is no personal motivation beyond these external ones, the well of creativity will eventually dry up. In fact, Amabile (1985) conducted extensive research into the importance of intrinsic motivation in creativity. She found that external factors such as work evaluations, supervisory styles, activity restrictions, and financial competition can actually undermine and inhibit displayed creativity. "There are lots of people who have great potential for creativity . . . many may have had some early successes, but afterward they just dry up or are unable to produce precisely because their work would or would not be evaluated" (Amabile, 1985).

Curiosity

Creative individuals are naturally curious. They are always searching for explanations and exploring new answers. They want to discover the "why" of things. This curiosity is highly personal. They need to know. Discovery is exciting. Answers incite new questions. Think of the typical three-year old and the endless "Why?" questions. Why is the sky blue? As any parent will tell you, no answer is quite final enough. Each explanation is met with another, "but why?" question.

Optimism

Creative people are positive. They tend to maintain an attitude that things can be done and problems can be solved. They are not discouraged when new ideas do not pan out. Failure becomes

Experience is a hard teacher. She gives the test first and the lesson comes afterward.—Unknown

just one more discarded experiment on the road to success. Thomas Edison was once asked how he perfected the light bulb. He replied, "I ran out of ways not to invent the light bulb."

Humor

Creative people use humor to enable them to take life and twist it around. They take lemons and turn them into lemonade. They use a sense of humor to produce new ways of looking at themselves and others. Humor is an invaluable aid to creativity. Humor helps to release information from our subconscious. This enables us to make connections and obtain insights we never would have had. Billy Budd, a literary creation of Herman Melville, possessed this quality in addition to abundant optimism. His fellow sailors, tired of his continuous good humor, served him a large bowl of moldy and weevil-infested porridge for dinner. "Find something good about that," one fellow jeered. "Well," said Budd, "there's plenty of it!"

Persistence

Solving problems is not easy. Luck does not help often. Creative people enjoy "noodling" with a problem. Trying different approaches and using different techniques are second nature. Creative people believe in the old adage, "try, try again." Solutions are bound to occur if a person is persistent.

Independence

Creative people are free thinkers who maintain a strong sense of their own identity. They are able to see things from a new angle or perspective. They can look beyond conventional wisdom. They enjoy

intellectual challenge. An artist was once asked how he decided what to carve out of a block of marble. He replied, "I see the image hidden within the marble; then I just chip away the unnecessary rock."

Self-Awareness

We all have emotional "buttons" that cause us to act certain ways in certain situations. Most problems we encounter will push these buttons. We project ourselves, our feelings, into a problem situation. As the cliché goes, "we are part of the problem." A problem is far easier to deal with and solve if we understand why we are reacting to it in a negative or positive way. Creative people have learned to recognize these emotional buttons and develop ways to turn them off.

Commitment

Because complicated problems do not come with easy solutions that will guarantee success, creative problem solving must develop a "can-do" attitude. The creative person "owns" the problem. This person believes nothing can deter her. She dedicates herself to developing a workable solution. Think of Joan of Arc. She saw the plight of France as her own. She made a strong commitment. Nothing deterred her. She solved the problem and achieved the goal. (Unfortunately, she won't be the last creative person burned at the stake for coming up with a nonconforming solution!)

Self-Discipline

Making progress requires discipline to stick with a problem and approach it from many different angles. The essential factor is the degree of progress made in working toward a solution, regardless of

Creativity is intelligence having fun —Albert Einstein

the approach used. Discipline is not to be confused with persistence. I have all the persistence in the world but it took discipline to write this book. I forced myself to work for a set period each day. Discipline is not the same as concentration or commitment, either, although they bear similarities. Many people are committed to a clean environment but lack the discipline to take action effectively. A person can be very disciplined but have a problem concentrating. Think of discipline as the scientific backbone in the creative body.

Impulsiveness

"Look before you leap." "Act in haste, repent at leisure." "Haste makes waste." "Think first, then act." There are dozens of similar sayings urging restraint, caution, conservative actions. We are all thoroughly indoctrinated in the fear of a rash act. We are trained to view impulse as something to be wary of, to be restrained and kept in check. The creative person knows when to break these mental chains and run free. We need to trust our intuition and positive impulses. We need to dive, head first, into the great pool of our subconscious thought. Taking this mental plunge frequently results in unexpected associations of ideas or concepts that might not have appeared if we second-guessed our leap. Even when our leap washes out, we have learned valuable information for next time.

Objectivity

The creative person is not just a "wild card" in the deck. It is imperative that objectivity be active as well. Without objectivity, there is little difference between creativity and schizophrenia. Creative people not only examine and explore their own ideas—they seek the advice, ideas, and critical eye

of other people. They want, need, request and use the factual criticism of others.

It is difficult to step outside of our own self-importance. We are all vested in our ego. Objectivity allows the creative person to do this—to seek advice from peers, friends, colleagues, or the general public. Without a degree of objectivity, it would be difficult to test an idea or conduct a test market for a product. Politicians rely so much on polls because they realize that they have a limited objectivity themselves. Conducting a poll, and using the results, allows them to inject a new objectivity into their political ideals.

By developing this trait, the creative person adds to personal insight, increases personal commitment, and produces a more creative outcome than could be accomplished subjectively.

Flow

Have you ever been so fully immersed in some activity that you didn't realize how much time had gone by? You were fully involved and were more concerned with the experience and the process of the experience. The goals were clear, the feedback was immediate, you were completely absorbed. You were in a state of flow (Csikszentmihalyi, 1996, 2003).

The more we understand the complex traits and nature of the creative person, the greater ability we will have to increase our own creativity and to teach it to others.

Creativity vs. Productivity

Before reading the next section about intrinsic motivation, it is important to understand the difference between *productivity* and *creativity*.

Although not mutually exclusive, they are not the same thing. A person can be extremely productive without being creative. When Amabile stated that some things (such as salary raises, bonuses, etc.) have been shown to have a negative effect on creativity, she was not commenting on how those perks affect job productivity.

As an example, I once had a job in sales. We had a sales quota and a quota of charge card applications we were expected to meet. It was quite a large company and I was always among the top three salespeople in both areas. On the Kirton Adaption-Innovation Inventory (Kirton, 1976), I have a style preference for working outside the given paradigm. I met my goals in playful but risky ways. I enjoyed the challenge and had fun with the processes of making sales and opening charge accounts. The only months I ever had difficulty, or failed to meet my goals, were those where bonuses, prizes, or similar external rewards were offered. I became anxious. I no longer wanted to "play"; I wanted to "earn." I stopped taking risks like joking, teasing, or theatrical displays, which were my usual style. I became "business-like": methodical, systematic, and pushy. I became aggressive and defensive. I wasn't being creative and I wasn't having fun. While I was still being productive, the opportunities for greater reward decreased my creativity.

The offer of extrinsic rewards certainly can increase our productivity. Ask any factory assembly line worker. In jobs that do not require creativity, extrinsic rewards no doubt have a positive influence on the bottom line. Amabile's research concentrated on those jobs requiring creativity and, more specifically, on the degree of creativity of the outcomes. In those types of jobs, intrinsic motivation is what matters most.

There are two ways to slide easily through life: to believe everything or to doubt everything. Both ways save us from thinking.—Alfred Korzybski

Amabile—Intrinsic Motivation

Teresa M. Amabile has long studied the nature of the creative person. She has been interested, as she puts it, ". . . in both the creative personality and the personality of creativity." Her study (Amabile, 1983) on creative nature led to the discovery of the "Intrinsic Motivation Principle of Creativity." This principle asserts that people will be most creative when they feel motivated primarily by the interest, enjoyment, satisfaction, and challenge of the work itself rather than by outside pressures. Creativity is increased in relation to the "intrinsic" or personal motivation the individual feels for the task. Supervisory restrictions, deadlines, or even positive rewards like a pay raise have little positive effect on creativity itself as these are "extrinsic" motivations.

Creativity Killers

Further study led Amabile (1996) to the discovery of "creativity killers"—factors that can damage or destroy a person's ability to use creativity. These six factors, when brought to bear on an individual who is doing something personally interesting and potentially creative, will undermine both the intrinsic interest and the creativity potential.

1. *Expected Evaluation:* People who are concentrating on how their work will be seen by others and judged/evaluated by superiors are less creative than are people who are not made to worry about evaluation. Many supervisors err by using evaluation as a positive motivator. "Hey Cindy! A promotion is coming up soon. The success of this project of yours is being really watched by the 'big guys.' Good luck and keep up the good

If you want truly to understand something, try to change it.—Kurt Lewin

work." By attempting to apply an extrinsic reward/ motivation, Cindy is more apt to feel pressured to succeed and less apt to "play" with project ideas. Her personal motivation—the fun she was having—is now restricted. This pressure will now limit her previously unrestricted creativity.

2. *Surveillance:* People who are aware of being watched are less creative than people who are aware that they are not being watched. Most of us have had the unpleasant experience of working for a boss who was always "breathing down our necks." People who feel the boss is always lurking will feel a need to "look busy" constantly. They will sacrifice valuable idea time. Productivity may increase, but creativity will not. More products might be produced, but new concepts for improving or developing them will not. Surveillance, whether implied or actual, increases stress and anxiety in the creative person. It becomes more important to look busy than to be busy.

3. *Reward:* This is a tricky one. Dr. Amabile told a wonderful example in her article "The Personality of Creativity" (1985). The authors were interviewing 120 scientists on how they stay creative. One of the scientists related, "One thing I've done to stay creative is to cut my salary down so management doesn't worry about what I'm doing every moment. Once a salary gets up there, management is forced to get involved in everything you do because every moment your time costs the company money. So I avoid this by turning down the raises. I'm here to have a good time. I have the joy of thinking. . . . I love just thinking things over,

just circling a problem. I am interested in things that don't work and I even seek them out. When I see conceptual contradictions, I go get them. Just let me play. Give me a big enough playpen and I'll go from there."

Now most of us will not be willing to turn down a raise like that. However, the outside reward cannot supply us with the same satisfaction as our own inner reward system. People who see themselves as working primarily to get "the big bucks," a promotion, or some other extrinsic reward will be less creative than those who are working primarily for the joy of it. In fact, numerous studies have shown that without personal motivation, outside rewards must be more frequent and larger in order to maintain the status quo. Have you ever thought "they better give me more money or I'm leaving" when you truly loved your job?

4. *Competition:* People who feel themselves in direct, threatening competition with others in their work will be less creative than those not focusing on competition. It is a familiar custom in many large and small companies to pit individuals or departments against one another to encourage greater productivity and profits. I once worked in a gourmet grocery in the deli section. The owner of the store would come over at least once a week to tell us how poorly our department was doing in relation to other departments within the store. I am sure she used this tactic to inspire us to work harder and sell more products. Just the opposite happened. She took a healthy, outgoing, well-trained and enthusiastic young staff and undermined it. Staff became resentful and despondent. As morale decreased, so

Everyday creativity – it's where the living happens.—Hope Mayes

did creativity. We began to produce less, rather than more, sales. Cross-references to other departments became rare. Why should the deli send customers to house-wares or the bakery when they were already doing so much better than us? Staff turnover increased 300% over any other department. We had lost our intrinsic rewards, our personal motivations, because of perceived competition. Competition in itself is not necessarily detrimental. It is the type of competition. Think of the fun and creativity generated by a brainstorming session. There is often a high degree of competition but it is internally generated. We are competing with ourselves. We are competing with our group to produce more creative ideas. This is fun, exciting, productive, positive competition. Everyone is an equal winner.

5. *Restricted Choice:* People who have their choice in how to do a task restricted will be less creative than people given a freer choice. In the Intrinsic Motivation Principle of Creativity study, this factor was rated particularly important by the participants. Freedom of choice in how to do one's work was the single most potent element in being creative. Business is beginning to recognize the value of unrestricted choice by allowing employees to job share, set their own hours, work out of their homes, and enjoy many other job-related freedoms. Many are forming task groups in which members are given a goal and allowed to develop it themselves. Group members divide up the work based on individual skills and personal motivation.

6. *Extrinsic Orientation:* People who are encouraged to think only or primarily about all the outside motivations and reasons for

Ideas are my compass.—Roberto Ferreira, limo driver, Arrowhead California

doing what they are doing (i.e., punishments or rewards) will be less creative than people who are thinking about all the personal satisfactions of the job.

Not all jobs require equal creativity. If a person is involved in routine tasks that do not require creativity, he/she will need extrinsic motivation. Factory assembly, bookkeeping, and jobs with similar routine tasks require precise and repetitious industry. Here you may need a system of rewards, evaluation expectations, surveillance, and so on to get the work done correctly and on time. If, however, you want to produce innovative ideas, you will need to have, develop, and encourage intrinsic motivation. Amabile (1997) makes this excellent example using the "rat in the maze" metaphor: "Imagine that a task is like a maze that you must get through. Say, for simplicity's sake, that there is only one entrance to the maze. Say also that there is one very straightforward, well-worn, familiar pathway out of the maze. A straight line that you have followed a hundred times, and that you could practically follow in your sleep . . . and it does lead you out of the maze. By getting out, you have fulfilled the basic requirements of the task. You have found a solution that is adequate. It is also uncreative. There are, of course, other exits from the maze and these solutions might well be creative, elegant, and exciting. The problem is that none of these exits can be reached from the familiar, straightforward path. Some deviation is required, some exploration through the maze. Moreover, risk-taking is required: in any maze there are more dead ends than there are exits. [You] must have the flexibility to recover from getting stuck in a dead end, to back up and intelligently try something else" (p. 65). If you are primarily motivated by extrinsic factors, such as a reward for "finishing" and leaving

The more original a discovery, the more obvious it seems afterwards.—Arthur Koestler

the maze, the most reasonable thing for you to do under these circumstances is to take the simplest, safest path, to follow the familiar routine, the conservative method. That way, you run no risks and you know you will get the external reward. If, however, you are personally motivated to do the task, you enjoy being in the maze. You enjoy the activity itself. You want to explore in the maze and you will be able to take those dead ends in stride. It is when you start out intrinsically motivated and when your work environment encourages and allows you to keep that personal focus, that you will be likely to discover a creative exit.

Amabile's Model of Creative Behavior

Amabile identifies three components that are necessary for creative behavior (1983): Domain Relevant Skills, Creativity Relevant Skills and Task Motivation.

1. *Domain-Relevant Skills:* These are the skills needed for your particular line of work. If you are trying for a job as a musician, you need to be able to play a musical instrument, for example. The domain-relevant skills are usually a combination of talents and skills learned through formal education and life experience.
2. *Creativity-Relevant Skills:* These are ways of thinking and working that are necessary and encourage creativity in any occupation. These will usually include an independent and nonconforming personality, a high energy level, and a way of looking at new views on problems.
3. *Task-Motivation:* This means the intrinsic motivation for doing the task. Some people are more inclined to need outside

rewards than are others. A creative person needs both personal motivation and a work environment that encourages and acknowledges the intrinsic rewards.

It is important to creativity that outside influences—extrinsic motivators—be reduced. It is also important for the creative person to have a task that is personally satisfying. The overall level of creativity in an idea or a product will be determined by joining the person's level of domain/job relevant skills, creativity-relevant skills, and task-motivation. These do not have to be equal in degree. A person may be less personally inspired but compensate for that by bringing a high level of experience and skill to the job. It is equally important for the creative person to acquire the necessary skills and experience the job requires. A person with a more developed group of skills will find more personal satisfaction in putting them to good use. Increasing our personal skill level through additional education and training requires an increase in new ideas. Thinking up new ideas leads to increased creativity.

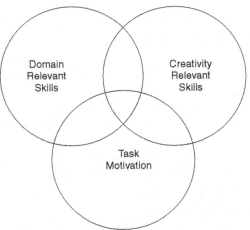

Amabile's Model of Predicting
Creative Behavior

Source: Michael Fox

Creativity begins at the end of your comfort zone.—Unknown

We need to concentrate on our intrinsic motivations. If we can tune into a sense of wonder, challenge, interest, and enjoyment in our job, we will be less bothered by annoying outside constraints on our motivation and creativity. We will become immunized against the "pointy-haired" bosses of the world.

Intuition in Decision Making

"Intuition may be defined as a tacit form of knowledge that orients decision making in a promising direction. In the context of problem solving, a promising direction is one that leads to potentially effective outcomes. In the context of innovation, a promising direction is one that leads to potentially creative results" (Policastro, 1999, p. 89). Webster's dictionary defines *intuition* as "the power of knowing . . . a quick or ready apprehension."

Agor (1986, 1989) sees intuition as a decision-making tool. He found it to be a crucial skill in management climates where there is a high level of uncertainty, little precedent for action, variables that are often unpredictable, facts that are limited, known facts that do not point in a clear direction, limited time, and pressure to be right, and it is necessary to quickly choose from several possible alternatives. As he states, ". . . intuition is, and increasingly will become, a critical brain skill necessary for the successful company executive in the 'megatrend,' 'future shock' environments we now face."

Although Agor's research subjects were all top management executives, all creative people face the same challenges in a world defined by rapid change and crises. The creative person uses his/her intuition not as the only resource but as a valuable addition to logical thought. Intuition is

True leaders do not create more followers. They create more leaders.—found in More magazine

based on our experiences over the years, facts we currently possess, and a well-developed sensitivity and openness to our physical, emotional, and psychological worlds.

The creative person uses intuition to see possibilities and to supply ingenuity to problems. Intuition helps us deal with and solve complex issues where facts and data are incomplete. It furnishes us with new ideas and helps us see into the future. It may help us to motivate ourselves and others to "do the impossible."

William McGinnis, a former city manager in California, offered this insight: "I believe that good intuitive decisions are directly proportional to one's years of challenging experience, plus the number of related and worthwhile years of training and education, all divided by lack of confidence or the fear of being replaced (personal communication)." If we have experience and self-confidence, we can learn to trust and use our intuition.

Developing Your Intuition

Agor developed 18 keys to enhancing and using creative intuition:

1. *Intent:* A creative person learns to value intuition as a tool and set about developing it.
2. *Time:* Creative people take the time to listen to intuitive body cues: the "sense of excitement in the pit of the stomach." They create a space in their life for developing this sense.
3. *Relaxation:* For creative intuition to function effectively, we must let go of physical and emotional tension.
4. *Silence:* Creative people learn how to quiet the mind and weed out unnecessary "mind chatter," all the negative "rational" ideas that intrude.

The greatest block to solving a problem is the human mind.—Gabe Brown, a "no-till" farmer, Bismark, North Dakota

5. *Honesty:* We must learn to face our own self-deception and be honest with ourselves and others. It is so tempting and so easy to see problems, situations, and people the way we want them to be, rather than the way they really are. We confuse what is true in fact with what we would like to be true. We need to get out of our own way.

6. *Receptivity:* Creative people are open to new and different ways of doing and seeing things. A father takes his daughter to a zoo. "Look Daddy!" she says excitedly, "A horse in striped pajamas!" The father corrects her, explaining that the animal is a zebra. "Okay" the little girl says thoughtfully, "but it still looks like a horse in striped pajamas to me."

7. *Sensitivity:* Tune into both your inner and outer cues. What "vibes" (as we said in the 60s) are you picking up on? What is there in the physical or emotional environment that is causing the sensation you are feeling? What is giving you concern? If you could change part of the environment, would you still feel the same?

8. *Trust:* Most of us have experienced a situation that made us feel anxious, uneasy, nervous, or even fearful. When we tried to analyze it, we could come up with no facts, no logical reason for our feelings. Many of us lost that argument with our intuition and acted against our better judgment. "Gut instinct" is usually correct. We need to learn to trust our intuitive sense. I am reminded of a little nursery rhyme, "I do not like thee Dr. Fell, the reason why I cannot tell, but this I know and know full well, I do not like thee Dr. Fell."

9. *Openness:* The creative individual will embrace new experiences and feelings both internal and external.

Worry is the mis-use of imagination.—Unknown

10. *Courage:* A creative person respects risk and inherent danger and can look honestly and objectively at them. A friend of mine has a real fear of public speaking and yet she has a large following on the public lecture circuit. She had the courage to face her fears, confront them, experience them, and let them go. She knew, intuitively, that her fear was unfounded.

11. *Acceptance:* Creative people can increase their intuition by adopting a nonjudgmental attitude toward things as they are.

12. *Nonattachment:* Let go of your personal involvement. Sometimes we become so attached to a person or an idea that we ignore our feelings that it is time for a change. We become afraid to lose our preferences or preconceived picture of the ideal reality.

13. *Practice:* Like all skills and tools, constant usage translates to ease of use. The more we make the decision to adopt intuition as a resource, the more useful it will become.

14. *Support groups:* Find friends and colleagues with whom you can share intuitive experiences. Encourage the exploration of this factor in decision making. Share insights without judging.

15. *Journal keeping:* Keep a record of your intuitive insights—an "inspirational" notebook. Record what you were feeling or sensing when you made a decision based on intuition. Record outcomes and reactions.

16. *Love:* Practice love and compassion. People who are gentle with the feelings of others are frequently highly intuitive. As President Clinton was fond of saying, "I feel your pain."

17. *Nonverbal Play:* Practice ways of expressing an idea without using words. Many a great

idea has popped into my head when I was just "doodling" on a piece of paper. Try expressing thoughts by humming, drawing, or elaborate pantomime. Nonverbal play can get the creative juices going when you are stuck.

18. *Enjoyment:* Just "go with the flow," experiment, and have fun. Allow spontaneity.

Try an intuitive idea just to see what happens. Not all ideas have to be great ones. There are several analytical exercises Agor suggests using. Most blend and overlap with what other researchers have discovered about the creative person. We can discuss the problem with colleagues who have different perspectives as well as with respected friends. We can concentrate on listening to not only *what* but also *how* people express themselves. We can immerse ourselves totally in the issue at hand. It is helpful to identify the pros and cons, then assess our feelings about each option. We should consider the problem only when we are most alert. We can be sensitive to how we are reacting to our immediate environment. We can recommend a "creative pause" before reaching a decision to allow time for us to assess our intuitive response. We can ask ourselves, "What do I want to do"? and "What do I feel is right to do?"

Fourth-Grade Slump

One's level of creativity goes up and down. Torrance (1968) documented three predictable slumps in creativity for most young people, as measured by the TTCT. The first was in kindergarten, then again in the fourth grade, and yet again in the seventh grade. These drops in creativity test scores were due to social and cultural influences—not biological. Later Runco (1999)

found the same evidence. However, due to a greater awareness of creativity and the environment to support it, some positive changes are beginning to occur. Children entering kindergarten begin to experience conformity and regimentation. The largest slump was in the fourth grade. Students experience new, predictable social/cultural norms. They sit in rows and raise their hands before speaking; younger children change rules of a game while older children stay within the rules. In the seventh grade, there is a strong adolescent conformity. This is expressed as a strong desire to be different, as long as it looks like everybody else. Here the emphasis is on learning and implementing the rules of convention and the rules of society. Each of these slumps in creativity reflects a sensitivity to norms and expectations. Another, yet-to-be-validated reason is the reduction in reinforcement of the behaviors associated with imagination. Your authors posit that knowledge and evaluation skills are reinforced as a function of the perpetuation of the species with less reinforcement of the behaviors associated with imagination.

Habits and Blocks to Creativity

Anything that gets in the way of your creativity is a block or barrier to your creative success. It may not be a sophisticated definition but it remains true. There are thousands of possible blocks to creativity but, in the main, they can be grouped into five categories (Davis, 1986)—*learning and habit, rules and traditions, perceptual barriers, cultural barriers, and emotional barriers.* Blocks and barriers keep you from using creative problem-solving strategies.

First we will take a look at *learning and habits*. It is not a bad thing to have good habits. They bring order out of chaos and help us function easily. We

have been trained or have trained ourselves to see them as effective ways to think and respond to situations we deal with daily. We view them as the "correct" responses to our routines and to our patterns of behavior. For instance, we learned in grade school to raise our hands and wait our turns to answer a question. If we just blurted out an answer, we might have received a stern look and a reminder to "wait our turn." Raising our hands and waiting then became a habit that worked for us. We may no longer raise our hands, but do we still have the habit of "waiting our turn" before offering new opinions or ideas? Is this habit still necessary or is it keeping us from moving ahead? Habits can too easily translate to a mental block. We hear (and say) constantly, "but we've always done it this way!" or "but this is the way we're supposed to do it." You can think of many more examples from your own personal and/or business life. We are all creatures of habit but we need to consider why we have them, how we use them, and when it would be better to challenge them. Our habits make us feel safe and comfortable but we need to acknowledge that safe and comfortable can also keep us in a rut. Creativity, like change, is a challenge and challenges require us to move outside the realms of safety and comfort. You must be prepared to really look at your habits and see how they may be blocking your ability to accept new challenges.

Rigid values are another part of learning and habit barriers. We all have values and we all need them. Our values bring us together as a culture, as a people, and unite us with others who can share them. Unfortunately, they can cross the line into barriers to creative thought and actions. If we place too much emphasis on our traditional ways of doing things, the result can be a conformity that is neither necessary nor useful. If your value system has become rigid, you may approach

everything as being either good or bad, acceptable or unacceptable. This "either/or" mind set can keep you from making connections or novel relationships between ideas. A rigid value system can keep you from seeing the possibilities in an idea that is outside your belief system. You do not have to change your values; you only need to allow yourself to see the potential good that can come from elements of other value systems outside your own.

© *iQoncept/Shutterstock.com*

Moving on, we take a look at *rules and traditions*. We all have them and we all need them. It would be impossible for society to operate without rules and traditions. whether they were learned from your family, your friends, media, or the educational and corporate worlds, they have value to you. These rules, regulations, policies, laws, etc. guide all our behaviors in our personal lives as well as our interactions in the greater society.

They give us "correct" ways to respond to those around us. The problem arises for us when, instead of letting these rules and traditions guide us, we let them both restrict and inhibit us. We use them to keep from seeing if, perhaps, there is a better way to respond. They may make us become inflexible and unwilling to change. They may make us reluctant to "play," to accept a level of uncertainty in our lives. We may use them to avoid frustration and to avoid facing the scary "unknown" of change. They may make us reluctant to let go of traditional patterns of thought or behavior that keep us from positive changes. They may restrict our search for balance in our lives. They may inhibit our need for fantasy and imagination—the very elements of creative thought.

For example, think of your family's holiday traditions. Now, imagine that a member of your family has married someone whose traditions are much different than yours. Could you accept them as equal in value to your own? Could you imagine a way to graft them into yours? Could you consider adapting your traditions and theirs into a totally new tradition?

Corporations, educational institutions, and government bodies all have their individual rules and traditions. Someday you will find yourself a part of them. If you have an awareness of both their strengths and their weaknesses, you will be better able to use creative approaches to changing them if you find it necessary.

Here is a short list of some of the negative consequences rules and traditions may contribute to:

1. Coercive leadership that has a history of not seeing employees as truly contributing members of the organization
2. Rushing to premature judgment

3. Repressing creativity so as not to "upset" the system
4. Anger, frustration, and resentment when faced with challenges
5. Conformity for the sake of conforming
6. Automatic and negative responses to any change in the usual "rituals" of life, business or personal
7. Being bound to habits and inability to even consider change
8. A narrow focus without the ability to see or entertain a different course of action

Challenging our view of rules and traditions can lead to some pretty positive results, a few of which are listed next:

1. A more visionary leadership that can look ahead, anticipate problems, and consider novel ways to deal with them
2. The ability to use critical analysis and judgment instead of relying on the usual procedures
3. The ability to use creative thinking and creative teamwork to work on new solutions
4. The ability to be more flexible in the way we approach problem situations
5. A renewed sense of excitement with trying new ways of approaching life
6. Renewed pride and purpose to our daily and work lives
7. Increased sensitivity and responsiveness to those around us who may or may not share our rules and traditions
8. A more lively dynamism in our interactions, personally and in the workplace

Perceptual barriers influence our usual "mind set"—the way we view the world through our

emotions. We use our perceptions to "see" the outside world and decide how we will react to it. Our perceptions can be both helpful and harmful in our lives. Perceptions are an outgrowth of our learning and our habits. We may use them to keep us from really seeing anything out of a limited familiar focus. We may develop what psychologists refer to as "functional fixedness": the inability to adapt to any other way of responding to situations we are faced with. We do it the same familiar way because it is what is comfortable to us. We perceive that any other way to react would be dangerous.

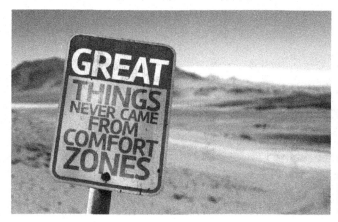

© ESB Professional/Shutterstock.com

Some of these perceptual barriers are:

1. A certain sensory dullness. We have a limited ability to "read" people or situations. We accept without question or "data" not only that our perceptions are the only ones but also that others share them.
2. We see old meanings in new situations. "A" always equals "B."
3. We are restricted in our ability to gather "data." Although each of us possesses the five senses of sight, sound, touch, taste, and

smell, we restrict ourselves to using only a select few (usually just the first two) to store things in our memory banks. Limiting our sensory perceptions restricts us in gathering knowledge.

4. We jump to conclusions rather than attempt to further explore options for action.
5. We stick to the familiar rather than try something new, either in our thoughts or actions.
6. We cannot get an accurate view of our current situation because we allow our perceptions of the past to color our view of the future.

© Leremy/Shutterstock.com

Cultural blocks/barriers to our creativity are the pressures we get from the social influences, expectations, and pressures to conform that come from our social and institutional structures. They make us fearful of seeming different. Of being "outside the norm," of not behaving the way we are "supposed" to. These are the "rules" that our society imposes on us in order to be "liked" and accepted. They come from outside pressure, media influence, peer pressure, and our own combinations of values/rules/traditions/ and belief systems. I am sure you have heard family members or business associates squelch any attempt to do things differently with, "That's the way we do things here!" Our cultural

Human beings, who are almost unique in having the ability to learn from the experience of others, are also remarkable for their apparent disinclination to do so.—Douglas Adams

barriers can make it hard for us to change because
we face the uncertainty of acceptance. It is our
human nature to want to be accepted by the group.
We do not want to be different. We act as we perceive
others expect us to act. It is uncomfortable to be
"different." We like, even cherish, being "right" and
having others agree with us. We fear disapproval,
criticism, sarcasm, and "being made fun of." Listed
below are a few cultural blocks to our creativity:

1. Valuing logic and reason over imagination
 and fantasy
2. Social expectations and stereotyping of
 ourselves and others
3. Valuing practicality and economics over
 innovation and creativity
4. Valuing competition and cooperation over
 individuality and spontaneity
5. A desire to protect the "status quo"
6. An emphasis on obedience, duty, and
 conformity
7. Acceptance of self-limiting social and
 cultural roles, traditions, beliefs, and
 customs

Think about you own life and I am sure you
can come up with many personal examples of how
cultural blocks have inhibited your own creative
growth. For example, if you grew up female in the
years before "women's liberation," you might have
narrowly restricted the educational and career
choices you made because the culture then said
women should marry, raise children, and not try
to "compete in a man's world." Women then simply
accepted that they would be paid less than men
if they "chose" to work. Most "working women"
restricted their choices to culturally accepted
careers, such as teaching or secretarial jobs. They
became nurses, not doctors.

In order to "grow" our creativity, we need to look closely at our own perceptions and to be honest about which ones hold us back and which ones make us strong.

© ESB Professional/Shutterstock.com

The last barrier we will deal with concerns *emotional barriers*. All of us have experienced times when our emotions influenced our actions, both with positive and with negative results. Emotions are incredibly powerful and can affect our ability to be creative profoundly. They can keep us from thinking clearly, hinder our imaginations, and keep us from taking any actions, much less creative ones.

Fears, such as the fear of failure or the fear of ridicule, can make us "play it safe" rather than taking a risk or pushing the boundaries of a problem. Anger can be a potent emotional barrier, inhibiting the ability to see or accept challenges. Anxiety can make us be hesitant to accept ambiguity or to accept that a challenge will contain a certain amount of uncertainty. Hate, whether

associated with a primitive emotion like anger or a societal one like racism/sexism/etc., can make us unable to reach out and compromise. Even love can affect our creativity. Anyone who has been in love can relate any number of stories about how that wonderful, giddy feeling just left them "love stupid."

To overcome emotional barriers to creativity, we need to recognize them and to honestly examine how they affect us personally, in terms of our creativity. Does the emotion we are experiencing make us fearful of taking risks, is it challenging our value system, is it blocking our ability to use innovative approaches? Is it affecting our self-esteem and making us self-conscious? We can begin to analyze what is emotionally affecting us. Is it caused by external sources, such as our families or our supervisors? Is it an internal source such as a challenge to a personal belief?

When we find our creativity being sabotaged by an emotional barrier, we can choose to use our creativity to free us again. A simple step is to ask the old question, "What problem am I trying to solve?" and then ask ourselves, "What might I do about it?" It may be simply enough to acknowledge the emotion and wait for it to pass. Failing to recognize and to deal with our emotional barriers may lead to personal timidity, a habit of constantly being our own worst critic, and, eventually, finding ourselves with chronic levels of low self-confidence and self-esteem.

Many otherwise creative people underrate their own strengths and abilities because they suffer from a poor self-image. They tend to undervalue their own experiences and the amount of resources that are available to them, both human resources and material ones. A person with low self-image often has an inflated image of the skills of others, particularly if they are persons in positions of

power. People with low self-images are reluctant to express or push their own views. They do not challenge the right of these others to dominate them. They are reluctant to take risks. They set low goals to decrease their possibility of failure. They are reluctant to express any opinion or feeling that may lead to criticism or challenge.

Overcoming all of these blocks to creativity and barriers to effective problem solving are possible. The key is in wanting to. The individual must have a personal motivation to change. For this to take place, a person must first be dissatisfied with the way things are, must want to be more effective and creative in solving problems, must have some goal that will be achieved by changing (a goal that is better than the current situation), and must be aware of specific and practical steps to take to reach that goal. Individuals wishing to increase creativity can do so by becoming more aware of the personal barriers and blocks that affect them and deliberately choose new techniques to overcome them. They won't settle for the first answer; they will consider a second, third, or fourth one. They will learn to tolerate ambiguity. That is a learnable skill. They will take a risk in their thinking and consider the "impractical" instead of just the "logical." As the author says to his students, "Have a mistake quotient of thirty mistakes a day. Double it if you run out." IBM founder, Thomas Watson, was famous for saying, "The way to succeed is to double your failure rate!"

Style of Creativity

Level and style of creativity are different. How much creativity you have is not the same as how you prefer to show your creativity.

How Creative Are You?

Is your creativity gas tank full, about half, running on empty? We used to think that how much creativity a person had was pretty much all here was to it. What you had was all you got. The Creative Studies project of 1970–1972 (Parnes, 1987) clearly showed that creativity could be taught and creativity could be learned. If you fell victim to the "fourth-grade slump" or packed your creativity away because of an environment hostile to creativity, you could still get your creativity back. Applied creativity was "on a roll." We found methodologies to teach skills that enhance your ability to generate more ideas (ideational fluency), to be more flexible in your thinking, to fill in the details (elaboration), and even to have more original ideas. These and more make you "better" at being creative. They increase your level of creativity. They fill your creativity gas tank.

We knew where we were going and how to get there—until STYLE entered the picture. That was a major change to the "how much" question.

How Are You Creative?

In fact, a new question arose: How are you creative? This shift is not simply a clever play on words. It is a question that looks at a range of preferences for displaying one's personal approach to creativity. We will examine these preferences through the lens of cognitive style.

Cognitive style is about your preferred way of thinking, particularly the thinking that you are not even aware that you do. Your preference for a style of thinking is so transparent that you probably do not even know it exists.

Assuming we are mentally healthy, what we think shows up in what we do and what we say. If

There is great arrogance in technology. It assumes that technology and technologists know all our needs. The individual control over one's environment reduces chronic stress and increases health and freedom.—Mike Fox

the preferred cognitive style is the same between two people in a conversation, there is no noticeable challenge. Both players get along. If there is a substantial difference in styles, there will be a noticeable discomfort for at least one person in the conversation. The outcome of the conversation will be less than effective.

There are five underlying parameters for cognitive style (Zilewicz, 1986).

1. *Cognitive styles are concerned with form rather than with content.*

 Style deals with how we perceive, how we think, how we define problems, how we solve problems, how we relate to others, etc.

2. *Cognitive styles are pervasive.*

 They seem to cut across boundaries to traditional "compartmentalizing" of personality. An individual's preferred style will be the same at work, at home, and at play. Wherever you go, your preference stays the same. You will flex as the situation requires. Flexing easily or reluctantly or deciding not to flex at all is the question.

3. *Cognitive styles are stable over time.*

 This does not mean they are unchangeable. Some may be easily altered. However, we can predict with some accuracy that a person who has a particular style one day will have the same style the next day. In the main, the style preference you displayed as a child is very likely the same style preference you have now. It is equally likely that you will carry your style preference for the rest of your life. Alternatively, you can learn to flex so well as to display a nonpreferred style for a long period of time and it will look like a preference. The job you

have may put you in a constant state of flex, but that does not mean your preference has changed.

4. *Cognitive styles are not an either-or situation.*

Your preferred style is just that: a preference. There are no individuals who are purely one style. In fact, you have every style there is. You cannot escape this. Given no external constraint, you will function in your preference. It is like a home base. If you need to flex away from your preference, you will, but only for as long as the situation requires.

You have developed flexing skills. To get where you are now, you have been flexing all of your life. Sometimes flexing is easy because it is only for a short duration or for a short "distance." Sometimes flexing is difficult as the duration is simply too long or for too great a distance. Flexing is exhausting, messy, slow, and requiring much concentration but is still doable. Just as soon as the need for flexing is over, you will go back to your preference.

5. *Cognitive styles are value neutral.*

There is no such thing as a good style or a bad one. One style is not better or worse than another style. Each style possesses a set of strengths and weaknesses. The strengths of one style might be the weakness of another style. When your preferred style is consistent with the situation, life is easy. When your preferred style is different than the situation, you will flex to meet the external constraint or you will leave or modify the situation. Both of these options have costs.

Views of Style

There are many, many views of cognitive style. A classic approach to cognitive style is that each person has a preference for processing information and making decisions based on psychological type. It can be measured by using the Myers-Briggs Type Indicator (MBTI). This is certainly a rich instrument that establishes sixteen possible preferences for the way an individual approaches the world. It is a robust theory and instrument, but complex— more complex than we will discuss here. I mention the MBTI here only as a point of reference, because it is so well known. We will, however, look at two other theories and instruments that readily translate into one's preferred style of creativity: Kirton's Adaption-Innovation Inventory and Puccio's Four-Sight instrument, a theory of style directly related to applied creativity.

Kirton Adaption-Innovation Inventory

Dr. Michael Kirton (1976, 2003) has concentrated his research into the area of cognitive style. It is an exciting and fascinating premise. Kirton started out studying the nature of decision-making styles. He developed a tool to measure how people with distinctly different preferences for cognitive style solve problems. He pictured a long line, like a ruler. On one end were those people that used systems and paradigms to define and solve problems. He called these *Adaptors* as they adapted the systems to the challenge at hand. At the other end of the continuum were the *Innovators* as these people ignored the existing systems and paradigms in their problem-solving efforts. Those in the *middle* could be called Middles, because really, what other choice is there?

This measure shows your preferred style. All of us have the ability to "flex" when necessary. Few of us fall exclusively into one or the other personality types and never deviate from it. It is interesting to note that in trial after trial, neither intelligence levels, amount of education, social development, occupational status, age, race, sex, nor cultural orientations seem to matter at all as these are "level" issues, measuring differences in amount.

Although neither style is, in itself, preferable to another, I would like to encourage you to acknowledge "word prejudice." In America, the term "adaptive" conveys dullness or conformity. We are a nation that prides itself on "innovation" and independence. In England, where Kirton devised his measurement tool, these terms are not so emotionally charged. There, both terms are neutral. Unfortunately, in America, I have had highly creative "adaptors" wail "I can't be an adaptor! I'm too creative." Here we all want to be innovators. Try to maintain neutrality on these terms.

In Kirton's theory, adaptors are those who seek to solve problems by introducing change that supports the current system. They like and expect to succeed by working *within* a system of rules, procedures, boundaries, and values. They seek to improve the organization from within. They have no desire to rock the corporate boat. They like to resolve difficulties or make decisions in a way that will be the least unsettling to the company. Thomas Edison is a good example of both a "high-creative" and an adaptor. His philosophy was "within the rules I can change the world." Adaptors develop novelty within the existing system and expect to succeed by using the rules.

Innovators, on the other side, like to do things differently. They are likely to see solutions in changing the status quo. Innovators expect to succeed by working <u>outside</u> the system to

improve it. They like to "shake things up." Their motto might be, "Without rules I can change the world." Leonardo de Vinci was a classic innovator. Innovators develop novelty outside of the existing system and expect to succeed by bending or ignoring the rules.

© Yes-Royalty Free/Shutterstock.com

© G roman/Shutterstock.com

Are you a Line or a Squiggle or maybe somewhere in the Middle?

Both types are valuable to an organization. Indeed, both are necessary. The broader the diversity of preferred styles in a group, the greater is their problem-solving potential.

Dr. Kirton (1976, 2003) lists six basic strengths for each type.

Adaptors
- Employ disciplined, precise, methodical approaches
- Are concerned with solving rather than finding problems
- Attempt to refine current practices
- Tend to be detail oriented
- Are capable of extended detail work
- Are sensitive to group unity and cooperation

Innovators
- Approach tasks from unusual angles
- Discover problems and discover avenues for solutions
- Question basic assumptions related to current practice
- Have little regard for details
- Have little tolerance for routine work
- Have little or no need for consensus, and are often insensitive to others

Middles or moderates are individuals who do not report clear preferences for either the adaptive or innovative style. They will share characteristics of both. They often act as a bridge between extreme style preferences and enhance communication within teams. Here is a list of characteristics of a Middle.

- Structured
- Secure

- Dependable
- Integrated
- Well-rounded
- Versatile
- Calculated risk-taker
- Resourceful and original
- Generate innovative ideas that have practical uses

Confusing Level and Style

One of the challenges with understanding style is the pervasive myth or popular view that Innovators are the creative ones and Adaptors are something else. The results from Puccio and Chimento's (2001) study showed lay people perceived innovators to be significantly more creative than adaptors (both students and professionals), and innovators were much more likely to believe that they were more creative than adaptors. Here is the truth revealed: There is no relationship between level and style. They are independent of each other. Adaptors and innovators are expressing their styles in different ways. Each has an equal chance of being creative. After a debriefing session on styles I still see the occasional person buying into the myth. They want to wear their style like a badge: I am an *A* or I am an *I*. To these I say "Get a life. You haven't been listening or your ego exceeds your intelligence."

In their own ways, both adaptors and innovators may display equal levels of creativity. Each style has its own problems. Because their preferred styles are so opposed, these two groups frequently misunderstand and stereotype each other. Until we understand style, we tend to have pejorative language about those who are not like us. To adaptors, innovators are "wild-eyed, impractical radicals," neurotics, "grand-standers," and misfits.

The best way to cope with change is to help create it.—Sen. Robert Dole

They seem bent on upheaval and destruction. They are "flaky," childish, and disruptive.

To innovators, there is nothing more boring than an adaptor—dogmatic, conservative, inflexible, "organizational bean-counters," nay-sayers, and insurmountable obstacles to change.

If one steps back and looks at both groups fairly, neither view is accurate. These stereotypes tend to promote factions within an organization, with everyone being called upon to choose sides. This tends to restrict the opportunities for looking objectively at the merits of individual ideas.

The Creative Studies Department at SUNY Buffalo State conducted a series of lab experiments using student participants. All participants were assessed using the KAI. They were divided into three groups; all adaptors, all innovators, and mixed combinations. The groups were put in separate observation rooms and given a simple task: work together to make an invention out of newspaper. The adaptors became frustrated with a lack of direction, lack of information, and limited resources. They made newspaper hats. Safe. Predictable. Not particularly creative.

The innovators attacked the problem gleefully but with total anarchy. At the end of the timed experiment, they had lots of ideas but had not actually produced anything. Exciting. Spontaneous. Neither creative nor productive.

The mixed innovator/adaptor group was another matter. As one of the observers commented to the head researcher, "I don't know what is different about this group, but boy are they interesting!" The innovators introduced ideas and built on them. The adaptors took the ideas, evaluated them, and selected workable ones. Together they produced four useful and novel inventions and had two more in progress.

Of course there's a lot of knowledge in universities: the freshmen bring little in; the seniors don't take much away, so knowledge sort of accumulates.—Dr. A. Lowell

Matherly and Goldsmith (1997) were interested in how to incorporate creativity and the creative person into business. They found a significant difference between what organizations said they valued and what the common practices within their organizations indicated they valued. They found that while organizations endorsed open communications, flexibility, risk-taking, trust, innovation, and spontaneity, this was not what was actually encouraged by standard corporate practice. The systems in place in these same corporations tended to discourage these behaviors and instead to reinforce evasion, rigidity, caution, suspicion, and stability/ conformity.

Why does this happen? Matherly and Goldsmith maintain that it is because management is confused about what creativity is and because they emphasize creative processes but neglect creative people.

If management, they maintain, does not understand creativity, they are not likely to either identify creativity or nurture it in its infant stages. They may believe that everyone possesses great creative potential just waiting to be released by some "magic formula." This may be somewhat true, but the majority of research has proved that the level of creativity a person has varies tremendously; in fact, the majority of creative ideas in any group, corporation, or business organization are usually generated by a handful of people. How then can a corporation best manage creative people? One way is by understanding and using the insights gained by the study of style.

Matherly and Goldsmith suggests there are three major areas at which management must look:

1. *Matching Creative Style to Organizational Needs:* What is needed or valued most in the organization—stability or flexibility? In

In this fast-paced world of complexity, competition and change, innovation is a necessity for survival. When cutting costs, it is inappropriate to eliminate that which you need to survive.—Mike Fox

which direction is the company headed—up or down? If the company is facing rapid growth or extensive expansion or needs a rapid retreat or repositioning in the marketplace, a flexible, divergent individual would make the best manager. An Innovator would be the best choice. However, if the company is in a position of steady and continuous growth, is in the process of consolidation, and is harvesting a steady profit, than the stable personality of an Adaptor would make a better managerial choice.

Since a company usually fluctuates over a corporate lifetime, it is important to have a management team that is composed of, and values, both extremes of management styles.

2. *Matching Creative Style to Job Requirements:* One of the most critical tasks for corporations—and for business in general—is to match the skills of people to the demands of a job. I once worked for a company that did not believe this at all. It was a large, upscale grocery business with many gourmet departments: deli, bakery, kitchen/café, and "exotics." Staff turnover was staggering. The company interviewed people and simply plugged them into spots the company deemed needed "a warm body" regardless of the skills or aptitude of the employee. In the deli, they employed a person trained as a baker and one trained as a cook. An employee with four years' experience as a deli worker was transferred to "stock assistance" (putting things on shelves). They promoted the kitchen dishwasher to baker's assistance, bypassing the trained baker they had working in the deli. These are just a few of

the poor decisions they made. Staff turnover remained a problem.

Using screening, interviewing, and evaluating tools to select employees whose aptitudes best suit them to a particular job can be good business. It is even more important in the case of managers and supervisors. Their skills, particularly in communication and problem solving, can be of critical importance.

Creative style may be especially important in certain areas of a business. If the main focus of the business is the development of new products necessary for long-term survival, you need people at the top levels of management who can set the tone, create the "press" of creative action. You need innovative problem solvers who enjoy the task of creating and developing novel solutions and ideas that progress to new products. Adaptors are better suited to administering existing product lines, improving existing production and delivery systems, developing ideas into products, and "keeping things running" through administration and maintenance.

The man who came up with the idea for "flavored gelatin" and discovered the process for making it quickly sold the idea for $125. The man who purchased this idea and turned it into the product "JELL-O" made many millions. Guess which one was mostly innovative and which one was mostly adaptive. Had they formed a partnership instead of a buyout, what glories might they have produced?

3. *Training:* A lot of the interpersonal friction that goes on between management and staff could be reduced if management and

staff were trained to understand creative style preferences or problem-solving styles. Matherly and Goldsmith listed three areas where an awareness of the Adaption/Innovation continuum would be of benefit:

A. *Overcoming Judgmental Barriers:* A good creative manager who is aware of style issues will be more objective, less emotional, and more open to the skills of her employees. She will be able to put aside the stereotypes we discussed and use style strengths to balance the team.

B. *Expanding Individual Creative Repertoires:* A creative manager can lead by example. Adaptive managers can encourage adaptive employees to develop "flexing skills" by introducing greater novelty into her problem solving. Conversely, creative innovators could demonstrate flexing abilities by encouraging more systematic ways of approaching problems and implementing solutions.

C. *Adopting Appropriate Behavior Responses:* A creative manager who has received training in style awareness issues will be better prepared to recognize her own preferred style and that of her team. This will help her adapt to specific problems and situations with appropriate problem solving behavior.

Matherly and Goldsmith provide a concise picture of their research with this summary:

> The ability of a firm to generate internal changes in procedures, to produce new products, or to react to new competitive situations is often essential to its long-term survival. Change may take the form of radical departure from the organization's established operations, or it may involve less sweeping modifications in behavior of and in the

organization. Though they differ in style, both the innovative and the adaptive contributions are creative. The truly creative input are recognized and valued for what they can offer, and where each is encouraged in those situations in which it is appropriate. By recognizing the potential contributions of both of these creative personality styles, organizations can build balanced, creative management teams and enhance organizational effectiveness (1997, p.75).

Puccio's FourSight Instrument

FourSight is an assessment measurement designed to help individuals and/or teams to better understand how they approach solving problems. It helps individuals develop awareness of natural strengths and tendencies when approaching a problem and to develop an awareness of areas that pose a challenge or may be a "blind spot" limiting problem-solving effectiveness. By increasing awareness of challenges, individuals and teams can learn strategies for dealing with and overcoming them.

FourSight is designed to improve increased collaboration. This results in improving the successful results of problem solving situations by individuals, teams, groups, and organizations. Understanding the results of this instrument helps develop tolerance and appreciation for the different styles of team members and the choices they make in the problem-solving process. FourSight creates understanding of team dynamics, increases positive communication among members, and creates a more positive working atmosphere.

The FourSight instrument is an outgrowth of Dr. Gerard J. Puccio's work with the "Creative Problem Solving" (CPS) model. The CPS model

Any activity becomes creative when the doer cares about doing it right or better. —John Updike

has a more than fifty-year history of development and research of its own and is considered one of the most widely used and best researched creative thinking models worldwide. FourSight helps groups, teams, and individuals understand how they interact with the seven steps of the CPS process as expressed in the Thinking Skills Model of CPS." See Chapter 3 The Creative Process for details on the Thinking Skills Model.

This systematic process for analyzing problems, generating and refining ideas, and implementing effective action plans has five basic theoretical principles. The creative process is a natural process. All normally functioning people solve problems in creative ways in both their professional and personal lives. The CPS model is a valid way of depicting areas of operation within the creative process. The CPS process involves a series of mental operations. People possess preferences for different mental operations (cognitive styles). Since the creative process is a cognitive process engaged in naturally, people will possess different preferences for areas within the creative process.

Puccio began to develop the FourSight measurement instrument in the early 1990s after observing students (both undergraduate and graduate level) involved in CPS courses. He also observed the behaviors and reactions of business and community groups he was facilitating in the CPS process as a creativity consultant. He had many conversations with other creativity field researchers to gather their observations of individual and group dynamics as they facilitated these processes. The observations held true not just for student and outside groups who were learning the CPS process but also for facilitators who were already experienced with the process. Individuals tended to concentrate their attention on areas

of the process they enjoyed and avoided those areas that were not areas of natural preference. Hence, FourSight was developed out of the need to address these strengths, biases, and preferences for problem-solving situations.

In 1992, Dr. Puccio began to ask himself, "What mental operations are unique to each stage of the CPS process?" He began the initial item creation for what would become the FourSight instrument. He wanted a framework to identify distinctly different problem-solving behaviors that were being naturally expressed by those learning or facilitating the CPS process. It was important for the success of this measurement instrument that it not use technical language, that it not be a reflection of CPS tools, that it not be a measurement of "learned behavior" but a valid indicator of inherent preference. He wanted also to ensure that the language of the instrument expressed style preferences rather than ability.

The first "item pool" had 87 questions. Puccio then gave the item pool to six CPS experts {graduates of the International Center for Studies in Creativity} who had extensive experience with both using and facilitating the CPS model. They reviewed the questions and pared them down to 64. Eight different versions of the FourSight instrument have been tested, retested, and refined in field trials that have involved over 3000 people before it was pared down to the current 37 questions. This painstaking effort over a twelve-year period has resulted in an instrument that displays the two main criteria for psychologically sound measurement: reliability and validity. It was proved to be consistent and accurate in measuring the variables it was created to measure. It has been crafted to maximize its usefulness both in research and in practice.

Before we go further, it is important to stress that the FourSight instrument measures only preference. It does not measure ability. We cannot stress this strongly enough. Preference does not equal ability. FourSight does not measure skill level, nor is it meant to.

The 37 questions on the FourSight questionnaire are designed to measure which areas of the CPS model a person is most comfortable with. These may be single preferences or a combination of two or more preferences. The preferences are the "faces of innovation."

Clarifier, Ideator, Developer, or Implementer. These titles refer only to the part of the problem-solving model to which a person is most drawn—the preferred problem-solving area.

The Clarifier likes to spend time clarifying the problem. The Clarifier does not like to move too quickly to a solution. He/she wants to be sure the right problem is being addressed. He/she wants to gather information to understand the situation. The Clarifier likes to look at the details. He/she may have a tendency to analyze to the extreme and keep the process from moving forward.

Some characteristics of Clarifiers are that they are focused, orderly, serious, methodical, deliberate, and organized. In order to be their most effective, they need to have order, be given the facts of the problem situation, have an understanding of the history of the situation, have ready access to information, and feel they have "permission" to ask questions.

Clarifiers, in a group or team setting, may annoy others by appearing to ask too many questions, by pointing out obstacles, by identifying areas that they think have not been well thought out, by overloading people with too much information, and by being "too realistic."

A person with a preference for being a Clarifier needs to recognize that it is not always possible to have all the facts and that the effort to secure all the facts is sometimes not worth the time they invest in searching for them. This person must strive to become more comfortable with some degree of ambiguity. The Clarifier must try not to get too caught up in the historical approaches to the challenges; he/she must learn to recognize when the old "tried and true" should yield to the "new and improved" solution.

Although most comfortable with taking a straightforward and methodical approach, this style type must accept that breakthrough thinking does not always progress in this predictable step-by-step manner. The Clarifier needs to remain open to others who may have a less methodical approach.

Although difficult, the Clarifier can learn to avoid being overly cautious and to recognize those cases where any action is better than no action. Balance can be achieved by building up a tolerance for taking risks.

The *Ideator* likes to look at the "big picture." The person enjoys toying with ideas and possibilities, really likes to stretch his/her imagination. When solving problems, a person with this preference sometimes takes a more intuitive approach to

problem solving. He or she has a "gut feeling" about it. The Ideator enjoys thinking in more global and abstract terms. This may cause a tendency to overlook the details.

© design36/Shutterstock.com

Some characteristics of the Ideator are the ability to be playful in approaching the problem. The Ideator is social, flexible, independent, imaginative, adaptable, and adventurous. Ideators need room and the "permission" to be playful. They need constant stimulation and crave variety and change. They need to be given "the big picture" to be most effective.

In groups or teams, the Ideator may annoy others by seeming to draw attention to themselves, by being impatient when others do not understand their ideas. Their ideas may seem too "off the wall" to other team members. Ideators may be too abstract or have trouble sticking to one idea.

Ideators like to think in broad, conceptual terms. It is important for people with this preference in problem solving to recognize that some will find these "out of the box" ideas impractical or outlandish. It is important for the

Ideator to find people who will listen without judging or to learn to not allow the judging to squash the innovative and creative spirit they possess.

The Ideator is a highly fluent idea generator. The flood of ideas this person generates may overwhelm others in the group unless he or she learns to prioritize and communicate only those ideas that she/he believes offers solid promise.

The Ideator can achieve balance by developing an ability to focus, to stop trying to chase every good idea. These ideas will be accepted more readily if, when communicating them, concrete descriptions of the ideas are offered. How will they work? What are the benefits? What would the concept look like in action?

The *Developer* enjoys putting together workable solutions. He/she enjoys thinking about and planning the steps to implement an idea. This person enjoys analyzing and comparing potential solutions and likes to examine the "pluses and minuses" of an idea. He or she might get stuck in trying to develop the perfect solution.

Developers are reflective, cautious, pragmatic, structured, and very planning oriented. To be effective, they need time to consider the options, time to evaluate, and time to develop their ideas.

The Developer may annoy others by being too "nit-picky," finding flaws in others' ideas, getting locked into one approach, and/or spontaneously seeing the shortcomings in an idea being offered.

Developers like to refine ideas and hone their thinking. Their desire to strive for perfection can enable them to move an idea from the "half-baked" stage to brilliance. To make the most of their thinking preference, this person needs to learn to live with imperfection and recognize that others may grow impatient with the time they invest in tweaking their ideas and plans. The Developer needs to be conscious that continued elaboration and analysis may have reached a place where they are causing diminishing returns. Also, this person needs to be aware that what they view as an objective approach may be interpreted by others as impersonal and overly analytical. The Developer must be sensitive to those who take a more subjective approach. Although difficult to accept, a person with this preference for problem solving must remember that some decisions will defy logic and that intuition can have a role in choosing the best course of action. There is a risk that this person will get so wrapped up in one approach that she/he loses sight of other worthy alternatives. The Developer can learn to create and entertain diverse options before committing to one path forward.

The final preference is that of the *Implementer*. A person with this style preference likes to see things happen. They enjoy giving structure to ideas so the ideas can become a reality. The Implementer enjoys seeing ideas come to fruition. They like to focus on ideas and solutions they believe

are workable. They take the "Nike Approach" to problem solving (just do it!). One potential drawback to this preference is the person may leap to action too quickly.

The Implementers are persistent, decisive, determined, assertive, and very action oriented. They are their most effective when they think that others in the group are moving just as quickly as they are. They need a sense of control and to receive timely responses to their ideas.

© ImageFlow/Shutterstock.com

Implementers may annoy team members by being too pushy, expressing their frustrations too readily when others do not move as quickly as they do to a course of action, and they have a tendency to oversell their own ideas.

The Implementer, like persons with the other preference styles, must learn to achieve balance. While innovation cannot occur without implementation, the Implementer must resist the impulse to chase off those who question or point out the potential drawbacks of an idea that is on the brink of action. Their feedback might actually improve the final results.

In their drive for progress, Implementers must be careful not to leave others behind. They need to keep communications open throughout the problem solving process. They need to gain early buy-in and support by not springing ideas on teammates at the last moment. The Implementer must guard against a tendency to let their desire to get things done get in the way of getting things done right. They need to be careful not to rush the innovation process. Some of the most important ideas need "incubation time," time for simply thinking and playing with possibilities. Committing too soon to one idea may leave other, more powerful ideas undiscovered.

You have every style there is. You cannot escape that. The issue is where is your home base? Where is your preference? It may be one preferred style, two, three, or four. Again, it is important to remember that each preference has its strengths and its potential weaknesses. Preference does not imply skill. A person can have a strong preference and still be bad at it . . . or good!

Team Building and Style

Diversity

A team's success rests directly on its diversity—diversity in values, diversity in feelings, diversity in culture, diversity in styles. The wider a team's diversity, the greater is the team's problem-solving ability. Diversity is the basis for flexibility and strength. It is at the very core of a team's ability to meet the changing demands placed on its members. Increase the team's diversity and the team responds well to turbulence and ambiguity. Decrease the diversity and the team becomes stagnant. Eliminate diversity and the team fails.

Communication

We are a language-based species. Language is the "currency" of human beings. So it follows that communication is the single most important aspect of a team's success. The ways in which we communicate are a direct reflection of cognitive style. How we think is directly translated into how we communicate: what we say and how we behave.

In a conversation, less than 10% of the message communicated are the words themselves. More than 90% of that which is communicated consists of the behaviors, body language, changes in the muscles around the eyes, voice inflections, and the conscious and unconscious decisions we make about the messages we send and the messages we receive. One's preferred cognitive style is the major processing screen for outgoing and incoming messages.

You use your preferred cognitive style in everything you do that requires thinking. Each of us flexes out of his/her preference when the situation demands it. You have every style there is. Yet, given no obvious external constraint, you will cognitively process in your *preferred* style. The challenge comes when your preferred cognitive style is significantly different than that of the person with whom you are communicating! A less-than-satisfactory outcome is likely.

Diversity is the inherent strength and the Achilles heel of a team. The downside of not understanding style is dissatisfaction with the team experience and outcomes. It is emotionally draining. It leads to a lack of productivity. On the other hand, understanding preferred styles is an easy and productive way to overcome the inherent weakness in diversity.

Use the knowledge of cognitive styles to overcome the inherent weakness of diversity and propel the team to success. In an effective team,

you can express freely, be appreciated and valued for what you bring to the team and its challenges. An effective team that understands your preferred cognitive style will satisfy the components of who you are. Turn your teamwork into quality time. Make your team experience a challenge worthy of *you*. The power of a diverse team will prevail.

Interpersonal Relationships

VanGundy (1984) focuses on the interpersonal relationships people need to be creative. What sorts of personalities encourage creativity? What needs to be happening within a group to encourage creativity to flourish? If group members do not get along, little creative or productive work will get done. Interestingly, getting along too well can also stifle creativity. If group members become too socially comfortable—develop true friendship relationships instead of maintaining a colleague identity—there will be too great a tension to just "go along" with an idea.

VanGundy lists ten measures for maintaining good interpersonal relationships within a group structure:

1. *Interpersonal Trust:* Group members will have faith in their individual abilities and confidence in the skills of the rest of the group. They will acknowledge this confidence both by saying so and by putting this faith into action. A high level of trust in the group goes a long way toward preventing or minimizing misunderstandings and hurt feelings if conflict arises.

2. *Acceptance of Deviant Behavior and Ideas:* VanGundy does not mean to imply one should tolerate a group member fond of

starting a meeting by "mooning" everyone. I prefer the term "contrary" to deviant, as being less emotionally charged. It is true that many behaviors displayed by a creative group might be considered unconventional by a less creative, more traditional group. My colleagues are fond of having "chair races" down the hallowed halls of academia to release creative energy. They find this pumps them up for generating ideas. Some members of the group, particularly the more adaptive members, view this as undignified but both tolerate and accept these behaviors without criticism. This is an example of the willingness of a creative group to be unconventional in a creative way.

3. *Willingness to Listen:* Relationships within a group are based on verbal and nonverbal communications. It is not just what is being said but how it is being said. It is also the way in which individuals within the group react to what is being said. More ideas are killed with the raised eyebrow or the rolled eyes than by an unkind comment. Just listening is not enough. The members of the group must be sure they "heard" and understood the idea being presented. Group members who have good interpersonal relations will make statements such as, "If I understand you correctly, you are suggesting we. . . ." Or they will ask questions about the proposal, "Do you mean . . .?" A creative group will always try to check that their perceptions and meanings are in agreement.

4. *Friendliness Toward One Another:* Group members encourage creativity by being considerate and friendly. This does not mean that they must always agree with each other. Nor does it mean there will never be any

conflict. It means that when these emotion and value clashes occur, feelings will be displayed with respect. "I hate to disagree with you, Ann, but I feel we should. . . ." One of your authors approaches it this way: "I genuinely like my students and the people I work with. When conflict arises, I like to focus on as many positive things as I can about the presented idea before I offer my areas of concern. I start by saying, "You know, what I like about that idea is . . . but I am concerned about. . . . How might we solve this"? I find this approach shows respect for the other person's ability, shows where I disagree, and makes us equal partners in finding a solution. The other group member may continue to support his or her original idea but won't feel defensive. It is more useful to leave a door open than to slam it shut."

5. *A Spirit of Cooperation:* Members in a creative group can "park their egos at the door." They work hard at putting aside their individual differences, prejudices, and judgments to work together toward a common goal. Once the group has developed the ability to cooperate, it will unleash its creative potential for problem solving.

There is a group in New York called "Common Ground." They organized themselves to help radically different groups work together. Recently they brought together members of both the "pro-choice" and "pro-life" movements. Through cooperation and creative problem solving, they were indeed able to find some common ground. They have agreed to work together on certain issues such as preventing teenage pregnancies and facilitating adoption and

prenatal health care. They were willing to put aside deep personal beliefs in a spirit of cooperation toward a common goal.

6. *Encouraging Expression of Idea:* Creative group members are careful to urge and support idea statements. They recognize that people keep silent only out of a fear of appearing ridiculous or because they feel somehow intimidated or threatened by one or more group members. They will not allow silence to drag out very long and will encourage each member to comment on an idea. A safe way of doing this is to say, "Now that we know what Bob feels, what do you think, Mary?"

7. *Open Confrontation of Conflicts:* In every group there will eventually be "ruffled feathers." As polite people, we have been conditioned to just "let it slide" or "don't let it get to you." It has become normal to bottle up our negative emotions and withdraw from conflict. We consider it rude to "get in someone's face." There is, however, a difference between civility and repression. It is best to confront a conflict at the start before resentment sets in, sides are taken, and group unity is broken. Getting conflict out in the open helps diffuse it. This can be done in a nonhostile, nonconfronting way.

I once had a supervisor who had a blind, irrational dislike of me. I recognized it as a style conflict. I am an extreme innovator and she was an equally extreme adaptor. I diffused the tension I was feeling by meeting with her and calmly saying, "When you say this, I feel this. . . . Was it your intention to make me feel . . .? My supervisor was genuinely surprised to learn how I felt. Although we never developed a friendly

relationship, we did develop a cordial one that allowed us to work together effectively. It is useful if group members can openly express feelings in a nonjudgmental way.

8. *Respect for Each Other's Feelings:* This is closely tied to the previous element. Hurt feelings can seriously undermine the creative climate. We should remember that every idea comes with a real person attached. It will not always be possible to avoid hurting a group member's feelings. Sometimes it must be done to improve the group's ability to be creative and successful. We should always balance the costs against the benefits. For example, if one group member is always an "idea killer," constantly negative or aggressive, the group might be improved by pointing this out, "Bob, when you repeatedly say . . ., we feel intimidated. Please allow us to continue by rephrasing your comments in a more positive way." Bob may feel temporarily hurt but the group will benefit.

9. *Lack of Defensiveness:* A creative group will be composed of members who can hear a negative comment and react in a positive manner. The individual must use "selective perception." Instead of thinking "they don't like me," the individual can choose to look at the comment objectively. Let's go back to Bob. He can storm out and sulk, feeling dismissed and belittled, or he can say, "It wasn't really me they object to but a certain behavior I can change." This is Bob's choice and ours. By attempting to see the *intent* and *meaning* of a negative comment, we can increase our personal understanding about the way we are perceived. We might learn something new and useful. I recognize that I have a tendency to be defensive. I know I frequently take

things personally when nothing personal was meant. I have learned, as I demonstrated with my difficult boss, to ask for additional information. Another way to do this might be to say "If I understand correctly, you would like me to stop this behavior. . . . What might be a better way for me to handle this . . .? How would you prefer to have this done?"

By refusing to attack or counterattack, we diffuse the need to feel defensive. We can restate our position in a nonthreatening way, "I am sorry that I. . . . I meant to imply. . . . Please let me know when I . . . again. I appreciate your concern and want to thank you."

This tact puts the group or group member on your side. You have accepted the comment as instructive and not been put on the defensive. The person who was being critical now wants to be helpful to you.

When receiving criticism within a group, you must "winnow" out the good from the bad, the relevant from the irrelevant, and the useful from the useless.

10. *Attempts to Include All Group Members:* In a creative group, there is real teamwork. All members feel important, understand their individual roles, and accept and understand what is expected of them. It is absolutely necessary that groups work at drawing out contributions from every member, especially the shy or noncontributing members. Everyone needs to be heard and to participate.

To understand the creative person, we must be aware of the personal traits common to creative people, the motivations that inspire creative people, the preferred problem solving style of the individual, and the interpersonal relationships necessary to maintain this level of creativity.

I never know how much of what I'm saying is true.—Bette Midler

Chapter 3

The Creative Process

We have examined the traits and characteristics of creative people, cognitive styles, habits and blocks. We now move into the applied creativity, that of the creative process. How does it work? If we can duplicate this process, will we become more creative?

In this chapter, we will examine some of the processes people use to be deliberately creative. Most of these processes are rational (logical and repeatable), cognitive (It's about thinking, not waiting for a muse to bring inspiration!), and semantic. (We are a language-based species, after all.) Some processes include affective creativity, too.

In the last half of this chapter, we will concentrate on the tools of creativity. If a carpenter gets a hammer and a saw and a cook gets a spatula and a pan, what kind of tools do you get if you want to be creative? Creativity tools are based on rational, cognitive, semantic, behavioral, and affective skills. Imagine a large toolbox. Inside are many tools for solving problems and building ideas. All of us have a toolbox; we all possess a certain number of tools. Not all of us possess the same level of skill using them as a master carpenter might have. We can, through study and repeated practice, learn to use them better. In this chapter you will sharpen the tools you have, add a few more to your current collection, and identify how to use them best. We will learn what methods enhance creative

thinking and make it easier to use. Like the old Star Trek crew, we will "explore new galaxies."

Brain Hemisphericity

Most of us have heard the "right brain/left brain" theory of creativity. This is the theory that the two hemispheres of the brain divide into specific areas of dominance. The left brain is said to be "reality oriented," controlling analytical thinking and rational thought. Supposedly this area of the brain is considered to be a fact-gathering function. Math experts are referred to as "left brain focused." According to this argument, the right hemisphere of the brain is believed to house the "intuitive or imaginistic functions"—the mystical, magical, playful area associated with daydreaming and symbolism important to "artists and other creatives." So if you want to be creative you need to get into your "right mind!"

Those of us in the field of creative studies consider this notion wildly simplistic. As Mike Fox says, "Left brain, right brain, whole brain, no brain." Get a grip. Every part of the brain is involved in the creative process in some way, somewhere, along the process of the act of creation. It is naïve to assume that only one chunk of the brain is responsible for creativity. "Shutting down" one hemisphere of the brain with such odd devices as forcing yourself to use your left hand if you're a right-handed person will *not* increase creativity. It may very well increase frustration. Wouldn't it be nice if we could just wear a right-brain stimulation device to become creative?

Unfortunately, creativity is not that easy. It is a complex process of using what Freud called the conscious and the subconscious areas of the mind. The facts we know by the evidence of our five

senses (sight, sound, taste, touch, smell) and the things we know just by the way we feel about them. Each works together in the creative process.

The Workings of Process

From the most global perspective, creative processes can be separated into three major areas: cognitive, behavioral, and affective. Cognitive processes (thinking, perceiving, knowing) are learnable, teachable skills, just like reading and writing. Behavioral processes are often a deliberate outgrowth of the thinking skills and practices associated with using the tools of creativity. In this text, however, we will not examine creative processes such as sitting under a pyramid or wearing aluminum foil hats to become more creative. These behaviors may work but we have not seen reliable research to support the assertions. The affective processes deal with the emotional (pleasurable or unpleasurable) aspects of mental process.

Creativity is a process of thought, rational, fact-based knowledge, and emotional feelings that result in some form of change: a product, concept, invention, service, or some outcome that is both novel and useful.

Let's contrast fads with true creative breakthroughs. A fad usually bursts on the scene with great fanfare, promotion, and excitement. Remember pet rocks, Cabbage Patch dolls, and a myriad of dance, clothes and makeup styles? These were often fun and interesting variations on more normal "mainstream" products or styles. They were new, fresh, and novel. We enjoyed and embraced them—and still do. That does not make them particularly creative, though. One question to ask in defining a creative outcome: is it *both*

Just as we can throttle our imagination, we can likewise accelerate it. As in any other art, individual creativity can be implemented by certain techniques.—Alex F. Osborn

novel *and* useful? Truly creative thought processes will produce both attributes. Another way to define the creative process is, "does this way of thinking change the way I look at things"? Is it truly a breakthrough? Does it produce, or will it produce, a permanent change in the real world I live in? For example, think of the difference between two dance forms the "twist" and the waltz. Both were wildly innovative, popular, and even controversial when first introduced. Both were seen as creative expression. Only one changed popular culture in a radical way and endures across social, ethnic, and geographical boundaries. The waltz was the first dance to concentrate solely on the individual couple as contrasted with the couple as part of a group. It introduced touching and holding as an integral part of the technique. Before the waltz, individuals performed an often-complex series of steps in synchronization but without any physical contact or with minor touching of fingertips. The waltz inspired innovations in music beyond the dance and these innovations in music inspired innovation within the waltz. It was, and is, an ongoing process of change, of adding to, subtracting from, and building into the mainstream concepts of normalcy.

Every field has examples of fads and examples of creative process. We no longer believe in the practice of "blood-letting" to cleanse the body of "evil humors." This was a centuries-old practice, widely accepted and practiced by trained physicians. It was based on accepted scientific fact by society as a whole. Think how radical the idea of deliberately injecting a disease into the body must have seemed. The notion that putting a mild disease into the bloodstream (cowpox) could prevent a major disease (smallpox) must have seemed dangerous lunacy. The fact that Edward Jenner was able to use both his analytical senses and his intuitive senses led to this world-transforming concept being eventually accepted.

He observed that dairy workers rarely fell ill and died during smallpox epidemics. He conducted studies and found the one thing survivors among the dairy workers had in common were cases of cowpox. This was similar to what we call chickenpox today. Cows can transmit this disease to dairy workers. Jenner had a feeling—an intuition— that somehow this form of animal smallpox had changed the dairy workers in some way, making them immune to human smallpox. He combined his observations with his imagination to develop what he called "immunizations." The World Health Organization noted the last case of smallpox in the early 1970s. We now accept "shots" as normal.

The creative process is not static. It is vibrant and alive. It produces solutions that grow and evolve. An idea that is merely novel may seem creative at first glance, but if it has no application, is it really creative? A faddish thought process is a tumbleweed. Any purpose it serves is transitory. Gone before you know it. The creative process is a tree with deep roots and has many uses. A robust ideation process ought to combine originality and usefulness in the broadest set of applications.

C. W. Kaha (1983) called the creative process "the unity of being and knowing." In early studies of the creative process, psychologists such as Freud, Jung, Maslow, Kubie, Rothenberg, Hausman, and others focused on elements of thought and brain functions. From them we received such classifications as primary process, preconscious, extraconscious, subconscious, unconscious, incubation, and secondary thinking. We learned to define ourselves as "ego" and "id." We tried to explain the human mind as we did the human body. We came to accept these divisions of brain functions as concrete neighborhoods. We could travel from block to block around safe streets. To get past id, take a left past ego, exit at primary process, and

go right on to conscious thought. We must accept that most of our accepted "facts" about brain function are, in reality, only theories. Good theories, it is true. *Lots of evidence to point us there.* Still unproved. When we follow the evidence, we find the process of creation is a function of the entire brain. By the way, for those who still think that humans use only 10% of the brain, it's only true of students! The rest of us have been using all of our available gray matter.

Terminology

Before we advance, we must touch briefly on accepted terminology. By understanding the psychological theories, we can develop a better understanding of thought processes in general.

The major distinction placed upon the functions of the mind really boils down to Freud's theory of the "conscious mind versus the unconscious mind." He believed the unconscious mind was unknowable—we could not ever understand our deepest motivations because we could never know we had them. He believed the conscious mind was divided into two different modes of thinking. Every human being used either a primary process or a secondary process to solve problems and to function. He believed the primary process was concerned with emotion, did not recognize logic, and was not concerned with content. He placed it within the unconscious sphere of the brain. It produced "word pictures," dreams, images, metaphors, and symbols. It was our primitive "gut reaction" to issues. It converted abstract thoughts to emotions. Freud believed we could use these images, emotions, and symbols to reinterpret any situation we found ourselves in. He did not believe we could understand why we interpreted them the way we did.

The secondary process was one of deliberate and conscious thought. We used it to define our world. Logic, analysis, order, content, rules, and physical senses were all parts of the secondary process.

In the primary process, we daydream, imagine, and jump from image to image like a skipping stone on still water. We become "id"—a highly personal emotional being, primitive and independent. We "need." In the secondary process, we plan, organize, develop, and define. We think in a straight line. A leads to B, which leads to C. We become "ego." We "want."

Wason and Laird (1968) preferred a third concept, the preconscious. Like Kubie, they believed creativity sprang from this area of quick, flexible communication and consciousness. The preconscious thought allowed us to throw off the restraints of anxiety, fear, and unconscious neurosis and to work with our intuition and emotion in a logical decision. The preconscious allows us to use the language of abstract thought to communicate our ideas to our rational conscious mind. Think of the preconscious as the telephone operator between two calling parties. The creative conversation cannot flow unless both elements of the mind are connected.

Incubation

Wallas (1926) described the creative process as having four steps: Preparation, Incubation, Illumination, and Verification. A closer examination of Wallas' process can be found later in this chapter. Here we will look at incubation.

Incubation is the period of creative thought when we let an idea brew. We are not consciously thinking about anything in particular. These are those involuntary thoughts that pop into our minds

in a random fashion. Perhaps we are thinking about something else entirely. Have you ever had the experience when you are trying to remember something—say the name of your third-grade teacher—and you just couldn't? You put the question out of your mind. Hours (or days) later while eating breakfast or taking a shower, you suddenly exclaim, "Mrs. Jones!" That is the process known as incubation. Incubation allows the brain to shift from the "subconscious" (an area Freud believed we chose to "dump" unnecessary data into) to the preconscious to the conscious mind. It is a period of rest the brain enters into after periods of intense concentration and frustration when we cannot find a solution to a problem.

The most important feature of incubation is that we are unaware that it is happening. We have no idea that our brain is still sorting through our mental file cabinets for information. Although incubation is only a theory, it seems logical to us. Where else do those flashes of insight come from?

Rothenberg and Hausman (1976) referred to incubation as "extraconscious process." They disagreed with Freud's concept of the subconscious. They viewed their theory as an alternative explanation. As they stated, ". . . evidence appears to be strong that mind or consciousness is associated with a limited but shifting area of integrated activity in the cortex of the brain . . . such activities could go on, however, in other parts of the cortex and at the time be unrelated to conscious states . . . by using the term 'extraconscious processes' to define unrecognized operations which occur during attention to urgent affairs or during sleep, the notion of a subconscious mind can be avoided."

I have a new theory of eternity.—Albert Einstein, after listening to a LONG after dinner speech

The theory of extraconscious thought maintains that conscious thought is just a small part of the creative thought process. Think of a Morse code message. In a series of symbols and sounds, dot dot dash, the extraconscious process relays the message to the conscious mind, which acts on it. We can view the conscious mind then as the final source—the interpreter of abstract messages.

All of these theories try to explain the process of thought. How does an individual recognize and evolve knowledge? We come up with thoughts, ideas, and innovations constantly. The information, data, and concepts must come from somewhere, in some form. If the information is abstract, we cannot be fully conscious of it. We must use some process, be it primary thinking, secondary thinking, preconscious or subconscious or extraconscious thinking. At some point in our mental process, we do become fully aware of the information we have. We may not be aware of how we received this information, but we know we have it.

Back in the 1950s and 1960s, much attention was paid to the concept of "subliminal messages." Researchers had a theory that if images were produced at a speed too fast to be consciously seen or sounds repeated at a frequency too high, or too low, for our hearing perception, the brain still received and processed them. Movie theaters ran "commercials" in the middle of movies. Verbal or visual "subliminal" messages were played telling us we were hungry or thirsty. The hypothesis was that we would then get a conscious urge to go buy something at the concession stand. We would act upon information we were not aware of receiving or experiencing.

Defined Processes

At about the turn of the twentieth century. Dewey developed a two-stage model of problem solving: a state of doubt followed by an act of searching. In terms of generic problem-solving models, it just doesn't get any shorter than that. Dewey's model is elegant in both simplicity and precision and still holds as a foundational model of problem solving today.

As stated earlier, Graham Wallas in his *Art of Thought* (1926) posited the creative process had four definable steps: preparation, incubation, illumination, and verification. Preparation was the gathering of information, developing knowledge, improving skills and abilities, and generally becoming equipped to do effective problem solving. Incubation is the other-than-conscious mental processing of the challenge. Illumination is the moment where we seem to have the answer. It is the A-ha! The light goes on! Then we need to test it out—verify that the idea or answer is indeed workable. Frequently creative ideas or answers need work or a bit of polish—leaving the verification stage full of surprises.

For me, the creative process, first of all, requires a good nine hours of sleep at night. —
William N. Lipscomb, Jr.

Torrance defines a creative process in a similar way. First one senses a problem or a gap in the available information. This is followed by forming a hypothesis or an idea. Then, as in Wallas' process, there is a testing stage possibly requiring some modifications to the idea. Finally there is communicating the results—making the results known.

Synectics™ is a brand name of a problem-solving methodology developed by William J.J. Gordon and George M. Prince in 1958. Synectics uses an "excursion" thinking process that takes one away from the problem, an artificial vacation so to speak. It uses analogies to put distance between the problem solver and the problem. It is based on the principles of first making the *Familiar Strange* and then the *Strange Familiar*. In this way one would make new connections and new insights to develop new and useful solutions.

TRIZ™ is a knowledge-based vs. psychology-based creativity and invention methodology. TRIZ (a Russian acronym for Theory of Inventive Problem Solving) was developed in Russia by Genrich Altshuller, a patent examiner. He based his model on the principle that the accumulated knowledge of human innovation could be exploited to enhance breakthrough thinking in the creation of new designs and new inventions. It requires a knowledge base of the evolution of various systems. Altshuller developed 40 *Inventive Principles* that repeated themselves in different technical areas over time. It is an excellent model for new product development.

DeBono (1967, 1985) developed Lateral Thinking to move the user into side patterns of thinking and away from logical thought. This was the basis for his notion of Parallel Thinking, which led to his Six Thinking Hats model as a way of organizing thoughts. Six hats requires the user to engage in only one thinking mode at a time by literally or

figuratively wearing a colored hat that represents the kind of thinking to be done at that moment.

White Hat – Concerned with generating information

Green Hat – This is the "creative hat, used for idea generation

Red Hat – Expresses emotions without the need to justify them

Yellow Hat – Judgment and strengthening

Black Hat – Logical, critical, constructive thinking

Blue Hat – Controls the process and organization of the use of other hats

Creative Problem Solving (CPS) is a robust flexible process. It is the mainstay of the defined rational, cognitive, semantic models for problem solving. As such it will be considered in detail later in this chapter.

These various theories and models do not "explain" thought processes. Rather, they are useful only in giving us a way to define thought. They may point to areas of the brain where thought patterns appear to emerge but they cannot explain how or why that activity occurs.

The creative process occurs when we use all the brain processes in unity and harmony. The logical and the absurd must coexist to become productive. It is this contrariness of thought that produces creativity.

Creative Thinking Skills Can Be Taught and Learned

Creative problem solving, regardless of the model used, can be deliberately taught and learned. There is a dynamic balance between

generating options or ideas and judging those options or ideas—between generative thinking and judicial thinking—between divergent thinking and convergent thinking. This requires a *major* cognitive shift. Creativity is not a spectator sport. It takes training and practice. In this balance the underlying principle for divergent thinking is suspension of judgment. We all have an editing mechanism that makes choices on ideas as they come up for consideration. We can learn to defer the judging function until later. When "later" arrives, we need to judge the options in an affirmative way. Affirmative judgment is the principle that drives judicial or convergent thinking. Examining the idea for its positive attributes first reduces the likelihood of eliminating a potentially good idea just because it is outside the paradigm, is too novel, or on the surface appears to be unworkable. These thinking skills are as learnable as reading and writing.

Explicit and Implicit Views of Creativity Processes

Explicit views or theories of creativity have been borne out by research and the test of time. Implicit views are those each person brings to the "party." They are beliefs, values, myths, life experiences, that, on the surface, may seem valid. Implicit views or theories are a good place to start an investigation of creativity—one has to start somewhere. Implicit views by definition have yet to be rigorously examined to see if the data are generalizable. If they hold up under scrutiny, they evolve into explicit views, hypotheses, or theories of creativity.

As creativity evolved, and is evolving, the public perception of the discipline becomes distorted. This happened with psychology as it began to

be accepted into mainstream thought as well. We all know the "buzz words" and join in their misuse. We have all said we were depressed, phobic, or repressed when what we were feeling was quite different from what those terms mean to a psychologist. We are quick to make snap judgments and label someone a "psycho," "schizo," or "manic-depressive" although psychosis, schizophrenic, and bipolar disorders are rare. The same holds true in the discipline of creativity. Hence, the humor of the comic strip "Dilbert."

In the business world, as in the field of education, the terms and concepts have ignited the imagination. Management takes part in a short seminar and becomes full of enthusiasm. They are going to put "process" to work, "empower" their staff, "think outside the box," "brainstorm," and go "outside the paradigm." These terms mean quite different things to the serious researchers. The process tools we will cover are not easy to master. Not all of them work in every situation. Learning to recognize and use them properly requires patience and commitment.

We do not have to choose between creativity and quality. Creativity alone is not a primary goal. The creative process must have a productive outcome.

Divergent thinking and convergent thinking are not easily separated. We are used to combining the complicated process of thinking. We are taught from the very first parental "No No!" to judge and evaluate, to look for negative consequences, to picture the final outcome before acting. School adds to this mental conditioning. Right answers/wrong answers, good behavior/bad behavior, following the rules/being disruptive. We are expected, even compelled to use judgment.

It is far easier to say what is wrong with an idea than what is good about it. We have more practice at it. That is why learning to use creative process

Creativity arises out of the tension between spontaneity and limitations, the latter (like the riverbanks) forcing the spontaneity into the various forms, which are essential to the work of art or poem.—Rollo May

tools effectively is difficult in the beginning. It is
why "instant creativity" seminars produce so little
results. It is an ongoing process of deliberately
choosing to separate our usual way of thinking.
We choose to temporarily suspend judgment in a
particular way, using a particular process, for a
particular problem.

Another implicit view of the creative process
is that it is "disruptive." We are again working
with an emotionally charged word. "Must you be
so disruptive?" "Stop acting out." "Why can't you
behave like your sister?" Disruptive, disrespectful,
rude, destructive, unsettling. We are taught to
separate ourselves from disruption. We are taught
to appreciate order, conformity, and compliance. We
want to "get along," "be a part of the team," "play
well with others." Who has ever brought home a
report card with "Susie is a creative joy, she's just
so disruptive!"? This is a word with no good social
interpretations.

In the field of creativity, disruption is a positive
word. It means injecting new life into the usual
pattern of thought. It means adding insights that
might otherwise be neglected. When our furniture
gets dusty, we "disrupt" the dirt with a cloth to
reveal the value of the wood under it. When we
"disrupt" the usual way of thinking, we reveal new
perspectives. We clean the dust off the problem so
we can view it more clearly.

Another myth of the creative process is that it
abandons an orderly and established framework.
According to this myth it is chaotic, a glorious
anarchy of thought, spontaneous and illogical.

On the contrary, creativity enforces and
reinforces the need for a deliberate, logical, and
responsible pattern of thinking called "cognitive
skills." It is the way in which these cognitive
skills are used that makes the creative process
unique.

Using a creative process tool means reviewing and selecting a process using all of our thinking skills. David Perkins, in his book *Minds Best Work*, stated that creativity is achieved by using all our senses to assess a problem. We must cultivate noticing, recognizing, searching, remembering, and, yes, evaluating skills. All of these combine in the creative processes.

We do use cognitive, rational thinking. We do support analysis of data, judgment, evaluation, and quality. Creativity recognizes and supports existing frameworks.

Prescriptive and Descriptive Problem-Solving Models

A problem-solving process or model is really just a depiction of a way to think about solving problems. The model could be as simple as trial and learn or as complex as an airline pilot's emergency checklist.

One way to categorize models is a simple bifurcation: prescriptive models and descriptive models. Prescriptive models require the user to follow a step-by-step procedure. The sequence must be maintained. Descriptive models have steps or stages that can be used in *any* order to meet the situation at hand. Prescriptive or descriptive, each has its place. The trick is to use the most appropriate model for the situation.

In the descriptive process, there is room for exploration and options. In the prescriptive method, there is a step-by-step process that cannot be deviated from. Think of going to a doctor for a complex weight control problem. Doctor A suggests analyzing your emotional and physical cravings for food. He discusses your lifestyle and how it is affecting your weight. He explores the pros and cons of your health and the pros and cons of maintaining or losing weight. He discusses

different strategies you might try: diet, exercise, drugs. Together you arrive at a plan. This is a loose example of a descriptive process. Dr. *B* weighs you, checks your weight against the standard for your height, and gives you a regimen to follow: low-calorie diet, two hours of bike riding a day, and a diet pill to be taken twice a day. This is an example of the prescriptive process.

Here is a comparison of prescriptive and descriptive processes. Both have value. Both have a place.

© Dmitriy Domino/ Shutterstock.com

A Prescriptive Process Looks Like This—Start at the Beginning and Follow the Sequence

Prescriptive Process:
1. There is one set, right way. It has rules and an order of events.
2. It provides an outline of fixed choices. There are no other options. "Do *this* to get *that*."
3. It has predetermined starting and ending points.
4. It provides preselected techniques.

Descriptive Process:
1. It provides a catalog of possible tools and techniques.
2. It is flexible.

3. It has multiple starting and ending points.
4. It has an overall framework to organize techniques.

Creative Problem Solving Model—a Descriptive Process

The CPS model is a descriptive process. Any of the stages or components can be used in any order, or independently depending upon the situation. The combinations are practically limitless. Each stage allows for input, processing, and output of information. Each stage is like a page in a catalog: it describes the content on that page. If it fits your need, you go to that page. If it does not quite meet the need, you go to a different page. *A distinguishing characteristic of the CPS model is that one can go from any step to any other step at any time.* (By definition, a prescriptive model will not allow this.)

The process can be used by a group or by an individual. This model is most frequently known as CPS, but it is also known historically as the Osborn-Parnes model—from the originator, Alex Osborn, and the developer, Sidney Parnes.

The new version of CPS is called the Thinking Skills model or TSM. It evolved from the classic CPS model. It is explained in detail on (p. 130).

CREATIVE PROCESS

© rassco/Shutterstock.com

A Descriptive Process Looks Like This—You Can Start Anywhere

Background, Philosophy, and History of the Creative Problem Solving Process

Our research has shown there is indeed a creative process, that there are "processes" or "tools" that contribute to one overall process we refer to as "CPS" or "Creative Problem Solving."

Creative problem solving is the deliberate application of creative thinking by the use of selected process techniques. Creative problem solving was designed to specifically aid individuals and groups in developing successful and creative ways to solve problems. It is one of the primary techniques for organizing and guiding systematic instruction and training in the creative process.

The CPS process has evolved over six decades of research into theory and practice.

The CPS model is built on five fundamental principles:

1. Creative potentials exist among all people.
2. Creativity can be expressed among all people in an extremely broad array of areas or subjects, perhaps in a nearly infinite number of ways.
3. Creativity is usually approached or manifested according to the interests, preferences, or styles of individuals.
4. People can function creatively, while being productive to different levels or degrees of accomplishment or significance.
5. Through personal assessment and deliberate intervention, in the form of training or instruction, individuals can make better use of their creative styles, enhance their level of creative accomplishment, and thus realize more fully their creative potentials.

I like change as long as it's cheap, easy, and in my frame of reference.—Mike Fox

Some Opportunities and Challenges with Creative Problem Solving

Creativity responds well to a flexible process in which many tools are available. An individual or group working on a problem must be able to access these tools when they are needed and to determine the best one to use. This process has led us away from the prescriptive method. We do not view creativity and creative problem solving as a fixed number of particular steps or strategies that must be applied in a fixed and predetermined sequence. The emphasis must be on the need for careful and deliberate assessment of the intended outcomes, based on the people involved in the situation and the methods available. Creative problem solving involves a deep commitment by problem solvers to make, monitor, and manage specific decisions regarding the stages, methods, and techniques to be used and the order and sequence in which they will be used.

CPS is not a simple step-by-step model. You cannot just "run through" a prearranged set of steps. CPS requires that all individuals and groups invest a substantial degree of thought, reflection, imagination, judgment, and energy in their creative problem solving efforts. CPS does provide a flexible structure with process tools to use as resources, to draw upon as needed or desired.

> Not everything requires creativity. In fact, most problems just require straightforward actions. Just do it. But when creativity is required, creative problem solving will take you there.

Development of the Creative Problem Solving Process

The following section is a reprint in its entirety of a paper written by Jo Yudess from the International Center for Studies in Creativity

(January 2010). It is an excellent discussion on the history and development of the creative problem solving process.

Models of problem solving and creative process have a short history compared to studies of math or science. Graham Wallas (1926) presented one of the first models of the creative process consisting of 4 stages:

1. *Preparation*—the problem is analyzed and investigated in a conscious systematic way,
2. *Incubation*—moving away from concentration on the problem and allowing unconscious mental processes to explore and look for options,
3. *Illumination*—the sudden appearance of an idea that seems certain and is connected with the events around the original issue. This idea is preceded by a vague impression called intimation that mental processes are coming together.
4. *Verification*—the idea is examined, tested and modeled into a final form which can be implemented.

Osborn (1948) explored how people came up with ideas, and he introduced brainstorming, which was considered a major tool in the creative processes. But, creativity was not studied seriously by the scientific world until 1950 when Guilford, in his presidential address to the American Psychological Association, said, "psychologists have seriously neglected the study of the creative aspects of personality" (Guilford, 1950, p. 454).

Older views of the nature of creativity described a spontaneous process that sometimes just happened. Researchers began to examine

creativity as a deliberate cognitive process,
a choice to have a new and relevant solution.
Osborn saw it as a method of problem solving in
which a creative answer was encouraged by the
process. Problem could also mean a challenge or
opportunity. Osborn (1953) described his Creative
Problem Solving Process simply, and it is similar
to the Wallas (1926) model. He defined it as
balanced iterations of divergent thinking and
convergent thinking for different purposes which
led a person through a complete problem solving
process:

1. Think up all phases of the problem.
2. Select the sub-problems to be attacked.
3. Think up what data might help.
4. Select the most likely sources of data.
5. Dream up all possible ideas as keys to the problem.
6. Select the ideas most likely to lead to solution.
7. Think up all possible ways to test.
8. Select the soundest ways to test.
9. Imagine all possible contingencies.
10. Decide on the final answer.

The process described by Osborn has
evolved through changes in the model from
1953 through 2007. In the Osborn (1953) model,
creativity was addressed in every stage of the
process by allowing specific amounts of time
for brainstorming (divergent thinking) before
using criteria to select information (convergent
thinking) to use in the next stage. Later, through
his work with Parnes (1992), Osborn's earlier
models were adapted and clarified and it became

known as the **Osborn-Parnes Model** seen below:

Figure 1a: *6 Stage CPS Model (1980's–1990's)*

1. *Mess or objective finding*—looking at the overall situation to determine an area in which to begin
2. *Fact-finding*—examining the chosen area for what is known or data that are needed,
3. *Problem-finding*—reframing/redefining the issue to get many new perspectives and perceptions, and choosing one promising problem statement
4. *Idea-finding*—generating alternatives to the current view of the problem,
5. *Solution-finding*—evaluating alternatives, considering potentials and consequences,
6. *Acceptance-finding*—developing the best alternatives to ensure implementation.

Another adaptation was reported by Isaksen and Treffinger (1985) to show a diagram or flowsheet for the Creative Problem Solving Process (See Figure 1) depicting the Osborn-Parnes model steps more graphically and

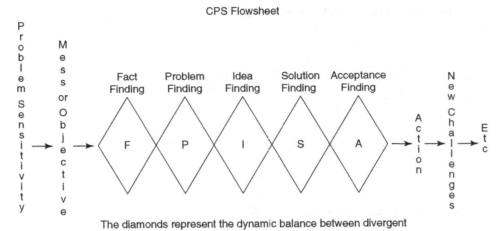

CPS Flowsheet

The diamonds represent the dynamic balance between divergent thinking and convergent thinking in each stage used to develop a product to move to the next stage.

Figure 1b: *Creative Problem Solving Flowsheet*
(Isaksen & Traffinger, 1985)

including the concept of the dynamic balance between divergent and convergent thinking in each step. Osborn's model, the Osborn-Parnes Model and the CPS Flowsheet were visually linear, but the Creative Problem Solving process was not meant to progress in that way. It was clear that a model that showed the dynamics more visually would be helpful.

Miller, Vehar and Firestien (2001) developed the **Plain Language Model**, also called the Component Model, using a Venn diagram to represent the stages of Creative Problem Solving. The steps, while renamed, were essentially the same as the Osborn-Parnes steps. Their graphic representation emphasized that the process was not meant to be linear, that in fact it could begin anywhere and loop back to steps already covered (see Figure 2).

The current Creative Problem Solving model: The **Thinking Skills Model** (Puccio, Murdock &

Figure 2: *Creative Problem Solving Plain Language Model*

(Miller, Vehar & Firestien, 2001)

Mance, 2007) as seen in Figure 3 added cognitive and affective thinking skills for each process step while maintaining the divergent and convergent phases of each. Puccio et al. (2007) took creativity study a level deeper by examining how they personally thought, or processed information, at each step of the process. They researched, identified and defined the specific cognitive and affective skills needed at each step.

Three additional affective skills were identified to assist with all steps. This model further emphasized the non-linear metacognitive process which allowed the user to choose where to enter the steps based on the nature of the data generated in the central function, Assessing the Situation (seen in Figure 3). The user then determined the kind of cognitive thinking needed and entered the process at that point. The process map is seen in Figure 3,

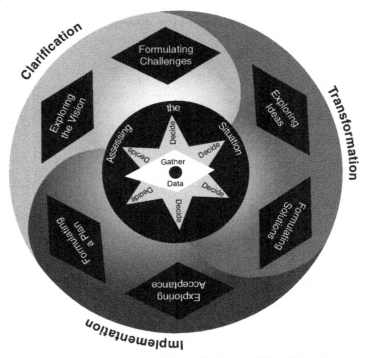

Figure 3: *Creative Problem Solving: The Thinking Skills Model*

(Puccio, Murdock & Mance, 2007)

the cognitive and affective thinking skills are in Figures 4 and 5.

With the changes in models, the process itself has remained basically the same for over fifty years: a series of steps with divergent and convergent thinking balanced in each step leading through a cognitive, rational, semantic process for deliberately and creatively solving problems, addressing challenges and meeting opportunities.

CPS-TSM Step	Purpose	Cognitive Skill	Affective Skill
Assessing the Situation	To describe and identify relevant data and to determine next process step	Diagnostic Thinking	Curiosity
Exploring the Vision	To develop a vision of a desired outcome	Visionary Thinking	Dreaming
Formulating the Challenges	To identify the gaps that must be closed to achieve the desired outcome	Strategic Thinking	Sensing gaps
Exploring Ideas	To generate novel ideas that address significant gaps/challenges	Ideational Thinking	Playfulness
Formulating Challenges	To move from ideas to solutions	Evaluative Thinking	Avoiding Premature Closure
Exploring Acceptance	To increase the likelihood of success by testing solutions	Contextual Thinking	Sensitivity to Environment
Formulating a Plan	To develop an implementation plan	Tactical Thinking	Tolerance for risks

Figure 4: *Cognitive and Affective Thinking Skills for CPS: TSM*
(Puccio, Murdock & Mance, 2007)

Openness to Novelty	Ability to entertain ideas that at first seem outlandish and risky
Tolerance for Ambiguity	Ability to deal with uncertainty and to avoid leaping to conclusions
Tolerance for Complexity	Ability to stay open and persevere without being overwhelmed by large amounts of information, interrelated and complex issues and competing perspectives.

Figure 5: *Affective Thinking Skills Underlying All Steps of CPS: TSM*
(Puccio, Murdock & Mance 2007)

Reward success and failure, punish inaction.—Robert I. Sutton

CPS: TSM Steps	Cognitive Skill	Definition of the Skill
Assessing the situation	Diagnostic Thinking	Examining a situation closely and using this analysis to decide what process step to take next
Exploring the Vision	Visionary Thinking	Describing a vivid and concrete picture of the desired future
Formulating the Challenges	Strategic Thinking	Identifying the critical gaps and the pathways that need to be followed to attain the desired outcomes
Exploring Ideas	Ideational Thinking	Producing original mental images and thoughts that respond to challenges or opportunities
Formulating Solutions	Evaluative Thinking	Assessing the reasonableness and quality of ideas in order to develop workable solutions
Exploring Acceptance	Contextual Thinking	Understanding the interrelated conditions and circumstances that will support or hinder success
Formulating a Plan	Tactical Thinking	Devising a plan in specific and measurable steps for attaining a desired end and monitoring its effectiveness

Figure 6: *Definitions for Cognitive Thinking Skills for CPS-TSM*
(Puccio, Murdock & Mance, 2007)

Leadership and Creativity Are Connected

Puccio et al. (2007) also make the argument that leadership and creativity are closely related and offer the following premises (p. xii):

- Creativity is a process that leads to change
- Leaders influence growth by facilitating productive change

CPS: TSM Steps	Affective Skill	Definition of the Skill
Assessing the situation	Curiosity	A desire to learn or know; inquisitive
Exploring the Vision	Dreaming	To imagine as possible your desires and hopes
Formulating the Challenges	Sensing Gaps	To become consciously aware of discrepancies between what currently exists and is desired or required
Exploring Ideas	Playfulness	Freely toying with ideas
Formulating Solutions	Avoiding Premature Closure	Resisting the urge to push for a decision
Exploring Acceptance	Sensitivity to Environment	The degree to which people are aware of their physical and psychological surroundings
Formulating a Plan	Tolerance for Risks	Not allowing yourself to be shaken or unnerved by the possibility of failure or setbacks

Figure 7: *Definitions for Affective Thinking Skills for CPS-TSM*
(Puccio, Murdock & Mance, 2007)

- Creativity is a core leadership skill for change
- Thinking creatively and facilitating creative thinking in others can be enhanced
- Developing and promoting creative thinking impacts leadership effectiveness positively.

Puccio et al. (2007) described the development of a change leader through a diagram, Figure 8, which indicates a process of learning, practicing and integrating relevant skills to widen the breadth of impact on followers.

This information is consistent with other researchers whose work in leadership has resulted

Creativity is allowing yourself to make mistakes. Art is knowing which ones to keep. —
Scott Adams

A Model for the Development of Creative Change Leaders

Breadth of Impact

Creative Change Leader:
Unconsciously Skilled

Integration

Internalize what you
have learned: become
a lifelong learner

Effective Practitioner:
Consciously Skilled

Proficiency

Practice what you have
learned and apply in
real-life settings

Student of Creativity:
Consciously Unskilled

Awareness

Begin to learn about CPS,
psychological diversity, climate,
and other aspects of creativity

Spectator:
Unconsciously
Unskilled

What You Need To Grow

What You Do To Grow

Figure 8: *Change Leader Development Model*

Puccio, Murdock & Mance (2007)

in descriptions of leadership skills that identify creativity as an important component of a leader's repertoire. Kouzes and Posner (2007) stated that the job of a leader is change and that leaders have to be innovators to help their organizations function in the global economy. One of the five practices they defined as necessary for exemplary leadership was challenging the process; going against what has always been done, disrupting the status quo. This included the commitments of searching for new opportunities and experimenting and taking risks. These could be seen as a definition

The things we fear most in organizations—fluctuations, disturbances, and imbalances— are the primary sources of creativity.—Margaret J. Wheatley

of innovation and change according to Oke, Munshi, and Walumbwa (2008) who stated, "Innovation can be seen as representing a change in the status quo and has been defined as involving the discovery of new things and the commercialization of such discoveries" (p. 64).

Leaders need creativity skills to prepare for, promote and produce the innovation and change that lead to company success. Andrew and Sirkin (2006) found that to get the maximum payback for innovation companies needed to organize around the innovation process giving people a supportive environment and time to be creative. Ditkoff (2008) stated that innovation does not occur without creativity, that it is the catalyst, the front end of the innovation process. Bienkowski (2008) reported that when Beth Comstock took over General Electric and was charged with changing the corporate culture to a more innovative one, she focused on creativity, bringing in creativity consultants, design experts and futurists. Puccio, Murdock, and Mance (2007) stated

> If organizational leaders do not nurture the basic elements that support creative behavior, it is unlikely that their organizations will bring about creative change, whether that is an innovative product, social change, educational reform, enhanced level of human service, and so on (p. 24).

Leadership skills and creativity skills are both needed for an effective leadership performance. Innovation, change, reform, future planning and other manifestations of creativity don't occur with knowledge alone (Boyatzis & Saatcioglu, 2007).

Learning how to use the knowledge to make things happen while encouraging and developing the people the leader works with are important keys to success. Using a cognitive, rational, and

semantic process to produce deliberately creative outcomes in groups is the aim of creativity education.

As you progress in creativity education, consider how these developments in the process model have made it easier for you to understand how to solve problems creatively. Think also about the growth of your facilitation skills and how they will help you take your place as a leader in whatever field you enter.

A Closer Examination of the Steps of the Thinking Skills Model

For those who want the nitty-gritty details of each stage of the TSM, read on.

Assessing the Situation

Everything is data. Go get some. This is the starting place, the place to be revisited regularly. Assessing the situation will tell you where to start in the Thinking Skills Model—and what step to move to as you progress. In gathering data, pose the basic questions of "Who? What? Where? When? Why? How?" These questions lead to many important facts, opinions, impressions, disruptions, concerns, paradoxes, and circumstances that must be considered in any problem opportunity or challenge. Once the group has acquired more facts about the problem, they can then begin grouping this information into areas of importance. Grouping data into more important/less important clusters often points to the direction that the group will want to focus on for solutions and other positive developments in their problem solving efforts. Data will tell you where to start and what step to move to.

Explore the Vision

Vision, goal, wish, or challenge statements are used to define the ambiguous concerns that make up the issues that face us or we wish to engage in. These statements have three general characteristics: they should be brief, broad, and beneficial. They generally describe the basic areas of need or challenge on which the problem solvers will focus their efforts. A well-crafted statement remains broad enough to allow many perspectives

to emerge as the problem solvers look more closely at the problem situation. Criteria for selection of a goal, wish or challenge statement would include ownership, motivation, and imagination. If "new and useful" are not desired, you are using the wrong model!

For example, a group of marketing executives might say, "We want to test market our products to a new target group in order to reach out to new potential customers for our products." After a period of divergent and convergent thinking, they might come up with a statement such as, "Wouldn't it be nice if we could develop a new test market group." In this scenario, they have a clearer focus as a result of identifying the goal, wish, or challenge.

Formulating Challenges

If a group has a clear focus, they might move to the second step: Formulating Challenges. This stage helps the group or individual focus on finding the most productive problem statement to work on. When using divergent thinking tools, work at developing a wide range of problem statements. These must be phrased in an open and positive way. Statement starters such as "In what ways might . . . ?" or "How might . . .?"—are very productive. Statements that include the word *might* invite many possible responses—not to single correct answers. They create a desire for shared communication. It makes the problem solvers equal partners.

These statement starters, or invitational stems, should also include an owner such as I, we, they, a name, title, etc. Keep the statement short and free of criteria. Set aside criteria for use later to measure the acceptability of the ideas generated for the problem statement.

I recently had a problem with an airline over lost luggage. I could have fired off the usual letters of frustration, anger, and demands. Instead, I sent a letter explaining my concerns and stating that I would like to continue to value the airline and then asked, "How might we solve this problem?" By leaving it open and non-accusatory and making it a learning/sharing experience for both of us, the problem was solved. I got a free travel voucher. The airline got good will.

By coming up with many new problem statements that frame the problem in a positive way, the group can produce new, varied, novel, and useful options for problem solving. In fact, a well-crafted problem statement is often as far as you need to go. The answer may be straightforward or a simple calculation. Never underestimate the power of a well-defined problem. And do not underestimate the confusion of solving the wrong problem precisely!

Exploring Ideas

Once a problem statement has been developed, the need to generate options for action is necessary. *Exploring Ideas* begins the transformation from a challenge to an action. Typically this is the place in the model that generates the greatest novelty. Really stretch for ideas. Set a goal of fifty or more.

Formulating Solutions

After the group has selected a number of interesting or promising ideas, they may need assistance in developing, strengthening, and refining them for actual use. In *Formulating Solutions*, begin to examine options closely to determine what steps will need to be taken. If there are just a few promising options that can

be immediately used, the principal focus would be on refining and developing them to make then strong.

If there are a *large* number of promising options but not all of them can be implemented, the task might focus on ranking the options or setting priorities for using them.

If there are many new, novel, and promising ideas, the task might be to condense or compress the choices to make them more manageable. The group might need to evaluate a number of options very systematically using explicit criteria. Look for a common theme, or use tools to assess the strengths, the future potentials, and the limitations or concerns of each option. Additionally, priorities might be set by rating each of the options against all the others, one pair of ideas at a time.

Most ideas do not come out completely formed. Most likely you will have to strengthen, clarify, and support promising options. Spend some time here. Make your efforts worthwhile.

Exploring Acceptance

At this step of creative problem solving, it is time to evaluate and search for all or several potential sources of assistance and resistance for possible solutions. "Assisters" represent people, places, materials, and times that will support the groups' plan and contribute to its successful launch into reality. "Resisters" represent potential obstacles people, places, materials, and things that might go wrong, be missing at a critical time, or just plain work against whatever idea you have chosen to try. *Exploring Acceptance* helps the problem solvers identify ways to make the best possible use of assisters and either avoid or overcome possible sources of resistance.

Formulating a Plan

Implementation involves developing an action plan that describes and lists the specific steps that will be taken in order to get the proposed solution working. There are three basic elements to a specific plan of action: determine actions to be taken in the near term; determine actions to be near fruition of the "project"; and finally determine the *sequence* of steps to be taken in the middle. The plan should detail who does what by when—tactical and practical.

© Zbigniew Guzowski/
Shutterstock.com

Try Not to Get One of These on You!

Definition of a "Problem"

We need to define what we mean when we say "problem." In the terms of creative problem solving, a problem is not the negative thing we usually view it to be. It is not to be viewed as an obstacle that must be overcome. It is not a wrong waiting to be corrected. It is not a concept that implies only that something is lacking or deficient. It is not a puzzle waiting to be solved by one, right, clever, but hidden, solution we must find by following clues. Problems, for creative problem solving, are best described as opportunities and challenges for successful change and constructive action.

These "problems" or challenges present us with many opportunities for personal and professional growth. A problem is any important, open-ended, ambiguous, "not sure what direction to go" situation for which we want or need new options and a plan to carry out a solution successfully. It is important to remember that any plan is based only on "a" solution, not "the" solution. There will always be more than one solution to a problem.

Some Background on the Development of Brainstorming

Alex Osborn firmly believed that each individual had a potential for creativity and was concerned with developing this potential into creative behavior. Creative behavior would develop creative imagination. Creative imagination would lead to creative products by overcoming any problems in development. Osborn knew good judgment alone was not enough. Imagination was equally important. Both contribute to the creative process. Osborn believed strongly in this human potential for creativity. He believed that there was a means to bring it out, to free it in the human spirit. He knew that human creativity is fragile and easily destroyed. He needed a process that would allow the individual to respond creatively in a safe and supportive environment. The most widely known of Osborn's techniques is popularly known as "brainstorming."

Let us digress a moment. Just as we discussed the misuses of psychology terms, we must again emphasize that creativity terms do not always mean the same to professionals as they do to the lay person. I cringe when I hear someone casually say, "let's do some brainstorming." Actually, I prefer to think of its *misuse* as "skeet shooting" ideas. In a skeet shoot, someone tosses up a clay disk and one or more persons

compete to shoot it down before it lands on solid ground. In untrained hands, the same thing happens to ideas. Someone tosses an idea out and the group competes to shoot it down. They may listen to the idea just long enough to see where it is going, but the goal is to fire volleys of shots to bring it down. "That won't work, we tried that already." "Management will never go for it." "Okay Janie, that was interesting but let's get practical." I have taken part in "brainstorming" activities where the leader has actually said, "Okay, that's over. We've had our fun now let's get back to work." We have a prejudice that if something is fun, novel, and induces laughter, it can't really be serious.

There is a common brainstorming exercise given to students beginning in the creative studies classes at SUNY Buffalo State. It is called "Create the Perfect Bathtub." It produces wild, funny, zany results. It also produces solid, innovative, practical results.

Mike Fox gave this same training exercise to a group of Japanese businessmen. They developed an "environmental bathtub." It had a waterfall, glass-enclosed sides filled with plants fed by circulating hydroponic formulas and lit by special underwater lamps. Music was piped in through the walls. The bathtub screens were elongated saltwater fish tanks. The tub emptied and cleaned itself. The businessmen really dived into the exercise, suspending judgment, accepting all ideas. All ideas were recorded on a flip chart. Fox challenged them to come up with at least thirty ideas. Most of the more creative ones came after the first twenty-five.

The difference with this group of businessmen is they did not view the exercise as just a skill-building game. They looked beyond the fun they had and truly looked at the advantages of the design. They went back to Japan and developed and successfully marketed their perfect bathtub. They used brainstorming as a useful tool of creativity—a problem-solving tool.

© Africa Studio/Shutterstock.com

*If a Cook Gets a Spatula and a Pan You
should Get Some Tools for Creativity*

Osborn (1953) envisioned brainstorming as a process to free the imagination from the restraints of judgment, to give it an equally important role in processing information. He hoped it would encourage the river of free-flowing ideas beyond the usual predictable, normal, safe ones. He saw this as possible only if everyone agreed to suspend and temporarily withhold judgment, to allow a "brain storm" of ideas.

The acceptance of brainstorming had the usual rocky start of a new concept way outside the paradigm. As the popularity of this tool grew it became so widespread that misuse was inevitable. To many it refers merely to getting a group together and having a free-for-all idea-generation session—with no guidelines—while subjecting the ideas to immediate judgment and evaluations.

One critic likened brainstorming as merely "cerebral popcorn popping." Brainstorming has become so widely known that it is a part of everyday conversation. It is probably one of the most widely diffused terms across cultures and the

least understood. A student came into my office and announced, "I just had a brainstorm!" My immediate response was, "Did it hurt?"

Because it has become so accepted, brainstorming has become a cliché. Unfortunately, many people (even some professionals) overemphasize the role it plays in the creative problem solving process. This is a serious error in that it over glorifies the importance of divergent thinking in creativity and problem solving. Equally important is the need for judicial or convergent thinking. We must have tools to "bring it on home" and select workable ideas from our efforts. There must be a balance between judgment and imagination, or all you will have is frivolous, undisciplined, rambling chaos.

As Osborn believed, we are able to use both of these cognitive processes, and both are essential to creative productivity. It was this need to balance the convergent and divergent thought processes that provided the impetus for the development of creative problem solving.

Does Brainstorming Work?

Brainstorming as a tool for generating options and ideas has gotten support as well as a bad rap. Some authors report that brainstorming works well. Others report that it has little value no better than a discussion. Here is an interesting observation. I have assembled a bibliography of over 100 resources on the subject. Most of the authors that support the efficacy of brainstorming—based on research—make reference to Alex Osborn (the inventor of brainstorming). Alternatively, most of the authors that find that brainstorming has no or limited value cite anecdotal evidence with no reference to Osborn.

To lay this issue to rest, we offer the following.

Brainstorming is not the whole story.

It is the Process that matters. Brainstorming is simply a tool. If you are looking for a creative outcome an outcome that is both novel and appropriate use the separate processes of Divergent thinking and then Convergent thinking. There are tools for each phase of the process. Learn how to use them. Brainstorming is a divergent thinking tool. To evaluate the efficacy of the options generated (the wished for novel and useful combination) you must use convergent tools as well—but not at the same time. Most of the naysayers of brainstorming are not aware of this two-phase process.

Process

The point of process is (1) to generate many varied and novel options; and (2) to select from the options the ones that meet the target and can be developed into useful ideas. If you don't want novel and appropriate outcomes, don't use creative processes. Go have a meeting, come up with a couple of options, develop one or two, and be done with it.

It is the process that matters. A cook gets a spatula and a pan. A carpenter gets a hammer and a saw. Two issues come up. One is skill development in the use of the tools, and the other is that one or two tools don't make a master.

Here is an example. A carpenter wants to make a board shorter. A hammer will make the board shorter. A saw will to. The point is each tool has its strengths. But a tool is just tool. There is a whole process to be considered.

There are many divergent thinking tools. It is interesting to note that all of the divergent tools have the same guidelines as brainstorming.

- Suspend judgment (do the judging later)
- Go for quantity (stretch yourself; set a goal of 50 options as a minimum)
- Freewheel (allow for wild and ridiculous options)
- Hitchhike (build on ideas)
- Allow for the power of incubation

The process means generating options and then, separately, evaluating the options—definitely not at the same time.

As with any other craft of skill, training is essential. Without training brainstorming doesn't work well. With training brainstorming will generate many options. Some will prove to be novel and useful. By the way, if you don't want novelty, don't do this.

The Bus Study

To lay to rest the efficacy of brainstorming and specifically as a divergent thinking tool in a process, below we highlight the research effort known as the Bus Study (Puccio, G. J., Burnett, C., Acar, S., Cabra, J. F., Yudess, J., & Holinger, M., 2018).

The public transportation entity in and around the Buffalo, New York area is called the Niagara Frontier Transportation Authority or NFTA. The International Center for Studies in Creativity engaged in a real-life research effort to aid the NFTA with a challenge: How to increase bus ridership in the suburbs?

Three types of idea-generation groups were assembled. The first group had no training in brainstorming or in process. The second group

had no training in brainstorming but were given one process requirement: "Don't judge any ideas. We will do that later." The third group were well trained in process techniques. They were our graduate students and our alumni. Each group had 20 minutes to generate ideas.

The Results were Profound

The untrained group came up with two ideas. The untrained group that had one process requirement (don't judge) came up with about 20 ideas. The third group, the trained group, generated well over 100 ideas. The client (NFTA) found value in the ideas generated by the trained group. All of the ideas generated by the first two groups were discarded. The experiment was run several times with the same results. The results were *not* ambiguous. It is the process that matters. Brainstorming is simply a tool in the process. As with any skill, training is required.

A note to the naysayers. "Does brainstorming work?" is not the right question. The right question is complex—just like real life, "Does brainstorming work as part of a process used by well-trained participants?"

The Toolbox

It might be helpful to visualize one of those big red Sears Craftsman toolboxes. Imagine one with two pullout drawers. One drawer might have tools for taking things apart. These are usually single-purpose tools like screwdrivers, wrenches, pliers, etc. A second drawer might have tools for putting things together. Hammers, a crescent wrench, duct tape, and so on.

All of these tools are useful by themselves depending on the circumstances of the job. Most of them can be made to work outside an area for which they were designed. A screwdriver can pry off a paint can lid or the handle can be used as a hammer. The tool still functions but less efficiently than one designed for the purpose. Some tools work better when used together, such as a hammer and a nail. Some are designed to serve in difficult situations. Sometimes only a wrench will do.

The challenge with applying creativity tools is the same. You must be introduced to the tool, instructed in its proper use, and experiment with it in a safe way with proper supervision. As you get used to the tools, you will begin to experiment, to substitute, and to adapt these tools to get the job done. Trial and learn will make you comfortable with them. Like most tool owners, you will have to guard against developing "favorites." All tools are equally useful depending on the particular problem you are trying to solve.

© dashadima/Shutterstock.com

You Need a Toolbox for Your Creativity Tools

These tools are not presented in any order of importance. All are equally valuable depending upon the problem to be solved. Some tools in this grouping are easier to use than others. Some require a higher level of experience and are better suited to more complex problems. Not all work equally well in particular situations. Experimentation, trial and learn, skill building are all to be expected in becoming fluent with the tools of creative thinking. Many can be mastered with individual practice and mental "tinkering around." This is not a spectator sport. A few require expert guidance and training from a professional instructor.

Using the toolbox analogy, the top drawer is for your divergent tools (generative thinking tools), and the bottom drawer is for your convergent tools (judicial thinking).

Guidelines for Divergent Thinking

Divergent thinking is the process used in generating options. Options include more than just ideas. Options could include vision statements, goals, data, problem statements, criteria, elements of assistance and resistance, and so on.

The basic principle that drives divergent thinking is suspension of judgment. Judging an idea or other option is deferred until later. It is inappropriate and ineffectual to generate and judge ideas at the same time. All of the divergent tools that follow are based on the following five guidelines:

- Defer Judgment
- Strive for Quantity
- Freewheel
- Seek Combinations
- Allow for the power of incubation.

These are explained in detail under *Brainstorming*.

Divergent Tools

Brainstorming

Brainstorming is the tool most closely identified with the creative problem solving process. Brainstorming was originally created by Alex Osborn in 1938 as a group technique for generating many ideas based on the divergent thinking guidelines of deferring judgment, striving for quantity (research trends show that the most novel and useful ideas emerge after thirty ideas are generated), freewheeling, and building off other ideas.

Who Invented Brainstorming?

 Alexander Faickney Osborn (1888–1966) is credited for the invention of the technique brainstorming. Mr. Osborn developed this small group technique in 1939 while he was a partner with the advertising firm of Batten, Barton, Durstine and Osborn, or BBD&O. Osborn realized that if his employees were able to suspend judgment, or hold off on judging ideas until a later time, then their imagination would flourish. This basic belief is a guiding principle behind the Creative Problem Solving (CPS) process.

Osborn wrote many books and articles on his theories of creativity. One of which, *Applied Imagination*, is one of the most widely known and referenced in the creativity discipline. In this classic text, Osborn discusses the importance of imagination, barriers that block our creative potential and the beginnings of the CPS process. Osborn also provides exercises at the end of each chapter to allow the reader an opportunity to practice what one has just learned. *Applied Imagination* is a must read by anyone who is interested in the topic of creativity. Without Alex F. Osborn, creativity as we know it today may not exist!

By Russell A. Wheeler

Again, the guidelines for brainstorming are also the same guidelines for effective generation of options all along the Creative Problem Solving process. Brainstorming is used to generate a list of possible wishes, goals, or challenges in the exploring step of the Thinking Skills Model. It can also be used to generate data, possible problem statements, ideas, criteria, sources of assistance and resistance, etc. It is one of the most versatile tools in your "toolbox."

Brainstorming or "Skeetshooting" Which Will It Be?

Brainstorming is one of the most well-infused terms across cultures, yet one of the least understood. It is unfortunate that people say "let's brainstorm" to mean a free-for-all discussion

followed by idea slaughtering or *skeet-shooting* of ideas. In a skeet-shoot, a person goes off in a field and flings clay disks into the air. In the same field, other individuals or groups attempt to shoot them down as quickly as possible. The same thing can happen in an untrained group of "brainstormers." One or more people toss up ideas and the rest of the group tries to shoot them down. "How about . . . ?" says the idea-tosser. "Nope." "Won't work." "Tried that already." "Too expensive." Enough shots like this and the idea is effectively destroyed.

Brainstorming is not the same as a group discussion. It is a divergent thinking technique with clear and basic rules:

Suspend Judgment—Do it Later

- *Defer Judgment* Be open to all possibilities. Judging ideas—your own or other participants'—will get in the way of generating them! Do the judging later.
- *Strive for Quantity* Emphasize generating a large quantity of ideas. Set a goal of thirty or more options. You must work to get past the easy, obvious possibilities that come to mind right away. The greater the number of ideas,

the greater the likelihood of producing some that are new and useful.

- *Freewheel* Don't hold back any idea, even if it seems "wild" or "silly." Sometimes these can be the ideas that pave the way for other ideas that are very original and powerful. Here is an example: 3M, a major manufacturing company, developed an adhesive. This new adhesive had a problem. While it stuck to almost everything, it would not bond with anything. If you pulled on it, it simply separated from what you stuck it to. Not very practical for an adhesive. What use was it? The company was ready to admit defeat and accept the loss of its investment in the development of this new adhesive. Instead, they used divergent thinking. One employee joked,
 "We could put it on the back of small pieces of paper and stick notes on everybody's phones." Presto! The birth of "Post-It" notes, a mainstay of 3M for many years. Had they not been willing to suspend judgment, go for quantity, and freewheel, where would we be today? Still losing notes scribbled on matchbook covers.
- *Seek Combinations* Be a Hitchhiker. Be aware of, and look deliberately for, opportunities to make connections or to link a new idea with one or more others that you hear. Try to build upon or join together ideas you hear, to make them into still better ideas.
- Allow for the Power of Incubation It sometimes pays to step away from the challenge and let the issue incubate. Go to a movie, eat an orange. Later, come back and generate more options. For some, this really helps to get those novel and useful ideas.

Soap-Powered Interstellar Pickup Truck

Although the guidelines for brainstorming can be applied by an individual, brainstorming is considered a group technique. Given no external constraint, a group size of five to seven participants produces a high quantity of options over time, particularly if the group is diverse in style and background. Fewer than five participants and the flow of options slows down. More than seven, and there may not be enough air time for everyone to contribute. At ten or eleven players, social loafing becomes obvious!

In each group, one person is chosen as the "recorder." The group is given, or gives itself, a time line for generating ideas. The group is going for quantity, not necessarily quality. The recorder writes down all ideas as they come up *just as they are stated*. Selection and analysis do not begin until this divergent phase is completed.

There are also many useful variations on the basic strategy of brainstorming. In this section, we will examine two of the more popular

variations called Brainstorming with Post-Its and Brainwriting.

Brainstorming with Post-Its™

When using brainstorming, options generated by a group can come very quickly This can become an obstacle to the effective utilization of group resources. *Brainstorming with Post-Its (also known as Stick 'em Up brainstorming)* provides a number of advantages over other forms of brain-storming. Some of these include:

- *Speeding up the flow.* Participants do not have to wait for the Recorder to record each option before sharing another. Instead of having only one recorder for five to seven group members, there are now up to seven recorders.
- *Hitchhiking and building an options of others.* Other nominal techniques like brain-writing (to be reviewed next) provide limited group focus on the options generated by group members. Using Post-It notes allows all group members to hear and build on each other's alternatives. The energy of the group can also remain high.
- *Improved sorting and convergence.* Since each option is on its own Post-It, it can be moved around, categorized, and evaluated more efficiently.

The basic directions for using the Brainstorming with Post-Its Notes are:

- Be sure each participant in the group has a Post-It pad and something to write with. Make sure the pads are large enough to be

seen—3 × 5 inches is ideal. Pen-sized "magic markers" work well and provide easy-to-read ink.

- Inform all participants to make their responses: *readable* (write or print clearly, legibly, and large enough to be seen), concise (keep them brief, use telegraphic form) and specific (share the essence, keep them clear and distinct).
- When participants are finished writing an option or idea, they say the option out loud and then post their option on a chart or hand it to the leader (facilitator) elected for this service. (Write it, say it, stick it up.)

Brainwriting

Brainwriting is very similar to brainstorming in that it follows the same guidelines. It does, however allow for some decided differences. Deliberate building on ideas is usually easier. It changes the pace of idea generation and allows the reflective idea generator to more readily participate.

Each participant begins by writing in the problem statement at the top of the brainwriting form. Then he or she writes in three ideas across the first row. After a row is filled, the participant picks up a form from another person and adds three more ideas, repeating the process until the form is filled. Ideas tend to build on previous ideas, making hitchhiking and elaboration easy. Participants do not have to talk to each other. This can even be done by e-mail!

Forcing Connections

Forcing Connections (also known as *forced connections* and *forcing relationships*) uses a

deliberately chosen or randomly chosen stimulus that has no apparent connection to the task. This does two things. It has the potential to increase novel responses and it is useful for changing categories of ideas. Here is how you do it:

- Take a break. Observe several items in the room . . . in a store . . . on a page . . . in the street.
- Don't be selective. Just capture the first things you see: a bicycle, a fire extinguisher, a vending machine, a flag, a banana.
- Ask yourself, "What new ideas might this object give me to deal with my challenge in a new way?"

Forcing connections can be used to assist in idea generation when the flow begins to slow. Forcing connections will trigger a flow of options with *new* connections, *new* alternatives. Forcing connections is useful for changing categories, perspectives, or viewpoints during idea generation. And finally, forcing connections will usually produce more novel or unusual options.

Morphological Matrix

The morphological matrix (which comes from the word "morphology," referring to form or structure) is an idea-generating tool that can be used to produce a large number of ideas very quickly and to create some possibilities that are guaranteed to be unusual. It is also very easy to use.

For any issue or problem statement, ask, "What are some of the major parts or variables involved?" These are called "parameters" of the problem or challenge. There might be many parameters, but to keep the number of possibilities workable, we usually focus on four or five major parameters. A parameter

is a major part of the problem that might take many forms or have many values. In story-writing, for example, we might identify four important parameters: the main character, the place, a goal, and an obstacle. Each of these might have many forms or values. Many people (or things) might serve as the main character; the story might take place in any of a vast number of different places, and so on.

To use this technique, you will create a matrix (a grid or chart) of the main parameters of your problem, and then use it to explore many new ideas. Use the following steps to complete the matrix:

- Identify three or four important parameters for your problem, and put the name of each parameter at the top of one column on a sheet of paper.
- For the first parameter, list many attributes or values it might have; about ten will do just fine. Record the attributes, one to a line, down the column for the parameter. (For example, if the parameter for this column is, "Place for a story," you would list under that heading about ten different places where a story might occur).
- Repeat direction two for each of the other parameters.
- To explore new ideas, deliberately or randomly select one entry from each column. Look at the combinations that result, and explore what ideas that combination suggests. Feel free to try several different combinations, noting that each combination will produce intriguing new possibilities.

Note: If you have four parameters (columns), with ten rows in each column, there are 10,000 possible combinations. Among these, there will surely be some original and fascinating possibilities.

The author used this tool with a group of third graders in Ketchikan, Alaska. Their teacher was trying to encourage them to develop writing skills. She had been assigning them to write short stories each week. The students had been having difficulty with the assignment. The majority complained it was too hard and many were in active rebellion. I briefly demonstrated the matrix and then let them generate ideas under each parameter: main characters, places, goals, and obstacles. The students not only came up with wonderful stories, they enjoyed the process so much that they began to write during recesses and other "free time" periods.

Many became so delighted with this technique they excitedly explained it to their parents. Most of these Alaskan eight- and nine-year-olds came from logging and fishing backgrounds so the term "morphological matrix" was a nonsensical noise. One parent called the teacher after the training session and asked the teacher where she could get a "More Than Logical Mack Truck" for her other children to use. It seems the concept was simple for the child to use, but the terminology was a stretch. He knew what a Mack truck was. He knew writing was easier than when he was using his logic to create stories. He was happy with his new "More Than Logical Mack Truck" tool. He understood the process but could not quite explain it. In this case, the "why a tool works" was not as important as discovering that it does!

The following form is an example of using a Morphological Matrix to write a story. Step one: diverge on a variety of characters. Step two: diverge on a variety of locations for a story. Step three: diverge on a variety of goals. Step four: diverge on a variety of obstacles.

When you are ready to converge, select one or more options from each column. This can be done

deliberately of at random. You then have the stuff of a story. Maybe even a creative one!

Morphological Matrix

	Characters	Places	Goals	Obstacles
1				
2				
3				
4				
5				
6				
7				
8				
9				
10				

First column—list the characters . . . any characters (Fido the dog . . . an ugly bartender . . . a pirate . . .).

Second column—list different places where a story might take place.

Third column—list major concerns in a story . . . list any kinds of goals.

Fourth column—list obstacles or sources of difficulty (personality characteristics . . . villains . . . relatives . . . disasters . . . situational obstacles . . .).

Explore and extend interesting combinations— for example, you might randomly pick one item from each column and make up a story. You might want to use your phone number, roll the dice, or some other random selection technique.

SCAMPER

This tool was developed from Alex Osborn's "Checklist for Generating Options." It gives us another way to look at the problem or situation we wish to change: the acronym stands for Substitute, Combine, Adapt, Modify, Put to other uses, Eliminate, and Rearrange.

Several questions might be generated and answered using the SCAMPER tool:

Substitute	Who else? What else? Other material? Other ingredients? Other processes? Other place? Other approach?
Combine	How about a blend? An alloy? An assortment? An ensemble? Combine units? Combine purposes? Combine appeals? Combine ideas?
Adapt	What else is like this? What other idea does this suggest? Does the past offer a parallel? What could I copy? Whom could I emulate?
Modify	Magnify? What to add? Minify? What to subtract? New twist? Change meaning . . . color . . . sound . . . order . . . form . . . shape? Split up? Greater frequency? Stronger? Longer? Omit? Streamline?
Put to other uses	Could its form, weight or structure suggest another use? New ways to use? Other uses if modified? Change the context?
Eliminate	Suppose we leave this out? Fewer parts? Condensed? Lower?

Rearrange

Shorter? Lighter? Understate?
How can we make less more?
What can we do without?
Reverse? Turn upside down?
How about opposites? Reverse
roles? Turn tables? Interchange
components? Other sequence?
Change place? Change schedule?
Transpose cause and effect?

Here is a critical note for using SCAMPER.
Use the questions, not the acronym. The acronym
is clever, but the questions for each heading are
what make the tool effective. Some questions will
produce responses. Some will not. If the question
produces nothing, go to another question. This is
just a tool. It is not a miracle.

SCAMPER is also very helpful in beginning
to generate criteria that will be useful later in
convergent thinking processes. The acronym
SCAMPER is handy, but the real technique is to ask
the questions. Sometimes the questions will result in
more ideas. Then again, sometimes not. It's just a tool.

Convergent Thinking

Convergent thinking is basically the process
of selecting options. Convergent thinking is
used in judging and selecting from among the
options generated in divergent thinking. You use
convergent tools to screen, sort, select, compress,
polish, and investigate these options. (As in
divergence, options are more than just ideas.) The
basic principle that drives convergent thinking is
applying affirmative judgment. Ask yourself, "What
do I like about the option? What are its advantages
or pluses?" Do this *first*, before doing any other
judging.

These are the five guidelines for convergent thinking. They apply to all of the convergent tools listed below.

- Use Affirmative Judgment—Find the advantages first.
- Be Deliberate—Be planful and systematic as you do your evaluating.
- Consider Novelty—Look for new and unusual options.
- Work to improve your options.
- Allow for the Power of Incubation—It sometimes pays to step away from the challenge and let the issue incubate. Go to a movie, eat an orange. Later, come back and converge on the options again. For some, this really helps to make novel options useful.

Convergent Tools

Hits

Sooner or later one has to select options from a list generated during the divergent thinking phase. The simplest tool is making the hits. Here you identify and select the most promising options. A hit should have some useful qualities. Here are a few:

- Intriguing
- Clear
- Goes in the right direction
- Interesting
- Feels right
- Stands out

Highlighting (Hits, Clustering, and Restatement)

Highlighting is a handy tool for compressing a large set of hits into a manageable set. Highlighting

***Work to Improve the Idea— Make It
Sparkle and Shine***

has three steps: making the hits, clustering the
hits that seem to hold together, and restating or
labeling the cluster. Cluster the hits that have a
common theme into a group. Give the group a label
or restate the option to give the cluster clarity.
Sometimes a single word will do the job; other
times you will need a sentence or a paragraph.

Card Sort

Card Sort can be used to prioritize, rank, and
compare options. The options may include ideas,
solutions, criteria, or challenges in the form of
problem statements.

This tool is easiest to use with an uneven number of options—up to about nine. With more than nine options, it gets goofy (that's a technical term in creativity). Five to seven options are easy to manage. Once the pattern is established, you are diminishing the pool of options one step at a time.

Directions: The following scenario uses five options.

1. On Stickies (or Post-it Notes), write one option per card.
2. Decide on the language for the polar ends of the priority order (best -least, most important -least important, first -last, etc.).
3. Ask, "Of the options chosen, which one goes at the top?" Place the option at the top of the priority order.
4. Ask, "Of those remaining, find the one that fits at the bottom end of the priority order.
5. Ask, "Of those remaining, find the one that fits at the top end of the priority order.
6. Repeat the mantra until all of the options have been used. At this point, you have ranked or prioritized all the options.
7. Review the priority order to see if it seems right. Adjust as necessary.

There are two keys to a successful Card Sort: Decide on the language for the polar ends and then use the mantra, "of those remaining . . .".

At this point, you have ranked or prioritized all the options.

PPCo

PPCo was developed in the early 1980s by Diane Foucar-Szocki, Roger Firestien, and Bill Shephard as a quick, easy-to-use tool to

investigate and polish an idea. The PPCo is particularly useful when examining an ambiguous idea or problem. It is used to support, polish, and investigate an option by examining the option in a stepwise manner.

PPCo stands for Pluses, Potentials, Concerns, and overcoming the *key* concerns. Write the idea, challenge, wish, problem, etc. at the top of a sheet of paper. List three Pluses for the idea. Then consider the future Potential for the idea and list three Potentials. Semantics matter, so begin each potential with a statement starter such as "It might . . ." or "They might . . ." Next, list up to three concerns. Turn those concerns into problem statements beginning with a statement starter such as "In what ways might . . . ?" or "How might . . . ?" The word *might* is essential. It is a term that engenders possibilities. Do not use *should* or *could* or *can*. If one (or more) of the Concerns is a serious challenge—a "deal breaker"—then use brainstorming to try to overcome the concern. The lower case "o" is provided for just this. Sometimes the concern can be overcome. Sometimes not. PPCo is just a tool. It is not a silver bullet.

The PPCo is the "crescent wrench" of the creativity toolbox.

Wheelbarrow Story

This is the legend of the wheelbarrow with the "wheel in the wrong place." I use the term legend as I have no direct knowledge of what took place. The story was told to me by Sidney Parnes several decades after the event occurred.

Sometime during the 1960's Parnes, and others in the creative studies department, were told about a boss at a small manufacturing company near

Toronto that did things differently—and that they should go see. In fact, Parnes and company did make the trip. They shadowed the boss for a day to see what he did that created a positive press, a culture of creativity.

The day they were there, the man that stamped out shovel blanks came to the boss with a drawing of a wheelbarrow he designed. The wheel was in the back.

According to the legend, the boss said, "The hopper is big. It looks like it would hold a lot. It looks like it would be easy to manufacture. The handle is small and the design is simple, we might be able to keep the costs down. We might make money on this. If we can get a patent on this design, we might be in a good market position. How might we make a prototype? We are locked in to our budget right now. How might we find some money to pre-test this idea?"

Side Note: As I tell this story to my students, I ask them how they would feel if they had the idea and the boss treated their idea in this way?

The prototype showed that the hopper was too large for the leverage. The hopper was made smaller. The wheel became a pair of wheels. It was manufactured for a time, but the legend has it that it didn't make a lot of money. For a while the wheelbarrow was used by construction workers for light loads while negotiating steel I-beams. With the wheel in the back, the user could maintain a center of gravity close to the body by pushing down on the handle—a useful characteristic when making a 90-degree turn on a narrow beam.

Now we see the "wheel-in-the-back" wheelbarrow has evolved into the ubiquitous 2-wheeled garbage tote.

The PPCo is helpful in getting us to suspend judgment, tolerate ambiguity ("I just don't get it"), and encourage novelty It helps us remain open to new ideas and to get past negative initial reactions. It is an introduction to an alternative way of thinking. It encourages both generative and judicial thinking.

By the way, this wheelbarrow—with the wheel in the wrong place—actually exists. It has been used in the construction of high-rise buildings where the "sidewalk" is an I-beam. Push down on the handle and the center of gravity stays right in front of you, not over space, as you turn a sharp corner 20 stories in the air!

© Scorpp/Shutterstock.com

**PPCo—The Crescent Wrench
of the Creativity Business**

Critique Questions

This tool does not fit cleanly into the divergent tool drawer or the convergent tool drawer. So for now it's a "miscellaneous" tool. It uses both divergent and convergent thinking, *but not at the same time.*

I developed Critique Questions as a response to an experience as an invited lecturer in Landscape Architecture at the University of Minnesota. The instructors would give critiques to individual students as their designs were being developed. I noticed the students were not able to separate themselves from their work when the critiques got particularly pointed. If the idea is to learn something (change a behavior) then the critique ought to be about the process, the product, and the behavior and *not* about the student's *being*. This tool makes that separation.

When giving a critique of a product and a process, use affirmative judgment to evaluate the person's work (student, peer, employee, etc.). Below are five questions—to *be asked in order*. These five questions open a dialog to affirmatively and safely discuss advantages and limitations of the person's performance. Used as a standard format for the evaluation of a project, this helps to build trust and openness, as it serves to separate the person's behavior from the person's being.

1. What do you like about what you did?
 –This acknowledges the positives.
2. What would you like to see more of?
 –This acknowledges intrinsic value and the understanding of being "in process."
3. If you could do this over again, what might you do less of?
 –This probes the nature of transfer of learning.

4. If you could do this over again, what might you do or differently?
 –This probes the nature of transfer of learning.
5. Any surprises?
 –Sometimes the unexpected is meaningful or useful.

If the you see an area that clearly needs attention and you feel *impelled* to bring it to the person's attention, state the concern in the form of a problem statement, beginning with the invitational stem "In what ways *might* . . . ?" or "How *might* . . . ?" These invitational stems open up the realm of *possibilities*. Do not offer the answer. Discovery and dialog are in order.

Here is my favorite observation about criticism (it comes from *Negative Criticism and What You Can Do About It,* by Sidney B. Simon): "About the only time it may be necessary to provide direct feedback is when some else is standing on your foot and doesn't really know it."

Learning Creative Problem Solving Processes—The Creative Learning Model

As we have repeatedly stated, just like reading and writing, creativity can be taught and creativity can be learned. This holds true for CPS. The Creative Learning Model described below comes from Treffinger (1988). It is a useful pattern for instruction in creativity. The model is constructed upon three levels. The three levels are often considered as following one another and, in fact, are usually conducted and/or taught this way. The proposed sequence is based on the most logical way it is used, but it is not carved in stone. There has not been enough direct investigation of the effects

of following the steps or deviating from them to document the rate or quality of success of following the strict pattern of one, two, and three.

<u>Level One</u> involves learning to use creative and critical thinking techniques as tools for generating and analyzing ideas. Creative thinking tools are those that enhance or increase a person's ability to analyze, compare, refine, or improve ideas or to make choices and decisions.

We chose the tool image because people understand what tools are. Tools help us complete a job or task more easily, effectively, or efficiently. One can learn to use a tool skillfully. We know and understand that different jobs need different tools. A person can learn how to identify the tasks for which certain tools are useful and necessary. We learn how to identify and select tools depending upon the task we want to do. We understand that the use of some tools comes easy while others are more complicated. We know that using tools over and over, makes us comfortable with them, increases our confidence in our skill, and makes the job more professional at the finish. We learn the names of tools, recognize them when we see them, and learn the vocabulary related to their use. We know there are lots of tools, some simple, like a hammer, and some complicated like a jigsaw. We know from working with tools that first we must learn to use the basic ones and the wide range of tasks they can be used for. As our skills increase and we become more experienced, we want to acquire more complex and refined tools. Eventually we assemble a highly functional tool kit that we can use with ease and confidence. The more we use our tools, the more our skills increase and the more complicated tasks we can undertake with confidence.

Level One thinking tools include: brainstorming, brainwriting, forced relationships, and the morphological matrix for divergent thinking. They also include convergent thinking tools to screen, sort, select, prioritize, and compress information, such as Hits, Highlighting, Card Sort, or an Evaluation Matrix (a comparative matrix for idea analysis) or investigating, supporting, polishing, and decision-making tools such as the PPCo. Level One tools can be taught and learned through direct instruction.

Level One skills are not sufficient to ensure that a person is an effective or productive thinker. Unfortunately, a large number of "creativity consultants" and "motivational speakers" have latched on to and trivialized these concepts. Training programs, seminars, and "empowerment retreats" that focus solely on Level One tools usually become no more than a collection of meaningless tricks, games, or gadgets. People must have structured opportunities to progress beyond exercises and activities in a training atmosphere. Individuals and groups need opportunities to use the Level One tools in more complex situations and with real challenges in task relevant contexts. Using the tools for solving real problems in real settings, for real situations, is of vital importance. Creativity is not a parlor game.

Level Two involves learning and practicing a structured process or system for solving problems in which Level One skills can be applied, organized, and extended. The major goals in Level Two are (1) learning a structured approach for using your creative and critical thinking tools to solve problems and (2) gaining experience and practice in using the structured method so that you become both confident and polished in skill ability. This is done by practicing with problem exercises that are

pre-selected and contrived. The purpose of these exercises is to practice using the tools rather than come up with actual problem solutions. The exercise problems must be reasonably realistic so you will feel motivated and willing to work on them. It is also important that the problem exercises be open-ended and impersonal enough that the individual or group can stay aware of the process strategies while working on the problem exercise.

<u>Level Three</u> represents the most important desired outcome for training in creativity: to enable the individual or group to deal effectively with real problems and challenges. In <u>Level Three</u>, the major goal is simple: "Solve the Problem." This stage of learning involves real problems that really matter to the individual or group. Real solutions will be generated and carried out. The group or individual feels a real commitment or concern regarding the problem. This is not just an academic exercise. The challenge of finding a solution is personally felt.

If you try to *learn* the tools of creativity on a real problem, in your context, where you own the outcome, you are likely to have a really unsatisfactory experience. For all the good it'll do, you might as well shoot yourself in the foot!

Desired Future State Model

The creative process is effected by our view of current reality, our vision of a desired future state, and by the tension that naturally exists between the two (Fritz, 1989). (Fritz called his model the Creative Tension Model.) First, there is the current reality. This is the accepted view of the problem. This is the situation or problem we see a need to change. Then there is our vision, our desired future state, our "future reality." In the best of all possible worlds, that is where we would like to be.

Context **Values**

Work Setting **Strategies**

Individuals **Leadership**

Work Organization **Vision**

***Robert Fritz's Creative
Tension Model***

Between these two are our personal issues such
as motivation, level and style (how creative we
are and how we like to display our creativity—the
Person "P") and situational issues (those climate
factors that affect our ability to take risks or move
toward the unknown—the Press "P"). This tension
will resolve itself in either the direction of the
desired future state or in the direction of current
reality. The creative problem solving process can be
decisive in resolving the tension toward the desired
future state. Appropriate use of the Thinking Skills
Model can take the fear out of problem solving.
It can make the risks *calculated risks*. TSM can
help develop the novel idea into a new and useful
opportunity. And most centrally, TSM can prevent
the classic error *solving the wrong problem
precisely*.

Chapter 4

The Creative Press

Introduction to the Creative Press (Climate or Environment)

Creativity is not the spice of life. It is the very stuff of it. So, you need to make a space for it. The "space" in this instance is the environment where creativity is supported or denied.

"Wanted: An environment where I can have the challenge, the freedom, the time, and the resources to do what comes naturally for me." This is a basic wish. When we say this, we are talking about the climate conducive to creativity—those things that press in on us that help us to be creative—or not. So what does this climate look like and where does it come from? Everybody has some notions and a few terms that describe the environment that helps them concentrate, rise to the challenge, be productive, be playful, and generally feel good. This is the press—the space or the place where creativity lives. Press in the context of creativity means both the physical and psychological climate we operate in. School, home, or corporation, press affects our ability to use our creativity. Press is from the Latin pressus, meaning "a closet or a container." Press is the container that the rest of the Ps fit into. Press includes all those external and internal barriers and assisters in the workplace that "press" in on us. These factors can either help or hinder us in our creative pursuits. This "place"

***Press: Those Things Pressing on Us That Help
or Hinder Our Creativity***

has two basic components, the physical press and
the social-psychological press.

Physical Press

The physical press includes such things as
creature comforts. Is the temperature right for
you? If it's supposed to be dry, is it? Is it so noisy
you can't concentrate? Is it so quiet you can't
concentrate? After two hours of sitting, does
your chair still support your back? If you have a
question, is there anybody nearby to answer it?
Does the machine you're supposed to operate break
every third time? Have you ever found yourself
muttering, "I wonder what the designer of this
thing is doing today"? Or maybe the machine works
like it's supposed to, or you can actually reach what
you need without getting up! Maybe there's room to
spread out. And maybe the restroom is in the same
building! This is the stuff of the physical press. You

Physical Press

have a better chance of unpacking your creativity when the physical environment is supportive of your personal needs.

Part of the humor in the popular comic strip "Dilbert" derives from the physical press the characters work in. Many of us have worked, do work, or will work in companies using the "rat maze" design of small cubicles. The walls are designed to be too high for visual contact with our fellow "rats." Yet they are not enclosed enough to allow us privacy. We can hear activity all around us. If we cannot physically participate in it, then it just becomes

Play is the impractical drive from which practical discoveries are born. —Virginia Postrel

distracting noise. There are no doors to shut and no windows to look out. We feel isolated and stifled. The press becomes both impersonal and hostile. There is little or no way to humanize it. Nothing can be hung on walls; there is no room for furniture other than the minimum needed for daily production. The lighting is artificial and harsh. We are separated from all levels of management by physical barriers. Management has offices with real walls, ceilings, and doors. We must knock and wait. We begin to feel inferior, unimportant, unappreciated and resentful. The physical design of the work setting encourages the development of "Us versus Them" thinking. Creativity dies a long, painful, lingering death.

The physical environment may be too dark or too bright. Too loud. Too cramped. Too big. Departments may be in widely separated areas or in different buildings all together, discouraging communication. The temperature may be too hot or too cold. All of us can supply examples of physical press that have been less than ideal.

Contrast the usual physical press with these two examples:

The Creative Classroom: My son was enrolled in a "Gifted and Talented" program in Seattle, Washington. His classroom was a large carpeted room filled with plants. There was a large suspended platform reached by a ladder. It also was carpeted in bright colors and large pillows. There were many glass containers in the room containing fish and small "creatures" such as mice, hamsters, a tarantula named Freddie, and a small gray rabbit. The central room had small sofas, a long table, and "cubby tables." There were brightly painted bookshelves, a computer (a rare thing in the early 1970s in a fifth-grade classroom), and a television. There was room to mingle, room to "get away," and room to work as large or small groups. The outside wall was composed of windows. There was a second door that opened to a small outdoor area

garden planted and maintained by the students. The physical press was comfortable, safe, stimulating, and creative. Contrast that with the typical "classroom box" with the teacher's desk in front of a large intimidating blackboard and orderly, highly regimented rows of seats in which most of us spent our school years.

The Hallmark Innovation Center: In 1984, Hallmark (yes, the card folks) decided to build a place for nurturing people and ideas (Hucker, 1988). In Kansas City, Missouri, the 17,000-square-foot center houses staff from Advanced Technical Research, Equipment Engineering, Product Innovation, and their Creative Workshop departments. This building is across from the main Hallmark facility at corporate headquarters. It is a separate building that is accessible from the main building. Staff and corporate management can come and go freely between the facilities. About 180 employees work in the Innovation Center permanently. Others rotate through, staying for several months at a time to explore technologies and expand their creative visions.

The whole design of the physical building has been done to encourage communication. The building encourages a free flow of information. The design is a constant reminder that the function of the building is the exchange of ideas. There are conversation lounges with comfortable furniture. There is a small food service area in which to meet and mingle over meals. The lower and larger floor is an open area the size of two football fields containing all of Hallmark's working laboratories for traditional processes such as gravure, lithography, die cutting, silk screening, electronics, lasers, ceramics, and plastics. All the work areas and conference rooms are glass walled so that everyone is free to explore ongoing projects. There are few real doors; most rooms just have "holes in the walls." All the office walls are chest

high to encourage informal conversations and "open door" drop-in meetings. Light and color are considered important. They use a soothing teal and burgundy color scheme and a unique lighting system combining natural and artificial light. A corridor around the main workspace is all windows, allowing maximum exposure to sunlight and nature. There are ninety pyramid-shaped skylights for even, indirect natural light. At the first hint of darkness, photoelectric cells trigger fluorescent lighting to give the illusion of daylight.

Individuality is encouraged. Workers are encouraged to decorate their work areas. The ten cartoonists who work there developed a "Humor Workshop" decorated with cartoons, rubber chickens, a gorilla mask, and a life-sized stuffed soft-sculpture figure of a receptionist they call "Ernestine." They, as other workers, have a variety of work surfaces to use—roll-top desks, workbenches, traditional drawing tables, and an old wooden door someone brought in and set up on sawhorses.

What is the Creative Studies Teacher Doing?

The answer is, teaching creatively. Creative teaching is setting up student self, actualization. A creative teacher is providing a good environment to encourage creativity. There are no real rights or wrongs, because the teacher is deferring judgment and using affirmative judgment. Creativity comes from the bright side. The focus is on the positive. Creativity deals not in substance as much as in thought process. Your teacher is your guide and an example of how to cater to creativity. The realization of what it is all about ultimately lies in the student's taking advantage of a creative nurturing environment.

—Dan Butch (student with a minor in Creative Studies)

We become what we think. Always.—Mike Fox

No one is isolated. Everyone works together and shares ideas. An artist can work with a technical engineer and a marketing expert on the same project. Anyone passing by can offer an idea or opinion or be solicited to give one.

Employee "burnout" or "turnover" is virtually nonexistent. The average employee stays there 27 years.

Social-Psychological Press

As important as it is, the physical press is only a small part of the press issue. Even more important is the psychological climate. I am comfortable and safe in my physical place but am I comfortable and safe in my job?

Climate is established by leadership. Creativity *support* comes from the top down. There must be mutual support and communication between the person who does the job and the person who needs the job done. This is the psychological press.

Psychological press is divided into two main areas: external and internal. We will look at the external psychological press first. The external press is all the factors that form how you see your job. They influence how happy you will be there and how creative you can be. These factors include management controls, communications, reward systems, attitudes, feedback, information, energy, supplies, and values (VanGundy, 1984).

External Social-Psychological Press

Göran Ekvall (1987, 1996, 1999) developed ten major characteristics of climate that have a direct result on worker creativity. He compared these characteristics and their influence on innovation. He conducted research in several organizations over a twenty-year period. He developed the

"Creative Climate Questionnaire (CCQ) to measure individual workers' perception of their jobs. He compared the way workers viewed their work environment with how well a company did commercially. Did they develop new and original products and services? Could they deliver products quickly to market? Did they develop and promote original and commercially successful products?

Using the results obtained from the CCQ, he categorized the companies as innovative, average, or stagnated.

Ekvall's Ten Dimensions

Ekvall's research into the following ten areas contribute to our understanding of external psychological press: challenge, freedom, idea support, trust and openness, dynamism and liveliness, playfulness and humor, debates, conflicts, risk-taking, and idea time.

Challenge is the degree of emotional involvement and "ownership" each individual feels in the job. A person feels involved in the daily operations and long-term goals or feels alienated from them. In a high-challenge climate, the individual feels personally motivated to contribute to the success of the company. They feel it is "their" company. They find what they do meaningful and invest a lot of personal energy into doing it better. They view the success of the company as a personal success. They truly love their job.

If the company is one with a low-challenge climate, the individual does not feel like he/she is an important part of the business—"It's just a job." It is drudgery to come to work and the worker is unmotivated to do more than the minimum necessary. This is the external psychological press in the "Dilbert" comic strip. It accounts for the

Change is disturbing when it is done to us, exhilarating when it is done by us.
—Rosabeth Moss Kanter

feeling of escape the individual feels "when the five o'clock whistle blows."

Freedom deals with our ability to function independently in our job. How free are we to make decisions and act on them? In a climate with a lot of freedom, individuals are given the authority to define how much of their work gets done. The individual can set his/her own pace. There is personal freedom to schedule and manage the day-to-day activities. The individual is motivated to "take the ball and run with it." This freedom encourages people to acquire and share information, make plans and decisions about work, and to work together.

If there is little freedom in the job climate, the individual feels like a cog in a wheel. He or she comes in, carries out specific duties in assigned ways, and leaves. They begin to feel anxiety, lose personal initiative, and adapt the attitude, "I better not make any waves."

Dynamism and Liveliness deal with the activity level in the organization. Is there a sense of purpose? How often does change occur? Is there a feeling of excitement and enthusiasm? If a company is highly dynamic, new things occur often and changes in old ways of thinking and handling issues occur often. The climate is lively and full of positive energy. The individual feels "pumped up." Everyone tackles tasks "full speed ahead."

In a company lacking dynamism, there are no surprises. No new projects, no different plans, no new developments. "This is the way we have always done it" is the prevailing mind thought.

Trust and Openness refers to the safety of the emotional environment. What happens to new ideas? What happens if mistakes are made? If a company promotes a strong level of trust, everyone in the organization feels free to put forward ideas,

opinions and concerns. The individual can set on a course of action, a personal initiative, without fear of ridicule or reprisals if there is failure. Communication is open and straightforward. Ideas are welcome, listened to, and treated with respect. Everyone feels valued and important. There is an attitude of "we are all in this together." True team building takes place.

When this sense of trust is missing, individuals are reluctant to call attention to themselves. There is a fear of being made fun of, exploited, or being robbed of their good ideas. People become fearful of making a mistake. Faultfinding and finger pointing are the usual forms of communication. Ideas are stifled. People do not feel an emotional safety in working with each other.

Idea Time is the amount of time people can and do use for developing and elaborating on new ideas. It is the informal "think time" over coffee or around the water cooler. It is time allowed for "bull sessions." In a climate with high idea time, possibilities exist to discuss and test impulses and fresh ideas that are not planned or included in regular task assignments. It is the ability to say "Hey! I just got a brilliant idea. Why don't we try this?"—and being allowed the time to do it.

If a company does not recognize the value of idea time or allow for it, every minute is booked and specified. Every task has a time deadline. There is no alternative to dictated instructions and planned routines. Discussion and "give and take" are impossible. The employee begins to feel like progress is impossible; there are no solutions. There is no potential for change because there is always a task on hand.

Playfulness and Humor refers to the degree of relaxation, spontaneity, and ease that are experienced within the working atmosphere. Jokes and laughter accompany the work. Humor is gentle

Laughing helps. It's like jogging on the inside.—Unknown

and shared. Employees and leaders enjoy coming to work. There is a sense of family connectedness. Southwest Airlines is a great corporate example. They encourage the posting of cartoons, organize impromptu parties, have official "costume" events, and encourage their employees to take the airline seriously, but the job more relaxed.

In a climate with a low level of these qualities, the press is stiff, formal, serious, and even gloomy. Jokes and laughter are frowned on as undignified and unbusinesslike. Relationships are stifled. Everyone feels uncomfortable and "caged in." People become fearful of "making a bad impression." Creativity becomes stifled and the creative person shuts down.

Idea Support is the manner in which new ideas get treated. If the press is positive and supportive, ideas are welcomed. Bosses and teammates listen with interest and constructive, positive comments. The ideas are shared with others and built on. Opportunities for trying out new ideas are created. People work together to help an idea work. People feel safe offering an idea or making suggestions. There is a real enthusiasm for ideas at every level of the company. Even if an idea doesn't "pan out," there is no fear of ridicule or rejection.

If idea support is lacking, every idea is met with a list of reasons it won't/can't be tried. The "no" response becomes almost automatic. Each idea is met with either faultfinding or obstacle raising. Any suggestion for fixing a problem is met with counterarguments. People begin to feel frustrated and undervalued. People adopt a defeatist attitude. Eventually employees quit making suggestions or offering new ideas. The general feeling becomes, "Why bother? They won't listen to me anyway."

Debates are a healthy and necessary part of psychological press. Creative people need encounters with new perspectives, exchanges of

viewpoints, and exposure to others' ideas and experiences. In a company with a strong debating press, everyone has a voice and the freedom to be heard. Everyone expects to contribute to the flow of ideas and to give constructive input. No one feels defensive. Every opinion is respected. There is a high level of psychological safety in disagreeing or presenting an opposing view. Individuals feel a keen level of ownership in agreed upon action plans.

An environment that restricts debate is usually an authoritarian one. Decisions are handed down arbitrarily. People are expected to accept them without questioning them. The attitude becomes, "Hey, he's the boss. It's not the way to do it best, but I don't make the decisions." Personal responsibility is lessened. There is usually a lot of "buck-passing."

Risk-Taking is the freedom to "leap into the great unknown." A tolerance of uncertainty and ambiguity will exist in a risk-taking atmosphere. Even if there is no guarantee of success, people feel they can try a new plan. They can "take a gamble" on some new idea and know they will be supported come what may. Employees and their bosses are willing to "go out on a limb" to try experimental projects. Failures are seen as learning opportunities.

In a low-risk press, people are hesitant to try anything new. They are afraid to fail. They set up committees to "study the situation." Everyone works hard to "cover their back" before making any new decision. Each level of the company will wait to see what they think "higher-up."

Conflicts are tensions. They may be personal tensions between individuals, interpersonal tensions such as competition for resources, or emotional tensions like anger or frustration. Conflicts are different than the "friendly tension" in a good debate. Conflicts affect a person's sense of

well-being and happiness. When conflict is high in an organization, the psychological press becomes extremely stressful. Individuals and groups dislike or even despise each other. The climate becomes like a war zone. There is a feeling of "gotcha" complete with plotting and other emotional traps. There will be increased "back-biting" and malicious rumors and gossip. All sense of teamwork is demolished. There tends to be an increase in requests for "sick time." Staff turnover is high and morale is low.

If there is a low level of conflict, people settle their problems in a low-key, nonaggressive, personal manner. People exercise control over their behavior. There is a sense that problems or disagreements can be worked out in a reasonable manner.

Who Establishes Climate?

How does creative press happen? You might have considerable influence over the nature of the press. You might not. If you have the responsibility, the authority, and the resources, you are probably in a position to have a positive press. Remove one or more and the likelihood of influencing the press is markedly diminished. So, who has the say-so? Where does it come from? Who decides this stuff anyway? The short answer is leadership. The long answer is that it depends on you, too.

Leadership establishes conditions that support or confound the climate conducive to creativity. If the climate in an organization supports creativity it supports productivity. In this instance, it's the employee's perception of management's values and actions that shape the climate. Those values and actions come from the top down. Leaders are typically well educated and well trained. Perhaps there is a perception on their part that the followers

There is the risk you cannot afford to take, and there is the risk you cannot afford not to take.—Peter F. Drucker

are less well educated, less competent, less able. Barriers go up. The environment results in limited performance on the part of the employees. The compounding element is the limited acceptance and participation in enhancing the climate conducive to creativity on the part of the middle management.

The leadership of an organization affects the "corporate culture." This applies whether the "corporation" is a family, school, institution, or traditional corporation. It applies to profit-making businesses, not-for-profit agencies, or government/ political organizations. The emotional culture around us has a profound effect on our creativity. The culture of our job is another part of psychological press.

Children raised in families in which the "leaders" (i.e., parent or parents) are supportive tend to be self-assured, productive, and creative. If the "leaders" are dictatorial and emotionally withholding of approval, the children tend to be rebellious and nonproductive. Positive use of creativity will be lessened.

Organizational cultures are difficult to change. It is usually a crisis that precipitates real change. Sometimes the change enhances the climate for productivity (read that as creativity), and sometimes the change is devastating as it rocks the foundation of the organization.

Using our family example, suppose there is a "hostile takeover" and divorce ensues. If the culture for the child had previously been positive and supportive, the child will continue to function. Conflicts will be kept low. Ideas will be generated and supported. A new, stronger, even more creative child might result from facing the challenge. In our reverse family, chaos would result, more conflict would ensue, and the result would be an even greater loss of creativity and happiness.

Creative people are people who don't want the world as it is today, but want to make another world.—Abraham Maslow

Here is the caveat. ***You affect the climate, too***. Leadership may establish the conditions for the organizational press, but you can react in positive, proactive ways, not as victims but creative individuals. Your internal social and psychological press can support a positive, nurturing press. Your decision to exhibit a positive internal press, or to accept a negative social and psychological press, will determine the outcome. (By the way, deciding not to decide is a decision, too.) Your willingness to participate, your enthusiasm and energy, keeping up with assignments—all affect how the climate operates. This can be extrapolated from the classroom into the workplace. Similarly, the absence of these will affect the press negatively.

You might try doing what I do—self-talk. When someone asks you, "How are you today?" and you are feeling less than grand, respond with some high-energy self-talk such as, "Perfect—just perfect!"

Internal Psychological Press

The internal press is about the "I wants" and the "feel goods" we need for happy and personal satisfaction. Internal press comes from our personal values, our core values, the area that says, "I believe in and support this." For our internal press to be job positive, we must possess the basic knowledge and skills to do the assigned tasks. You can't be a computer operator without training on computers.

I once worked as an on-call substitute teacher in a small community high school. On my application was a section for subjects I was qualified to teach and subjects I could not/would not want to teach. I marked the "no math" block

and listed reasons under "comments." I worked several years as a substitute, mainly in English courses. One day I got a call asking if I could commit to three days of substituting during the school's upcoming teacher conferences. Over eighty teachers required substitutes. On my first day I received my assignments: four straight higher-level math and calculus classes! I immediately advised the principal of my application and my disability. He was not at all concerned. "Just wing it," he said, "they know what to do. We just need a warm body to stand in." I entered that first class on that first day tense, nervous, awkward, and somewhat fearful. I explained to the class that I would be unable to answer any questions that they might have due to my limited math ability. One student later became frustrated with an assignment and asked for my help. Of course, I was useless. I felt stupid and it was clear this was the general consensus of my students. Finally the student asked, "Why are you here?" I agreed it was a good—although unanswerable—question. When the bell finally rang, I escaped more eagerly than any departing student did. I was glad I had a full thirty minutes before my next group. I made my way to the teachers' lounge in time to hear a fellow substitute wailing "Shakespeare! What do I know about Shakespeare? I'm an engineer!" We quickly agreed to just quietly change job assignments. Both of us headed off to work with a great sense of relief. We both had very good teaching skills. We both had content knowledge. We both were assigned jobs that did not look at our skills. Had we not exchanged assignments, we would have received poor performance reviews. We would have doubted our abilities. Eventually we would have quit the job. Sometimes poor internal press is just as simple as being in the wrong job for your skills.

You can't cross a chasm in two small leaps.—Mike Fox

Bad Hair Day!

Organizational culture, like the culture in the school example, has the attitude that "we just need a warm body in there."

We bring many other internal issues with us. This is our personal internal environment. Are we mentally healthy? What external pressures are affecting us? A person who is having financial problems, family worries, or health problems will be less able to view the corporate culture as positive unless the company has a supportive press. If we suffer from sleep deprivation, pain, hunger, boredom, depression or similar negative influences we will not be as creative as if we alert, enthusiastic, and excited.

How do we choose to view life overall? What kind of self-image do we have? If a person has a generally negative nature, that pessimism will affect the external press around him. A more positive person will have a "can-do" attitude. There are no problems, only challenges.

It's important to remember this in problem solving sessions: when someone suggests an idea and everybody else laughs—look for a hidden benefit or for the logic in the idea. — Roni Horowitz

We all bring our unique life experiences, our personal "databases" to our job. One of the authors is a Vietnam vet. His wife and co-author is a former hippie. Obviously, we view situations differently. This different attitude colors how we interpret any given situation.

All of us have compensating mechanisms that help us function in life: patience, communication skills, special knowledge, problem solving, etc. All of us do something that will compensate for our personal limitations.

A good leader must not only recognize his or her own internal press but recognize and acknowledge the internal press each individual brings to the corporate culture.

Sometimes A Really Bad Press Feel Like This

© xpixel/Shutterstock.com

Corporate Culture and Climate

Have you ever lived in some region of your country where you liked everything about it except the climate? Maybe it had resources you loved, people you enjoyed, or activities that you really liked but it was just too darn hot or way too cold. After a time, the positive things you experienced there were

overcome by your sheer dislike of the climate. You couldn't take it anymore and you moved.

The world of business is much like the world at large. Many of us have found ourselves in jobs that just weren't right. We may have had the talents necessary. We may have enjoyed our duties. We had no complaints with our salaries. We just couldn't take the climate.

Climate is the observable artifact of culture within an organization. It is the observable behaviors, attitudes, and feelings of the individuals/ employees that, over time, reflect the organizational culture. This culture is established by leadership, reward systems, promotions, organizational values, beliefs, assumptions, and norms of the organization. It is the operational attitude of the organization rather than any stated or assumed official philosophy of the management.

For instance, one of the authors once worked for a department store chain. The *official philosophy* was one that encouraged innovation and participation of all employees, which led by example, encouraged creativity, and used mistakes as opportunities to learn. This official philosophy was posted in every manager's office. The *organizational culture* was quite different. The operational attitude was based on fear of failure, intimidation, harassment, and domination. The owners set goals without engaging store managers in the goal-setting process. If goals were not met, the owners called the store managers for a general "dressing down." These were usually quite public and involved threats and humiliation. The store managers then retaliated by yelling at the department managers, who, in turn, threatened and humiliated their respective staffs. The author liked her co-workers, enjoyed her customers, admired the products produced, and excelled in her duties. She could not, however, handle the corporate culture and left. You probably have examples in your own work history.

Culture is slow to change. Bringing in a new person, new idea, or new resource will not change the culture in and of itself. Typically, the culture has been developing slowly over time. When a problem with organizational climate is finally recognized, most organizations hire an "expert" who will "fix" it. Substantive change takes time. Climate can more easily change than culture but it will not maintain the change. Any change tends to be localized and varied. It is subject to the influence of local leadership. Does the leadership want change? If a "change leader" is a positive force, the local climate will be positive. If the leader is dissatisfied and a troublemaker, the local climate will be destroyed.

Culture exerts a strong influence on climate, and, subsequently, climate exerts an influence on creativity, job satisfaction, absenteeism, productivity, and, ultimately, profit. The connection is direct, immediate, and certain. A business that has a culture of negativity will lose the competitive edge it may have held. Its employees will lose the incentive to work toward the goals of the organization. They will lose focus. Eventually, they will decide to move to a climate that suits them better.

The reason people leave an organization is not for better pay. The top reasons are a poor work environment, feelings that their contributions are not valued, or not getting the resources or support for the job. Press, press, press. Not better pay.

Leadership Determines Climate

Leadership determines the climate. The climate determines the culture. The leadership determines the culture. The culture determines the climate. *It is an intertwined concept.* It is not easy to say which comes first. It is rather like trying to answer that old question, "Which came first, the chicken or the egg?"

Most organizational leaders deny their genuine influence on outcomes that are less than satisfactory.

The Effects of a Negative Press

I loved the hustle and bustle of working in the city and the fast-paced tone it set. Lines of customers formed out the door, from screaming babies to impatient businessmen. To me, and my co-workers, it was all the more reason to joke around. We knew that a shared laugh was all we needed to get us through those hectic nine-to-fives. We also received pay raises every three months and had direct involvement in creating weekly schedules favorable to our needs. Working at that fast-food restaurant was the best money I ever made, but the worst job I ever had.

A few months on the job I realized increasingly there was a common factor about work I didn't like— Abbey, the manager. Belittling us in front of customers, never letting us feel adequate, and on constant demand of unrealistic expectations started to take its toll. I rarely wanted to go to work and others felt the same as one by one my co-workers dropped like flies or constantly called in sick. We started letting long lines and arrogant customers trouble us, and soon joking around was out of the question.

One morning I made a silly mistake and for Abbey, it was the end of the world. She ranted and raved at me, embarrassing us workers and even the customer who I gave the wrong drink to. Afraid to screw up in her presence, our trust for her was lost. Other instances, she put her load of work on us, and if the store closed at seven, we didn't get out until nine.

My only emotional involvement with that job was guilt. No longer wanting to walk away from every shift feeling sorry for myself or others, I quit. If I learned anything in those eight months it was that some things just aren't worth my time, not even for a descent paycheck and great hours.

—Melanie (Student minoring in Creative Studies, BSC)

If goals are met, it is because they are brilliant leaders. If goals are not met, it is because you are a less than brilliant follower. A word to organizational leaders (and future leaders): If your organization is successful, it is because of you. If your organization is less than successful, it is because of you. Wishing it were otherwise will not make it so.

In The Organizational Culture of Idea-Management: A Creative Climate for the Management of Ideas, Ekvall (1991) expressed the ideas he had based on a long-term study of organizational culture in over fifty organizations in several areas of specialization.

He posited that a creative and nurturing culture would have a system for how ideas were to be treated and managed within an organization. "The concept of idea-management is about finding and taking care of ideas for change in the organization's operations, concerning both product and processes." He focused on two main areas of concern: features that stimulated or hampered innovation, and special formal systems and procedures for idea finding and use.

He defined culture as the deep-rooted assumptions, beliefs, and values that were "taken for granted" within the organization. These are the preconscious attitudes.

Ekvall described climate as the behaviors, attitudes, and feelings that resulted from the organizational culture. These were the conscious attitudes—the ones we like to call "operational attitudes." A person coming into the climate from "outside" will soon be initiated into these behaviors, attitudes, and feelings whether the person came in with them or not.

He sees climate as the ultimate manifestation of culture (Ekvall, 1999). His research concentrated on both "soft" areas such as values, climate, and leadership style and "hard" areas referring to

organizational structure, strategies, and systems for innovation.

As Ekvall put it, ". . . organizational climate is an intervening variable which affects the results of the operations of the organization."

In his research, he found that the way the prevailing culture affected the organizational climate was in its influences in the areas of communications, problem solving, decision making, motivation, and willingness or opportunities for learning.

Positive Press—The Good Boss

© Iren_Geo/Shutterstock.com

Negative Press—The Bad Boss

© Iren_Geo/Shutterstock.com

The culture of an organization and the resulting climate within the organization had a direct effect, whether positive or negative, on several different outcomes. Culture effects whether the products or services of the organization are of high or low quality, whether its employees rate their job satisfaction as high or low (which, of course, has a direct effect on employee retention or turnover), and, ultimately, whether the organization makes a profit or operates at a loss. If the organization relies on product development, one with a negative culture can expect no radical new product ideas. Any "new" products will be the result of small, "safe," improvements in existing product lines.

The human mind treats a new idea the same way the body treats a strange protein; it rejects it.—P. B. Medawar

Ekvall identified four classifications of organizational culture:

1. *Bureaucratic / Authoritarian*—Employees keep ideas to themselves. If ideas are shared, it is done through some form of autonomous system such as the standard "suggestion box." The ideas submitted reflect the fear of reprisal and/or the expectation of rejection. These suggestions are usually not so much ideas as they are negative comments/ jokes about the organization or they are some form of venting of frustrations with no anticipated action on the concern. In this type of culture it is common for the "us and them" mentality to exist where management and employees work in a negative conflict relationship.

2. *Bureaucratic / Humane*—Employee needs, feelings, concerns, and relationships with management are treated respectfully but in a formalized, administrative way. The flow of ideas is from the top down. The "chain of command" is absolute.

3. *Entrepreneurial*—This is usually the early phase of development in an organization. It is characterized by leadership from a "pushing, idea-rich and dominating person," usually the organizational founder.

4. *Relations and Cooperation*—This culture relies upon teamwork and networking among all branches of management and employees. It is idea stimulating, innovative, and diverse. It reaches across all levels, all departments, and all areas of expertise in the organization. It is sometimes referred to as a "greenhouse culture" where creativity and innovation result when different people and their differing thoughts and experiences

meet for healthy conflicts/debates on product or process ideas and concepts.

Culture and climate in an organization go hand in hand. Culture reflects the values, beliefs, history, and traditions that form the foundations of an organization. Climate reflects those recurring patterns that characterize life within the organization as perceived by each individual working there. Climate is not a static variable. Climate is dynamic and open to change. Corporate culture, "the way we do things around here," includes the visible elements of behavior, such as dress codes, office layout, and behaviors that include or exclude classes of employees. There is also deeper structure, consisting or values and beliefs that control the personal behavior of the workforce. The organizational structure and management's assumptions form the foundation of the company's culture in terms of values and standards of doing business. Management's actions have a direct influence on the work environment. Those that comply with the corporate culture are rewarded. And that which is rewarded will be repeated, until the behaviors within the system are unconscious. The outcome is the corporate culture.

A way to assess an organization's culture is to look at its operating policies. Who sets management policy? What sort of management controls are in place to see these policies get carried out? What are the most used forms of communications: memos, email, phones, meetings, face-to-face? Who controls communications from top to bottom? What are the reward systems? How is feedback given? How are changes made? What is the workload like? What kinds of supplies are available and who controls them? What is the general attitude held by supervisors towards subordinates? How do the workers regard their bosses?

Of course, how an individual views these issues is influenced by internal press.

George Burns, the comedian, was fond of telling the story of how he got into show business. He tried out in vaudeville and was told the job was his "for five dollars a week." He hesitated a moment then replied, "I don't know how I will pay you the five dollars, but I want the job and I'll take it." That's what we all want from a job—one we like so much we'd be willing to pay to work there.

Press According to VanGundy

Many factors go into the creative press. VanGundy (1984) divided press into four main areas: the external environment, people motivators, individual creativity, and interpersonal relationships.

External Environment

Under external environment, he looked at task-related actions. What must leadership do to make the company successful? He further divided the external environment into nine categories:

1. *Providing Freedom to Try New Ways of Performing Duties or Tasks.* Leaders should design the work press so employees are encouraged to experiment without fear of a "chewing out." Too many times and in too many companies, leaders fall into the old "this is the way we've always done it" mind set. Frequently, they listen but they do not "hear" their staff's suggestions for improving productivity. A leader should make sure the general atmosphere is one in which more emphasis is placed on the production goal rather than on the way it gets met. A good

leader should foster an environment in which reasonable and structured change is seen as desirable.

2. *Maintaining a Moderate Amount of Work Pressure.* This is a very delicate area for a leader. If there is too much pressure to reach the goal, too much emphasis on "500 widgets by Saturday, or else," then workers will become burned out. They will have little time or motivation to be creative. If a leader is always in a crisis state, then there is no time to develop a future for the company. A leader who hands the problem over to his/ her staff and stands back creates the perfect amount of work pressure. Just enough to create a sense of challenge. Although we think of work pressure as a negative thing, too little pressure can be a problem. If a company is too "laid back," employees might believe the bosses do not care or the task is not really important. They will not feel vested in their job. A reasonable amount of pressure and "deadlines" provides excitement and anticipation.

3. *Providing Challenging, Yet Realistic, Work Goals.* When I was in grade school, I had a teacher who assigned weekly vocabulary lists of twenty words. We had to look up and write the definitions of each new word. Next, we had to use each one in a sentence. Finally, we had a "spelling bee" that combined all elements: say the word, spell the word, give a definition, and use it correctly in a sentence. It was a real challenge and we found creative ways to study. We knew the goal was achievable because we had concrete steps to follow. The teacher was a smart leader. She made sure we would feel challenged, we would

work together on a common project, and
that we knew what the goal was and when
we had achieved it. The same holds true
for the workplace. Every member of the
group should know what the goal is and
what they need to do to meet it. The goal
must be realistic and achievable. Had that
teacher given us fifty words a week, the task
would have seemed so daunting we could
have never gotten started. Had she given
us only ten words, we would not have been
challenged and would have quickly become
bored.

4. *Emphasizing a Low Level of Supervision in
 Performance Tasks.* Most competent, trained
 employees resent too much supervision. It is
 hard to use all your creativity if you feel you
 are being watched, judged, or mistrusted.
 The leader who wants to create a positive
 press will use his/her supervisory efforts
 in guiding the tasks along. If the duties
 are being performed, there is no need for
 leadership to interfere. Supervision is
 most helpful in responding to problems
 in performance and finding support for
 increasing employee creativity. A good leader
 manages up, not down. A creativity teacher
 (and co-author Mike Fox) is fond of saying,
 "I like to grow colleagues." Leaders should
 provide the kind of supervision that will
 someday enable the individuals to become
 company leaders.

5. *Delegating Responsibilities.* Too many
 workers and managers allow themselves
 to get "bogged down" in the tiny details of
 their jobs. They, especially managers, forget
 that others in the firm have skills and
 talents, too. They fail to share the power
 and responsibilities. There is a character in

Shakespeare's "Mid-Summer's Night Dream" that well illustrates this point. "Bottoms" is an actor in a theater company. The director is assigning the roles to the cast. Each time another actor is given a part, Bottoms says "Oh! Let me do that one too! I can do both of them!" He ends up insisting on playing every single part although the play was written for several players. Many managers also forget they only need one role. View your job as director of the play and delegate those roles. You may, like Bottoms, feel you could do a better job yourself. Sadly, you are both mistaken.

6. *Encouraging Participation in Decision Making and Goal Setting.* One of the most important sentences a leader can utter is, "I would really like your ideas." Knowing that their opinions and suggestions are valued can provide workers with the self-confidence they need to open up and use their creativity. When workers are allowed to participate with management in decisions and setting goals or production quotas, they feel ownership and responsibility to follow through with them. This only works if the leadership has a sincere interest in the workers' opinions. We all have experience with leaders who made a gesture of asking for our advice and then never acknowledged or used it. If you include workers on goal-setting teams, you empower them with a feeling of importance. This feeling of importance leads to an increased desire to improve performance.

7. *Encouraging Use of the Creative Problem-Solving Process to Develop Problem Solutions.* Creative problem solving encourages the development of

many different types of solutions. The more solutions presented the greater the likelihood of solving the problem. One needs to avoid always being "rational" and "logical." Frequently these words are used in a negative way to kill ideas. "That was cute, Phil, but now it's time to be logical." Both words convey the impression that there is one, and only one, correct solution to any given problem. Creative problem-solving techniques are the greatest tools a leader has. A leader who uses these tools and encourages their use by his employees has a real edge in a competitive world.

8. *Providing Immediate and Timely Feedback on Task Performance.* A leader needs to let his/her workers know of needs, actions, and situations arising that may lead to problems. It is no use telling someone after the fact what should have been done. Also, if a job is going well and is on or ahead of schedule, feedback is equally important. A special education teacher I once worked with was an inspiration in this. She used to say, "Catch them doing good." She believed you needed to give praise at least six times to every negative comment. If workers only hear "you should have done . . .," job satisfaction and morale will soon sink and employee retention will suffer. Timely feedback will encourage, not discourage, a creative worker. Make it soon and make it positive. Mike Fox, one of your authors, uses this technique. When he must correct an academic or behavioral situation, he always starts the conversation with "What I like about this is. . . ." He then lists all the positive points he can. He then says, "How might we change this . . .?" That way he

Teamwork is an individual skill.—Mike Fox

makes himself part of the solution rather than a "pointer of blame."

9. *Providing the Resources and Support Needed to Get the Job Done.* A group faced with the need to problem-solve needs more than just creativity. The group will also need time to use their creative problem-solving skills, money to implement product development, supplies, information, and people resources. They will need access and input from technical advisers and from the decision-makers within the company. A group can use its creative skills to overcome a perceived shortage of resources only if it diverts this creative activity from the task it is trying to achieve. Creative press cannot be sustained for any period of time unless there is a minimum of actual resources provided to the group. This would seem logical and yet it is a growing concern among workers in a wide range of fields. Teachers are an excellent example. Frequently they have few, if any, basic supplies. Many times there are not enough textbooks for the numbers of students, maps are years out of date, and access to support staff is out of the question. When workers are required to furnish basic supplies or continue working without them, stress and resentment build and the corporate press quickly turns from a positive force to a negative one. The team becomes subversive.

Internal Environment

Just as important as the external environment is the internal one. What motivates creative people? What is necessary in the corporate climate to develop creative people?

1. *Encouraging Open Expression of Ideas*. This must come from the top down. Management at all levels must set an example for the rest of the organization. If top management is concerned only with the "bottom line," i.e., "we must produce a thousand widgets every Friday," they will not be open to new ways of thinking.

 They will fear failure if they deviate from the tried and true. Oddly, they will resist change even if the current way of business is clearly not working. They will shoot down advice and ideas from mid-level managers. In turn, mid-level management will acquire this fear of failure and reject ideas from their staffs. Eventually no one will feel comfortable making any suggestions that might "rock the boat."

 There is a story that illustrates this well. An employee of a company that made garden implements asked for a meeting with his boss to show him a new wheelbarrow design. On the surface, it was a terrible design. The wheel was in the wrong place. The handle was small. The hopper was deep. The boss was sorely tempted to point out all the terrible flaws in the design. Instead, the boss remained open and positive. "Well," he said smilingly, "It looks like it will hold a lot. The design is simple. That might keep the manufacturing costs down. If we held the patent on this design we might be in a favorable position in the market." He then asked, "How might we pretest this design?" We're locked into our budget right now. How might we find the money to build a prototype?"

He then asked the employee what made him think of such a radical departure from the regular wheelbarrow design. The employee explained that he had been observing construction crews on a high-rise skyscraper project. The crew had been trying to carry nuts, bolts, and hand tools along the steel I-beams at the top of the building. Going around a corner, the wheelbarrow's center of gravity was no longer over the beam. An unbalanced load could lead to an interesting moment! He watched the construction crew abandon the wheelbarrow and resort to carrying smaller amounts of supplies in buckets. But with this new design, the center of gravity would be directly in front of the operator, not over space! After testing a prototype, the capacity turned out to be smaller than that of a conventional wheelbarrow, but it worked. His new wheelbarrow design opened a new, untapped market for the company's products. Incidentally, the more common, everyday application we see is the garbage tote.

Because this company had a positive press, a successful new product entered the market. Had the usual atmosphere of idea-killing been in place, the employee, upon hearing all the things wrong with the idea, would probably have tossed the idea out. He would have feared rejection and ridicule.

Any other ideas he came up with he would second-guess or toss out without even presenting them. Had the original idea proved to be unworkable, the fact that the boss found something positive about it would have encouraged the employee to

Man has been endowed with reason, with the power to create, so that he can add to what he's been given. —Anton Chekov

continue presenting new ideas. Management must set the tone.

2. *Accepting Divergent Ideas and Points of View.* One problem in the corporate press comes when there is too much uniformity or "sameness" in an organization. There is such a thing as being just too comfortable. A good example is the corporation of the classic "good old boys" network. All white. All male. All middle-aged. No diversity. There is more likely to be a higher level of creativity when there is less conformity. It takes a greater diversity of ages, sexes, cultures, and races to produce unique perspectives. If everyone has the same base of knowledge and experience, it is very limiting. A company that understands, respects, and values the differences among its employees is far more likely to receive and use original ideas. A different point of view can, and does, lead to a higher level of creative output. Bringing in people from different fields, as is done at the Hallmark Innovation Center, helps generate unique solutions to problems. The computer programmer will have a different view from the person in marketing or the project engineer.

3. *Providing Assistance in Developing Ideas.* All of us have experience coming up with great ideas. Those spontaneous flashes of genius over coffee and doughnuts. The great inspiration that pops in during brainstorm ing sessions. Each of us could come up with at least a handful of examples. What happens to these great ideas? Most of the time, nothing. Why is this? Why do so many of us think of a great invention like the safety pin or a great marketing ploy like the

"pet rock" yet do nothing with them? It may be lack of resources, lack of skills, or lack of motivation. It certainly isn't from lack of good ideas. Getting an idea and refining it involve entirely separate skills and abilities. A good leader knows this. If a leader is presented with a good idea, it is the leader's job to assist in its birth. If the person who came up with the idea is unable or unwilling to do anything constructive with it, other people can take over those responsibilities. Both Edison and da Vinci had huge numbers of "underlings" working on design and production of their inventions. They may have worked on them, too, but they knew it was impossible to turn out their ideas solo. When a person who presents an idea sees it actually being developed, they are likely to feel rewarded enough to continue to produce more ideas.

I once worked in a company that had an awkward and unworkable system for keeping track of products in its inventory. I devised a new system. My manager thought it was a great idea and told me to buy all the supplies, develop it (getting it up and running while continuing my regular duties), and submit a bill for my supply expenses. I had a great and workable idea. Management was willing to supply the money, but not the time or the support. As a problem-solver, I prefer generating ideas. I have less interest in the actual implementation. Three years later the awkward system was still in place. A manager who had a better understanding of both my talents and my limitations would have assigned my idea to other more

task-oriented individuals. I never put forth another idea for fear I would have to take responsibility for it.

4. *Encouraging Risk Taking and Buffering Resisting Forces.* Being creative in a group or organization frequently involves a certain amount of risk. Presenting an idea always means risking a little bit of ego. As Gerard Puccio says, "With every idea, a person comes attached." Creativity requires that risks must be taken. It is of vital importance that management supports risk taking. This includes providing support if the idea fails too. It is the job of a good leader to try to minimize any negative consequences to a creative person who "tosses the dice and loses." A person who feels his manager will support him is much more likely to exercise his creative talents.

A friend of mine works in a program for mentally challenged adults. One of her clients is over six feet tall, weighs over 200 pounds, and has a mental ability of approximately a two-year-old. He is prone to both seizures and temper tantrums. She found a potential job for him in a post office as a custodian. With permission of her supervisor, she proceeded to use on-the-job training. The client took to the job with few problems. The postal staff developed a good relationship with the new employee. Things went well for about a year. One day the client came to work irritable. My friend made the decision to keep him "on task." She felt she could coach him through his bad mood. Instead, he threw a tantrum. Screaming, kicking, and yelling, he picked up a garbage can and threw it.

Unfortunately, it hit another postal worker, injuring her slightly. My friend removed her client to a quiet area, got him calmed down, and returned to the program office. The top management wanted the client removed from the program and my friend to receive a formal reprimand for her "poor judgment." Instead, her immediate manager supported her and her decision and buffered the consequences. The manager persuaded upper management that it had been a good idea, a positive experience for the client, had developed a new job site for other clients, and had given them greater insight into what types of jobs might be suitable for similar clients. The supervisor also worked with the post office to sooth fears and to work out problems. The postal site not only accepted the handicapped employee back, with restrictions, but also continues to provide more job opportunities. By buffering the consequences of risk-taking, this management supervisor retained an excellent staff person and created increased opportunities for organizational growth.

5. *Providing Time for Individual Efforts.* Although the stimulation provided by other people in a group setting can benefit creativity, too much focus on group interactions can become negative. We all need some time we can call our own. We need "down time," thinking time. We need to let ideas incubate. When we have time to be alone, to contemplate and think about the problems we are trying to solve, we can bring new ideas back to the group effort. We also need personal time to refine our ideas

No amount of security is worth the suffering of a life lived chained to a routine that has killed your dreams.—Kent Nerburn

and the ideas others have given us. We need to have a time for personal review with no underlying concerns about how others may think about or react to our ideas. Too much group activity can make us lose focus on our individual strengths and abilities. We cannot lose sight of the fact that a team—a strong team—is composed of confident individuals.

6. *Providing Opportunities for Professional Growth and Development.* As most of use have experienced, the knowledge we received during our formal education is seldom enough to meet the demands of the "real" world. Only a few years need to pass before our education and our skills need an upgrade. A computer produced in 1982 may work just fine, but it will not handle our current needs. The training received in 1982 won't either. Both professionals and nonprofessionals need opportunities to acquire new education and work skills. Creative growth and development will not occur without it. We will not remain competitive if we do not stay abreast of the latest information available in our fields. Our work environment must allow for growth and development in every area of the company and on every level of employment. Unfortunately, many companies view further education and training opportunities as management "perks." They forget that it is even more important to educate and train the other employees.

For example, I once worked as a retail clerk in a deli. I was responsible for selling a large selection of imported cheeses. However, only managers were allowed to

attend food shows, sales presentations of new products, or to meet with vendors. I sold the cheese. I was the one to meet the customers and answer their questions. I was the one who needed the product knowledge most. Any education the other staff or I received was second hand—if at all. Had management been far-sighted, they would have included me in these educational opportunities.

It is important for the individual to attend classes, seminars, workshops, and other forms of continuing education. This will only happen if management provides time, money, resource and encouragement to the employees. Leaders should provide an example by showing that they value continued training by scheduling growth opportunities. Even if it is only an hour a day devoted to reading trade magazines, it shows dedication to new ideas and a desire for keeping current in new developments.

As an executive I required all of my employees to read the newspaper everyday on company time, volunteer four hours a month in some community service—with paid time off, and engage in some form of personal educational growth twice a year. I either paid for a class or seminar or allowed paid time off for it. I had a loyal and highly motivated work force in a strong and growing company. When I left, a new executive stopped all that "frivolity and expense." Within four years, the company was in serious trouble with high employee turnover and low productivity.

7. *Encouraging Interaction with Others outside the Group.* The strength of a

group is that the individuals within it are working on a common goal. The desire to achieve this goal is strengthened and intensified if they are all working toward it together. Unfortunately, it frequently happens that individuals within the group become overly competitive. Then group competition for leadership and power can become dysfunctional. Competition itself becomes the goal. Creativity requires a degree of competition that is best achieved by opening the group up occasionally. Good corporate press fosters cooperation and information sharing among groups and individuals. There needs to be planned opportunities for two or more groups to work together. Management may need to bring in individuals with special insights. It is far too common for departments in a company to be pitted against each other.

A friend of mine worked in a large grocery store with many different departments: fruits and vegetables, meats, cheeses, paper goods, "exotics," etc. Each department was always told how poorly they were doing and how well a different department was doing. Competition there was unhealthy. Everyone felt stressed and resentful. No one was willing to offer or share information.

Contrast that with the Hallmark Innovation Center where departments were not only encouraged, but also required, to work outside their knowledge area. Writers worked with craftspeople. Artists with marketing. Food service with engineering. They had a fun and creative staff. Competition was friendly and mutual. Each

department had a vested interest in seeing the other achieve goals. Hallmark cards and products are found worldwide.

8. *Promoting Constructive Intra-group and Intergroup Competition.* In some situations, groups develop a feeling of being the center of the universe, particularly if they have had some recognized successes. This may lead them to a false belief that they have all the answers, are invincible as Superman, and become an elite force. They begin to operate to exclude or resist any outside "interference" from others. When a company not only makes it necessary but also makes it possible for groups to have regular contact with nongroup members, this is lessened. Increased communications lead to the introduction of new ideas into the group thinking.

9. *Recognizing the Value of Worthy Ideas.* It is surprising how few managers recognize the importance of recognition. We need those pats on the back and the occasional "nice job!" from our supervisors and management leaders. The reinforcement of creativity by positive comments and frequent praise is a low-cost morale and productivity builder. This is frequently even more important than a more tangible reward like a bonus or pay raise.

10. *Exhibiting Confidence in the Workers.* This sounds so simple yet it is frequently overlooked in the workplace. You are more apt to hear about "those idiots in accounting" than "Wow! Am I lucky to have those folks in accounting." The more that management reinforces a belief in the creative abilities of its employees, the more the employees will believe they are creative and act

accordingly. There used to be a poster that said, "If a child is raised with criticism, she will learn to criticize." That is true of the workplace too. If an employee is treated with complaints, then that employee will learn to complain.

Himes—Seven Attributes for a Creative Climate

Gary Himes (1987) suggested that there were seven basic attributes that contributed to positive press. He maintained that creativity could not flourish in an organization that did not attain them. Many of his ideas are similar to those put forth by Ekvall and VanGundy. It is interesting to note that three researchers, working independently of each other and in completely different settings, could develop such striking similarities. Or rather, less interesting than revealing. The more press is studied objectively, the more the results show consistency. The creative individual can only flourish in supportive and creative press.

1. *Good Supervisor—Subordinate Relation ships that Can Nurture an Atmosphere of Mutual Respect for Each Other's Ideas.*
 How well do you and your boss get along? Do you respect him or her? Does your supervisor respect you as a person as well as for what you can do? Do you like each other? It is important that there be an ease of manner between the supervisor and the employee. Creativity cannot exist if there is a tyrannical or cold relationship in this important relationship. There should be a feeling of equality of personhood between allies.

2. *Open Communications that Will Enable Free Flow of Information Throughout the Organization.*

There must be a system in place to let people talk, share information and ideas, and deal with conflict. This communication must flow both ways: top to bottom and bottom to top. Just take the example of poor Moses. View him as middle management between the owner of the company (God) and the staff (the Israelites). Moses received orders from above and conveyed them to the staff. However, there was little or any staff communication back "upstairs."

Disorder and chaos broke out and led to rebellion among the staff. Middle management became frustrated with pressure from above and rebellion below and had a nervous breakdown. The company floundered and the goals (those Ten Commandments) have seldom been met.

3. *Active Support and Cooperation from Management. A Definite Procedure is Established for Fair and Consistent Consideration of Ideas Conceived by Subordinates.*

Ideas are respected and valued by every level of employee. There is a system, for example, the "suggestion box," that encourages employees to submit ideas. Ideas are recognized and respected as the property of the idea-generator. There is no "idea stealing" by management. Many of us have had the poor experience of offering an idea only to see it implemented and credit given to someone else, usually a supervisor.

4. *Attention to Highly Creative Personnel.*

The person who shows creative behavior should be given work that allows her to

have a break from daily operating pressures. A creative person cannot create on an assembly line.

5. *Time to Think.*

There should be a measure of slack time. This provides opportunities for staff to think and be creative in their work. Nobody should feel pressure to fill every moment with "busy work." Some of the best, most creative ideas happen when we are relaxed and just "playing around" with an idea or problem.

6. *Avoidance of Premature Criticism.*

A manager shall avoid meeting an idea with all the things wrong with it. Find something positive to say, no matter how simple. Remember the story about the wheelbarrow?

Although the manager thought the idea was flawed, he pointed to one positive point. Instead of criticizing, ask, "How might we use this?" "What problem were you trying to solve"? And "What might we try to make this better?"

7. *"Loose-Rein" Management Style.*

Management directs but does not seek to dictate or control the process of making things work. Management tolerates, encourages, and expects a certain degree of risk taking. Management trusts the skills, knowledge, and experiences of subordinate staff and gives them goals, not orders.

Perhaps the most important and least studied of these areas is the one of good supervisor–subordinate relationships. It is the most significant and immediate element for encouraging a creative press. A good relationship between the boss and the employee is vital to establishing an environment of environment of trust and open communications.

A Good Press Today? A fair Press Today?
A Really Bad Press?

© Andrii Symonenko/Shutterstock.com

Trust Is the Basic Element

In the workplace the basic element for a climate conducive to creativity and productivity is trust. Trust is a two-way street developed over time in a supervisor–employee relationship. Badawy (2003) provides some insight into the recognizable, repeat-able structure for trust: feedback, direction, tolerance for mistakes, risk taking, and balancing freedom with structure.

- *Continuous Feedback.* This is essential for encouraging employees to be creative and to continue to work for continued improvements in their tasks and problem-solving abilities. Lack of timely feedback leads to frustration on the part of the creative employee. It also projects the image that the supervisor is not

interested in the project or concerned with its accomplishment.

- *Provide Appropriate Direction.* A good supervisor does not need to pamper the employees. The supervisor must be tolerant of working styles but able to tell the difference between a creative person's impatience with a project not going well and petulance over failure.
- *Know-how to Handle Failure.* The successful supervisor must be able to give the employees a wide margin for trial and error. Without this safety net, there will be no motivation to experiment, create, and innovate. Fear of failure, based on only negative consequences, destroys real initiative and puts a lid on creativity. The fear of failure increases in larger, more bureaucratic organizations than in smaller, more experimental and adventurous settings.
- *Maintain an Intrapreneurial Climate.* Make sure there is a sense of excitement, of invention. A company that nurtures the creative spirit will always see results in creative products. Major companies such as IBM, Hewlett-Packard, AT&T, Microsoft, and Texas Instruments have adopted this strategy. They encourage and reward employees for new product and service ideas.
- *Balance the Need for Freedom and the Necessity for Structure.* Freedom is important for creativity and innovation. Structure is crucial for productive business. There is a big difference between an "open door" policy and total anarchy. Deadlines must be set, products shipped, business hours set. No one can operate in chaos. A balance that gives employees freedom to operate within known rules is important.

Closing Thoughts on Press

Press is a complex issue that addresses all comfort issues. It includes the physical comfort factors of safety and design. It also includes the external and internal environments or climates, atmosphere, social climate, and emotional climate. How safe and happy am I? There must be trust and openness between managers and workers. There must be recognition of style differences. Press is literally, the world we live in as fully functioning human beings. We must recognize our needs, the needs of the group, and the needs of the company or planet. Like Earth itself, there are many positive and negative influences that affect and effect its health. We must learn to recognize when the press where we work is unhealthy. We must arm ourselves with both the knowledge and the desire to "cure it." Continued creative research into what is working, why it is working, and how it came to be positive to begin with, is of overwhelming importance. The authors find the issue of press as the most urgent of the "four Ps."

Chapter 5

The Creative Product

What is a creative product? How can it be distinguished from the thousands of products out there? How do we evaluate a product for creativity?

Product is the least studied, researched, and written about of the "four Ps"—person, process, product, and press.

Every form of thought and action produces a product or outcome. Countless poems, paintings, musical compositions, etc. are being produced yearly. Scientific "breakthroughs" are so common we almost yawn through them. Everyday we learn of technological marvels. Product, product everywhere. We know that not all products are equally creative and some may not be creative at all.

Many people refer to this area of study as *Innovation* rather than *Creativity*, because the focus is on the outcome of creative thinking. Examination of the creative product generally focuses on the characteristics of the outcomes of ideas. Creative products are not limited to the arts, sciences, or marketplace. They can be the results of a group effort or the work of an individual.

We can attempt to balance the two concepts of creativity and innovation. They are supportive and complementary to each other. Think of them as partners.

Creativity	Innovation
Imagination	Implementation
Process	Product
Generating	Developing
Novelty	Usefulness
"Soft" (promotion)	"Hard" (packaging)

Creative products can be both tangible, like an invention or a "touchable" marketable item, and intangible, like the development of a new service, a social technology, learning, or the design of a new process.

Although creative products can come about by accident, like the discovery of "vulcanizing" rubber, it usually involves the generation of multiple ideas. A study by Dun and Bradstreet was conducted on fifty-one American companies. They showed that it takes over fifty ideas (after screening, business analysis, development, testing, and marketing) to produce one successful new product. This is referred to as the "Decay Curve" of new product ideas. There is a growing trend in many product-oriented organizations to reduce this decay curve. Concept and design departments are trying to shorten the amount of time it takes to come up with one successful new product. They are trying to push more ideas through the entire process so that the number of successful products will increase.

This shift of emphasis has led to some interesting implications. Decreasing time for idea generation and increasing the number of ideas being pushed through quickly appear to be reducing the occurrence of highly novel and creative products. This trend seems to be promoting useful and stylistically modified products. The packaging is new and shiny, but the product is only slightly

changed. More companies are promoting "new and improved" versions of an existing product line. The end result of this trend is that we are able to see more and more dependence on modifications and improvements in existing product lines. Inventors and companies can use Besemer's *Creative Product Semantic Scale* to examine these products as well as to examine customer demands for the "new" product. This might aid in targeting the kind of new development they desire to meet market needs.

Of course, modification deemphasizes the importance of novelty and originality. We don't find ourselves asking "Is it creative?" but rather, "How is it creative"?

Evaluating the Creative Product

We will present four different approaches to evaluating the creative product or creative outcomes. According to your authors, everything is creative. It is just a question of the perceived amount, level, or degree of creativity of the product. According to MacKinnon, a product must meet at least three criteria to be considered creative, and then there are two more criteria that move us over the threshold to the, "Oh wow! That's really creative!" response. Besemer and O'Quin developed a semantic scale for evaluating a product in a deliberate way. Ostensibly, the degree or amount of creativity can be established as a total numerical value. Amabile and Hennessey posit that experts in the relevant domain have the knowledge and skill set for consensually determining the relative level of creativity of an outcome. You will have to make up your own mind as to which position has the most value for you in any given situation.

These Watermelons are Real

Fox—All Products Are Creative

According to your authors, the act of bringing something into existence is sufficient for a product to be creative. At that point the only question that remains is the degree of creativity. The strength of this assumption is that it removes the *threshold* issue. The weakness is that it leaves the *degree* issue unresolved.

MacKinnon—Explicit Criteria for the Creative Product

Donald W. MacKinnon, (1978), a researcher in this area, established one of the first criteria sets for assessing the creative product. He established three *absolute criteria* for product evaluation:

A. *New*: The creative product must be original. There must be a sense of novelty about it.
B. *Useful*: The product must be adaptable to reality. It must serve to solve a problem, fit the needs of a problem situation, or accomplish some recognizable goal.

Making the simple complicated is commonplace; making the complicated simple, awesomely simple, that's creativity.—Charles Mingus

C. *Produced*: The product cannot remain just an idea; it must actually be produced. It must be communicated in some way.

In addition to MacKinnon's three main requirements for creative products, he included two *optional criteria*:

D. *Aesthetically Pleasing*: A product must be not only novel and useful but also pleasing to the senses. In some fashion, it must be true and beautiful and possess a simple elegance.

E. *Transformational*: The product must alter the human condition, transcending and transforming the generally accepted experience of humanity. It will defy tradition and radically change our view of the world. This criterion is seldom met. Products at this level of creativity could include Darwin's theory of evolution, Copernicus' theory that the earth evolved around the sun, the Wright brothers and the airplane, among others. Think of the global changes due to the technological advances in computer design.

Besemer—Creative Product Semantic Scale

Besemer and O'Quin focused their research on addressing the need for evaluation criteria for rating product quality. The outcome was the *Creative Product Semantic Scale*. This instrument has three major scales for the user to consider (Novelty, Resolution, Elaboration & Synthesis) when making an evaluation. Each major scale has a set of subscales to give precision to the language. Shown on next page are the essential contents of the semantic scale.

Creativity shatters the cycle of mediocrity.—Jaime Dellipizzi

Novelty: Under novelty, there are three areas that help to describe the degree of novelty or newness. Is it *original*? Is the product one in which some concept of "newness" is introduced? Is it *transformational*? Is it so new that it will actually change daily life for the majority of product users? (Think of the simple pocket calculator, the safety pin, the car, penicillin, etc.) Is it *germinal*? Will this product generate new or related ideas? Do competitors want to copy it? One could say that Kellogg's™ Corn Flakes cereal was—no pun intended—a germinal idea that led to many similar cereal products.

Resolution: Does the product "deliver"? Does it do what it said it would do? Does it work? The creative product must meet an expectation better than similar products. You can use a hammer for a bottle opener. It is effective at opening the bottle, but presents only a partial solution as to why you wanted the bottle open. A creative product must follow some rules of *logic*. It must be *useful* and have a clear, functional purpose. It must have *value*: commercial, psychological, or sentimental. It must fill a perceived need.

Style: What is the "attraction"? What is unique about the product that will make us notice and remember it? Does it have style? Is it *organic*? Do all the parts work well together? Does it have a sense of wholeness or completeness about it? Is it *well crafted*? Is it readily *understandable*? Did the producer provide a clear image of the purpose of the product? Does it stand out? Is it either *complex* or interesting? Does it have an *elegance* of form? There is a wonderful quote from Charlie Mingus, the jazz musician, that sums this up well, "Making a simple idea complicated is easy. Making the complicated simple, awesomely simple, that's creativity."

How do You Decide Which Key Ring is More Creative

© optimarc/Shutterstock.com

Using the Creative Product Semantic Scale in Results-Oriented Businesses

Research shows that the CPSS has helped businesses in testing for marketability, new product design, product improvement, and enhancement of advertisements (O'Quin & Besemer, 2006, p. 34).

Testing the CPSS in business does not necessarily mean that a highly rated product will be purchased by consumers:

Im and Workman (2004) found a negative impact of customer orientation on new product novelty—that is, enhancing customer orientation is less likely to help a firm create novel products, perhaps because current customers may not approve more radical newness, or may prefer products they are familiar with (p. 114–32).

That said, O'Quin and Besemer (2006) posit the following:

It is interesting to note that the concept of assessing, strengthening, and developing products remains novel after twenty years. Happily, because of ongoing efforts that kept the focus on the usefulness, validity, and reliability of the CPSS measure, it has been possible to improve the measuring instrument as a product itself (p. 43).

Using the Creative Product Semantic Scale

Besemer believes that theory is only useful if it actually helps evaluate a product. Consider each subscale separately, focusing on the description for each. Assign a numerical score for each subscale. The total score for the product is less important than the cognitive process involved. Consider this tool a deliberate process for making a considered evaluation. An adapted version of the Creative Product Semantic Scale is found at the end of this chapter.

Amabile—Consensual Assessment

Hennessey and Amabile (1999) have developed another way of assessing the creativity of a product. They call their method *Consensual Assessment* or

the *Consensual Assessment Technique* (CAT). This technique is used for the assessment of creativity and other aspects of products by relying on the independent *subjective judgments* of individuals familiar with the domain in which the products are made.

While Besemer and O'Quin stress the value of objectivity in product creativity assessment, Amabile and Hennessey advance the opposite position, the value of subjectivity in assessing creativity. They maintain that evaluation judgments can ultimately only be subjective. It will, and they argue, must be based on the judges' own inner notion of what is creative.

The *Consensual Assessment Technique* is based on two very important assumptions. The first assumption is that it is possible to obtain reliable judgments of product creativity given an appropriate group of judges. The second assumption is that there are degrees of creativity and that judges and observers can say, at an acceptable level of agreement, that some products are more or less creative than others.

Amabile developed five basic steps for the procedural requirements for consensual assessment of creativity in a developed product:

1. Judges must be experienced and knowledgeable in the product field. The more specialized the field, the narrower is the range of potential experts.
2. Judges must make their assessments independently. They must not be trained in the technique used. They must not be given specific criteria with which to judge. They must not be allowed to confer before judging. If you are a fan of the Olympics, you will have seen this part of the CAT in

use. Judges observe the athletes, judge them based on their own values, and score them independently.

3. Judges rate the products relative to one another. For instance, in assessing the relative creativity of a painting, a professional artist's work would be compared only against the products of other professional artists. Products by beginning artists or children would be judged only against similar products. This reduces the issue of creativity being confused with the issue of skill level.

4. Each judge views the products in random order. No judge knows the order of products the other members may have judged already. This reduces the chance that a judge may be influenced by how another observer rated the product.

5. Each judge evaluates the product on other dimensions in addition to creativity. These other judged areas might include technical skills and aspects, visual or emotional appeal, "likeability" or marketability.

After all the judgments are in, the ratings are analyzed, assessed, and correlated to produce an average across all the ratings.

Hennessey and Amabile (1999) urge other researchers to use caution in using the Consensual Assessment Technique. Although their research has shown it to be a useful assessment tool across disciplines and across age/skill levels, they note, "CAT has only proven useful in identifying differences between the creative performances of individuals in a particular domain at particular points in time" (p. 358).

The advantages of using a subjective assessment tool such as the CAT is that it has a

broad application, is theory driven, and is adaptable to a wide variety of research situations.

The disadvantages are that it is impractical to use if the product has any time restraints. Pulling together a panel of judges who have expertise in the product domain is very time consuming. It is also difficult to use the CAT if the product to be evaluated is at the frontiers of a particular domain. It may be a revolutionary development, theory, or product that, because of a lack of agreement among experts in the field, precludes reaching a consensus. Imagine having to judge the creativity of Charles Darwin's theory of evolution if you were a contemporary scientist, with church-regulated and Christian doctrine–supporting views. Or, imagine believing firmly in the scientifically accepted belief in the sun's rotation around the earth and being asked to evaluate Copernican mathematics.

The Consensual Assessment Technique and the Creative Product Semantic Scale are both valuable tools that research has shown to produce consistent and reliable results. They appear to be diametrically opposed but actually can complement

© YummyBuum/Shutterstock.com

Consensual Assessment Technique

If we knew what it was we were doing, it would not be called research, would it? — Albert Einstein

one another. They are both good assessment methods. Neither is the only method and neither gives the final conclusion. Far more research needs to be done before we can lay to rest the question, "How do I know this product is creative"?

Details of Hennessey and Amabile's Research on the CAT

For those who want more details on the research on consensual assessment, we offer the following.

> ". . . But how are we to decide whether one product is more creative than another? It is appropriate for such creativity criteria to be laid out by the researcher? Or perhaps the creators themselves should have the final say? The Consensual Assessment Technique (CAT) for assessing creativity is based on the assumption that a group of independent expert raters, persons who have not had the opportunity to confer with one another and who have not been trained by the researcher, are best able to make such judgments. Over 20 years of research have clearly established that product creativity can be reliably and validly assessed based upon the consensus of experts. Although creativity in a product may be difficult to characterize in terms of specific features, it is something that people can recognize and agree upon when they see it" (Hennessey & Amabile, 1999, p. 347).

In their research, they made the decision to deliberately bypass objectivity and instead shoot for a consensual agreement. They cite numerous examples of historical precedence starting with Galton in 1870. He compiled biographical dictionaries of famous influential people based solely on the number of times each individual was credited as influential by others in his field.

Simonton did the same thing in measuring the creative person. The higher the number of citations a person received in historical records, anthologies, and biographies, the higher Simonton measured that individual's creativity level. Treffinger, MacKinnon, and other serious researchers have used this person-based method of research.

If experts in a field (domain) of work can reliably pick out the creative people in their own lines of expertise, it can be argued that the theory would hold up when applied to products as well.

Most previous research had been geared toward developing an objective methodology, such as the Creative Product Semantic Scale, and then training groups and individuals to use them. Amabile and Hennessey are leery of this method. They worry that the researcher conducting the training might unconsciously influence the judgment of the evaluations. They maintain that a researcher might have an inherent bias that would influence the way in which judges would view creativity as a concept.

As Amabile states: ". . . rather than impose specific definitions of creativity or related dimensions, researchers would more closely approach consensual assessment by allowing judges to make their own, independent product assessment" (p. 349).

When Amabile began her research in the 1970s, her goal was to both formalize and systemize consensual assessment. In her early studies her initial goal was to examine the effects of social and environmental variables on creative performance. An interesting and unexpected result of this study was to show that both the expectation of a reward and the expectation of an evaluation for the product had almost equal undermining effects.

In the research model developed by Amabile and her colleagues, the following paradigm was followed:

Leadership is, in the end, the most creative of the arts, because its medium is human potential itself.—John Frederick

Participants in the product research experiments were divided into two basic groups. Only the products of the two groups were compared. The first group produced products while performing under one or more extrinsic (outside) constraints or boundaries. The second group had no "rules" governing their product. The results of each group were then assigned to a panel of judges deemed to be knowledgeable in the product area.

Existing techniques for consensual agreement were standard "personality assessment" methods designed more to discover creative process or to determine personal creative potential than for assessing a creative product. Amabile determined that the accepted assessment tools did not meet the needs of her research.

She focused on developing a technique that would use two complementary definitions of creativity: an underlying *conceptual* definition used in building a theoretical formulation of creative process and an *operational* definition that would be readily applicable to empirical research.

The *Consensual Assessment Technique* is grounded in an operational definition. As Amabile puts it, ". . . a product or response is creative to the extent that appropriate observers agree that it is creative." By "appropriate observers," she means persons who were familiar with the product domain and could be relied upon to possess personal or subjective criteria.

The *conceptual definition* she used maintains that a product is creative to the extent that it is both novel and appropriate and is also a useful response to an open-ended task.

Product Is the Bedrock of Creativity

The word "create" arises from the Latin word creare, meaning "to make or to produce." Creation

is tied hand to hand with production. The dilemma lies in subtle definitions and shadings of the term. We can all create, but is what we create, creative?

Although the criteria for evaluating creativity have been debated since 1950, when serious researchers first began the scientific inquiry into creativity, everyone agreed that some form of evaluation is necessary. As psychologist Carl Rogers (1961) put it:

> "In the first place . . . there must be something observable, some product of creation. Though my fantasies may be extremely novel, they cannot usefully be defined as creative unless they eventuate in some observable product—unless they are symbolized in words, or written in a poem, or translated into a work of art, or fashioned into an invention" (p. 349).

Mel Rhodes, the developer of the "4Ps" of person, process, press, and product, stated back in 1961 that any objective investigation into the nature of the creative process could proceed only by starting with the product and working back to the person, the process, and finally the environment or press.

MacKinnon conducted his research in the 1960s and 1970s. He was asked why so little research was being done in such an important area. He replied that it was his guess that few looked at the actual determinations of the qualities that identify creative products because we know or think we know a creative product when we see one.

MacKinnon posits that the study of the creative product should be the basis upon which all research on creativity is done. Product, under his theory, is the very foundation of creative research. Product is an area from which all research can build. In his view, creativity can be reduced to three fundamental principles:

The neat part about creativity's definition is that your own needs define it.—Casey Coon

- The creative process or processes are those that result in creative products.
- A creative person is one who brings into existence creative products.
- The creative situation (press) is that complex set of circumstances that permits, encourages, and makes possible creative products.

A View of Some of the Research in the Creative Product

Some researchers argue that creativity itself is too vague or too personal a subject for objective criteria to even be developed. Other researchers disagree with such a pessimistic stance. They argue criteria can, and must, be established and that it must be based on productive output. How can you measure the degree of creativity a person has except through a display of what they produce? Evaluate the creative potential of the product and you arrive at the creative potential of the person who produced it.

According to Briskman (1980), it is impossible to identify creative people or creative processes without first identifying what level of creativity their products display. His research has led him to the conclusion that the creative process cannot be explained, understood, or even described without some references to the creative outcome or product that results from it. He maintains that research should look to the "priority" of the product—that the creative process is a constant interaction between the creative person and the creative product as it is developed.

Besemer and O'Quin (1999) looked at the commonly held wisdom that novelty and usefulness defined creative products and found this view limiting. Where did "new and improved" fit within

Laughter is the gateway to curiosity. Curiosity and laughter were part of the gift you got when you joined the human race.—Mike Fox

this definition? How could the use of minor modifications be creative using this definition? They argue that a third component is needed for evaluation— "style." This adds elegance or aesthetic quality to the equation. Does the product, only marginally new, present something creative in the way it is made, presented, finished, or implemented? Tide™ was a new product, a powdered laundry detergent instead of bar soap. It was new and original as well as useful. New, improved Tide™ with Bleach is just a variation on the original idea. Besemer and O'Quin would argue that it is still a creative product by adding an increased level of usefulness—a more finished product. The modification has style and an element of elegance. It takes a more complicated process and makes it simple. Instead of two processes, there is only one.

Besemer and O'Quin have researched the various ways other researchers have attempted to evaluate the creative products. They have grouped these efforts into the following four main categories:

A. Peer and Teacher Nominations
B. Measures of Eminence
C. Self-Reported Creative Activities and Achievements
D. Global Judgments

Peer Nomination is a common measure of creativity. Think of the Academy Awards and the presentations of the coveted Oscars. Experts in the movie field (domain); actors, directors, producers, etc., vote on the best, most creative, performance or other artistic achievement. They are asked to compare actors with actors, technical people with technical people, and then to select the very best. In order to do this, we must presume that this knowledgeable peer group must be considering

the quality (and, in some cases, quantity) of that person's work.

Similarly, teachers are called upon to evaluate student performance. The teacher must set aside such intangibles as the intelligence or "likeability" of the student and focus on the product the student produces.

Of course, one can argue that peer and teacher evaluations lack objectivity in judging the product. Evaluations of work can be biased by subjective influences. It is difficult for a teacher or peer to put aside a certain natural bias based on the peer's or teacher's feelings about the person producing the work unless an objective evaluation tool is used.

The second indirect measurement approach is to study famous or eminent people. MacKinnon, in his 1962 study of forty eminent and creative mathematicians, architects, and others, pioneered evaluation by *Measures of Eminence*. He used peer nomination to identify them. He asked scores of architects to name the most creative architects in their field. Forty names occurred repeatedly. Dean Simonton continued this line of research in the 1970s. He researched several fields, from music through science, by analyzing published historical and biographical material. He measured, for example, the amount of space that reference books devoted to different composers. The more space devoted to the composer, the more it indirectly supported the level of creative product that composer had produced.

In 1994, Colin Martindale studied the creativity of artists by the prices paid for their work measured over time. After accounting for fluctuating prices of "recognized artists" (i.e., Picasso), he found the prices settled down to an average price schedule. The higher this average price, the higher was the level of displayed creativity in the product.

Like intelligence, curiosity is one of the things you never have to fix.—Mike Fox

Many researchers use "achievement lists" to assess creativity. Typically, respondents are asked to submit awards they have won, honors they have received, reviews of their work, or other tangible symbols of product success. The problem with *Self-Reported Creative Activities and Achievements* as an indirect indicator of creative product is that there is often no indication of the extent to which respondents are being truthful in their self-reports. You may have won first place in a writing contest but it does not mean much if you were the only writer.

There is some feeling within the field that it is not really necessary to define creativity in general, much less by *product*. If the purpose of identifying a creative product is just a step in identifying a creative person, then what steps or criteria you use to evaluate will not be as important as the identification itself.

A *Global Judgment*, as defined by Besemer and O'Quin, is one in which the judgment of the creativity of one or more products is made by a panel of expert judges. In education, this might be part of the process of selecting children for special programs or achievement awards. In cases like these, evaluations may be made based on the assessment of a portfolio of work. In other fields, such as science, evaluation may be based primarily on a single product. The Nobel Prize for a scientific achievement is a good example. These awards are most frequently based on a single area of research by an individual or team.

Business also uses global judgments, especially in areas of production. Several studies of senior managers have shown the screening process of new product ideas to be an informal process. Research has shown less than 2% of screening decisions use a formal checklist, questionnaire, or scoring model to evaluate project ideas.

When you get the fear of failure and the craving for success out of your system, 90% of life's stresses drop away.—Wilson Greatbatch

Amabile is one of the leading researchers into global assessments of creativity in products. Her technique of *Consensual Assessment* is simple. Participants in her research are asked to create something, such as a story, which is then presented to a panel of experts for rating. This technique operates on the assumption that, over the course of years, the experts have developed their own highly personal criteria by which they evaluate creative products within their areas of expertise. Amabile sees no particular advantage in specifying what will be judged or how it will be judged by the experts. Her research has shown that the judging reliabilities of the creative assessments have been consistently high enough that even if a single evaluation method was not applied; the judges had enough personal experience and discipline-related expertise to accurately evaluate the product.

There are two areas of concern with this method of indirectly assessing the creativity of a product. First, creativity scores can only be compared with a particular sample; no norms can be established for comparisons with products from other samples. Second, the subjectivity of the judging panel is an issue. Global judgment is influenced, and can be clouded, by the personal likes or dislikes the judge may have for the person or product being judged.

We must admit, however, that judgments of products made consensually by a panel of experts are more likely to be stable and valued measures of commercial success than are those made with regular divergent thinking creativity tests.

Amabile, Besemer, MacKinnon, and others have helped advance the field greatly. However, do indirect and global measures answer the critical questions: How do you recognize a creative product? Can the measures map out the traits, attributes, and other criteria by which product creativity can be uniformly measured? What are

With each idea a person comes attached.—Gerard Puccio

the characteristics and qualities of a truly creative product?

Some in the field would argue that no single standard for evaluation would reach across domain-specific areas. It can be argued that criteria that apply to art would not work successfully for science, commerce, or technological domains. Your authors do not agree. One may need to be more specific in a definition of, say, "valuable" or "useful." Of what "use" is a play, or a carving, or any other artwork? If one limits a definition to money, or utilitarian everyday use, the artwork might rate poorly. We do not "need" art for survival in the same way that we need air or water. We must consider revising the definitions. Value might mean psychological or emotional value. We need music, for example, to soothe, calm, or uplift us. Music has social and personal value. A painting or other artwork may have usefulness for religious purposes. Think of Salvadore Dali's "Crucifixion." Art may be useful for patriotic reasons. Who can deny the value of the Statue of Liberty in our country's consciousness? A song may have ritual value such as singing the "Star Spangled Banner" before a ball game. A photograph may have the value of effecting profound social change. Consider the famous photographs of Kent State and of the young Vietnamese girl running from napalm.

One can use empirical testing methods, such as Besemer's Creative Product Semantic Scale (CPSS), to accurately rate creativity even in fields like art that are considered to be subjective, ambiguous, and complex.

No matter what criteria and definitions are used, evaluation must be done in an objective and analytical way. When evaluation is hasty and negative, not only does a product get damaged, so does a person. As. Dr. Gerard Puccio so frequently says, "With every idea, a person comes attached."

Curiosity is genetic. When you joined the human race you got some.—Mike Fox

Quick evaluations tend to reduce truly innovative products. In a press of subjective evaluations—the usual idea slaughtering—most product ideas will be the reworkings of an already proven product. Most current evaluation is the result of applying a familiar, recognized, and accepted focused framework of technical expertise that rewards the current standards of the domain culture.

Research today is focusing on identifying the broader characteristics that creative products share, in varying proportions perhaps, but that are common to all. Evaluation must be thorough, but kind.

The elevator to success is out of order. You will have to take the stairs—one step at a time.—Unknown

Dictionary of Common Creativity Terms

This dictionary is adapted and abridged from a master's project done by Danielle Kimball, who graduated with her creative studies master's degree in 2002. The citations following each entry refer to the source of the information for each term. No reference section will be shown for this dictionary; one must go to the original project on file at the International Center for Studies in Creativity, Buffalo State College. The dictionary is offered here as a resource.

A

Ability: The quality or state of being able; especially physical, mental, or legal power to perform. (CBIR, 1999)

Acceptance-finding (A/F): One of six CPS stages (Isaksen and Treffinger, 1985, 1992), in which potential solutions are translated into a plan of action, so there will be the greatest possible chance that good ideas will become useful ideas. (Isaksen, Dorval, and Treffinger, D.J., 1994, Index)

Achievement Motivation: A person who may have significantly higher levels of need for achievement. An example would be an artist or a scientist. (Sternberg, 1999)

Action Steps: Used to generate specific actions to address key planning issues identified in Sources of Assistance and Resistance. (CAPS, 2000)

Adaptation and Creativity: "Depending on the situation, adaptation can hinder creativity or support it. In some cases, adaptation means tightly conforming to a confining environment that stifles creativity. In other cases, it means creatively adjusting to the subtle nuances of a changing environment." (Creativity Encyclopedia, 1999)

Adaptor: The general term used to indicate that a person prefers an adaptive creativity style. In discussions of creativity style, this is often further summarized by use of the letter "A" (compared with "I" or a person who prefers an innovative style). (Isaksen et al, 1994, Index)

Adaptive Options: Direct, supplementary, modification, and tangential. These are the four categories of Idea Generation proposed by Gryskiewicz (1987). (CAPS, 2000)

Adjective Checklist: A "personality inventory." (Amabile, 1996, Index)

Aesthetics: The science of the beautiful; the study of the mind and emotions in relation to a sense of beauty. (American Collegiate Dictionary, 1970)

Affect: Feelings of what a person may feel while solving a problem. Example: conflict, anxiety, and warmth. (Sternberg, 1999)

Affective: A way of describing the domain of human behavior that involves feelings or emotional responses, rather than the thinking (cognitive) or physical action (psychomotor) domains. (Isaksen et al, 1994, Index)

Affective Illness: Leads to a higher creative process. Example: divergent thinking abilities of free association fluidity of thought and breadth of attention. (Sternberg, 1999)

Affective Disorder: "Modern studies and older evidence support the popular notion of a connection between affective disorder and creativity. Evidence is strongest around a personal or family history of bipolar disorders. However the relationship is not simple, nor does it apply to everyone with a mood disorder (or everyone who is creative)." (Creativity Encyclopedia, 1999)

Affirmative Judgment (subterm found under Thinking)**:** A basic principle of Creative Problem Solving (CPS), particularly important in the critical or convergent phases of each stage; emphasizes the need to analyze alternatives thoroughly but constructively. (CBIR, 1999)

Age Factors: Age and creative abilities work simultaneously: The more experience in a field and one's age affect increasing creative results. (Sternberg, 1999)

Aging: "Two competing models about the relationship between creativity and aging exist. According to the Peak and Decline model, creativity increases in adulthood until the late 30's and then begins to decline." (Creativity Encyclopedia, 1999)

A-ha!: A term used informally to describe the moment when productive creative thinking produces a breakthrough solution or idea to solve a complex problem, challenge, or situation. The illumination of thought often follows a period of incubation. (Isaksen et al, 1994, Index)

Adaption-Innovation (A-I), Group Differences: It has been shown when groups of different nationalities share a broadly similar culture, their A-I mean scores show very little variation. (Isaksen, 1987, Index)

Adaptors and Innovators in Organizations: Organizations, which are large in size and budget, have a tendency to encourage adaption to minimize risk. (Isaksen, 1987, Index)

Affective States: Several studies have demonstrated that people show higher level of associative fluency when they are in a positive affective state. (Amabile, 1996, Index)

Alcohol and Creativity: "There has been a romanticized connection between alcohol and creativity. Alcoholic results predate history so it is not surprising that references to alcohol are threaded through notable art and literature. Alcohol has also been the subject of many creative artists." (Creativity Encyclopedia, 1999)

Algorithm: A set of rules or procedures for solving a certain kind or class of problem. (Isaksen, et al, 1994, Index)

Alone Time: Personality trait of creative people who are usually reserved, reflective, and internally preoccupied. (Davis, 1998, Index)

Alpha Biological Inventory: Taylor and Ellison (1966, 1967) combine personality characteristics and attainment approaches. (Sternberg, 1999)

Alpha EEG: Measures arousal on creative thinking (Sternberg, 1999). "Altered and Transitional States: Aspects of waking human consciousness is often referred to as altered and transitional states. All of these hypothetical constructs (e.g. 'creativity' and 'consciousness') are social artifacts, and are viewed differently from culture to culture." (Creativity Encyclopedia, 1999)

Amabile's Three-Part Model: Domain relevant skills, creativity-relevant skills, and task motivation; the combination of all three of these leads to creative productivity. (Davis, 1998, Index)

Ambiguity: A trait that is vital to the creative process and contributes to both the existence and role of promoting creativity. (Dacey, 1989, Index)

Analogical Thinking (subterm found under Thinking and Process): The cognitive process of relating some characteristics between two or more things, which may be unrelated. (CBIR, 1999)

Analogy: Comparing a single instance (idea or thing) to one or more other instances; often used in the context of CPS to refer to the activity of choosing a seemingly unrelated object or item to use as a basis for seeking new connections for a problem statement. (Isaksen, et al, 1994, Index)

Analysis of Analytical Thinking: Logical, systematic, evaluative thinking, with a particular emphasis on examining a whole by breaking it down into its components or parts. Particularly important and useful during convergent phases of the CPS process. (Isaksen et al, 1994, Index)

Analytical Generation: A category of tools used to generate options by breaking a problem, question, or issue into its basic elements or subparts and using these three parameters as a starting place to generate further options. (Isaksen et al, 1994, Index)

Antisocial Traits: Associated with visual artists and artist's creativity; reasoning: artists are more introverted. (Sternberg, 1999)

"Applied Imagination": Written by Alex F. Osborn, who is credited with developing CPS in 1953. (CAPS, 2000)

Archival Investigation: "Both the science and the art of interpreting primary documents in the description, reconstruction, and corroboration of a subject, which in this case is creativity in all its varied forms." (Creativity Encyclopedia, 1999)

Artificial Intelligence (AI) (subterm found under Intelligence)**:** Systems that exhibit the characteristics associated with intelligence, and describes important areas of AI research as expert systems, natural language processing, speech recognition, computer-assisted instruction, automatic programming, and decision support systems. (CBIR, 1999)

Artistic Computer Simulations: Computer programs that stimulate creativity. (Sternberg, 1999)

Assisters: In Acceptance -Finding, Assisters refers to possible sources of support in implementing your solutions (including helpful people, places, resources, times, or reasons). (Isaksen et al, 1994, Index)

Association (free): The unconscious can be made conscious through association of thoughts. (Dacey, 1989, Index)

Associationism: "The proposition that the mind consists entirely of ideas (words, images, formulas, etc.), each of which is associated with other ideas. Thinking, therefore, is simply a process of moving from one idea to another by way of a chain of associations." (Creativity Encyclopedia, 1999)

Associative Gradient: "The relative degree of conventionality versus unconventionality or novelty of associations in response to a problem." (Creativity Encyclopedia, 1999)

Associative Theory: ". . . An explanation of the creative process. Creative Thinking as the formation of "associative elements into new combinations which either meet specified requirements or are in some way useful" (Mednick, 1962, p. 221)." (Creativity Encyclopedia, 1999)

Attention: "Associational theories of creativity have suggested that broad and diffuse attention is associated with indices of creative potential." (Creativity Encyclopedia, 1999)

Attitudes: (Stein, 1974, Index) Position, disposition, or manner with regard to a person or thing. (American Collegiate Dictionary, 1970)

Attribute Listing: An analytic generation technique used in CPS to generate ideas by examining and altering the characteristics (or parts) of an object, problem, or product, leading to many opportunities for re-combinations. (Isaksen et al, 1994, Index)

Attribute Modifying: The thinker lists main attributes of the problem object or process and then thinks of ideas for improving each attribute. (Davis, 1998, Index)

Autonomy Traits, Scientists: Scientists are more achievement oriented and less affiliated. Scientists are also curious, intelligent, and sensitive. (Sternberg, 1999)

B

Barron-Welsch Art Scale: Evaluates attraction to complexity, asymmetry, and ambiguity. Consists of 80 abstract line drawings that test takers simply mark (+ or -) to which of the drawing they like or dislike. (Davis, 1998, Index)

Barriers: Obstacles that must be overcome in efforts by an individual or group to express and use creativity; often the same as blocks. (Isaksen et al, 1994, Index)

Barriers to Creativity: "Two interacting concepts that influence both general and highly specialized types of creativity are removing or minimizing barriers to creativity and fostering the growth of creative attitudes." (Creativity Encyclopedia, 1999)

Behavior: (1) The manner of conducting oneself, (2) the response of an individual, group, or species to its environment. (CBIR, 1999)

Behavioral Approaches to Creativity: "Focuses on the relationship between an individual behavior and events in and properties of the individual environment. This approach employs techniques such as reinforcement, prompting, modeling, and environmental manipulations to creativity." (Creativity Encyclopedia, 1999)

Belief about Creativity: Beliefs sometimes become self-fulfilling prophecies. Creativity is determined by motivation. (Sternberg, 1999)

Big C Creativity: Creativity when it is a breakthrough, which occurs only very occasionally. (Sternberg, 1999)

Bilingual Advantage: Language, as vehicle of culture, can therefore be expected to shape creativity. (Sternberg, 1999)

Birth Order: "The sequence by which children are born into a family. The most important birth order positions are eldest, middle, and youngest. As a rule, birth order differences in personality arise as a result of how children are raised (functioning birth order, or rearing order) rather than in sequence in which they are born." (Creativity Encyclopedia, 1999)

Bisociative Theory of Creativity: The deliberate connecting of two previously unrelated (thought matrixes) to produce a new insight of invention. (Amabile, 1996, Index)

Blocking, Memory: Can provide insights into the nature of creative thinking, interference, and inhibition of creativity. (Sternberg, 1999)

Blocks: Personal characteristics, process gaps, inhibiting settings or situations, emotional or social stresses, threats, or hindrances that interfere with the ability or willingness of a person or group to engage in productive thinking and problem solving.

(Sometimes grouped into self-image, value, perceptual, and strategic blocks.) Often used as a synonym for *barriers*. (Isaksen et al, 1994, Index)

Blocks to Creativity (subterm found under Blocks): Factors or situations that inhibit creativity (CBIR, 1999)

Brain and the Creative Act: "The pattern underlying the Creative Act is the perceiving of a situation or an idea in two self-consistent but habitually incompatible frames of reference. The event in which the two frames intersect, is made to vibrate simultaneously on two different wavelengths, as it were. The event is not merely linked to one associative context, but is bi-sociated with two." (Creativity Encyclopedia, 1999)

Brain Hemisphericity: Have or relating to the portions of the brain, typically "left brain" or "right brain." (CBIR, 1999)

Brainstorming (subterm found under Problem Solving, Process, and Techniques): A group technique for generating many options based on the divergent thinking guidelines of deferring judgment, striving for quantity, freewheeling, and building on others ideas. (CBIR, 1999)

Brainstorming Variations: A category of generation techniques designed to modify the basic structure of brainstorming to be responsive to situational variables; for example, modifying brainstorming for individual application using brainwriting (Isaksen et al, 1994, Index)

Brainwriting: An example of a brainstorming modification technique in which group members write down their own ideas first and then share them with others. (Isaksen et al, 1994, Index)

Breakthrough: A sudden, important idea or "connection" that offers a novel and appropriate solution to a complex problem, challenge, or situation. (Isaksen et al, 1994, Index)

Build: Making a deliberate effort to improve an idea by offering other ideas that are modifications of previously presented ideas. (Isaksen et al, 1994, Index)

C

CARTS: Cost, Acceptance, Resources, Time, and Space. (CAPS, 2000)

Center for Creative Learning, Inc: The mission of the Center for Creative Learning is to be a primary source of ideas and information that will inspire and foster creative learning. The center is located in Sarasota, Florida. (CAPS, 2000)

Change Formula: $C = fe(D,V1,V2,P)$. The Choice and Commitment to change is a function of Dissatisfaction with current reality, a Vision of the future, Values that will endure, and a Process for getting there, reflecting the empowerment to effort change. (CAPS, 2000)

Change Leadership: "Involves people in the organization who are actively taking initiative to provide support and encouragement for people to change." (Creativity Encyclopedia, 1999)

Chaos Theory: "More technically called nonlinear dynamical systems (NLDS), is an exciting, rapidly developing area of mathematical theory with increasing application in the physical, biological, and social sciences." (Creativity Encyclopedia, 1999)

Client: A person or people with immediate or direct responsibility or authority for action. (CAPS, 2000)

Climate: (1) The place or setting where creativity takes place. It is a subjective feeling or atmosphere encountered. (2) The attitudes, feelings, and behavior patterns that characterize life within an organization. (CAPS, 2000)

Cognitive Style: "Consistent individual differences in the ways people experience, perceive, organize, and process information." (Creativity Encyclopedia, 1999)

Combination and Reorganization: "A process by which existing concepts are restructured to create the new understandings needed to solve novel problems." (Creativity Encyclopedia, 1999)

Competition: "This occurs when several participants in a situation are interdependent, in that the movement of one toward a goal that all are seeking decreases the chances that the others will also reach it." (Creativity Encyclopedia, 1999)

Componential Models: "Attempts to specify the set of abilities, skills, traits, dispositions, and/or processes that are involved in creative behavior." (Creativity Encyclopedia, 1999)

Computer Programs: "Computer-enhanced creativity software can be categorized in five ways: (1) creative problem solving programs, (2) outlining and presentation programs, (3) thesaurus programs, (4) incubation programs, and (5) groupware programs." (Creativity Encyclopedia, 1999)

Conflict: The presence of personal and emotional tensions in the organization and it is the only dimension that does not contribute positively to creativity; less conflict is generally better than more. (CAPS, 2000)

Context of Creation: "Set of infrastructional, professional, and paradigmatic conditions that constraint creativity." (Creativity Encyclopedia, 1999)

Convergent (subterm found under Techniques)**:** Bringing possibilities together, or choosing from many alternatives, to strengthen, refine, or improve ideas, and to reach a conclusion, synthesis, or correct response. Often used casually as an equivalent to critical thinking. (CBIR, 1999)

Consensual Assessment Technique (CAT): Addresses a perceived weakness of a guided product. Assessed when they are applied to social psychology and the investigations of creativity. (Sternberg, 1999)

Consensus: "Generalization across actors; that is, the extent to which other actors behave similarly in a given situation." (Creativity Encyclopedia, 1999)

"Copycat" System: This system finds analogies between alphabetic letter strings. Created by Hofstadter and Farg, 1995. (Sternberg, 1999)

Corporate Culture: The business context within which individuals hold perceptions of their working climate, usually referring to the deeper values and traditions of the organization. Those within the culture do not usually perceive it. (CBIR, 1999)

CoRT (subterm found under Models): An educational thinking program developed by deBono. (CBIR, 1999)

Cortical Activation: Cortical activation and creativity are related because as task complexity increases, the optimal level of arousal decreases. (Sternberg, 1999)

Cognitive Theory (subterm found under Theory): Relating to the mind as the source of learning and behavior. Behaviorism and the new science of cognition. (CBIR, 1999)

Communication Tools (subterm found under Communications): Something used to allow the exchange of information. (CBIR, 1999)

Cognitive: Of, relating to, or involving cognition. Based on or capable of being reduced to empirical factual knowledge. (CBIR, 1999)

Combinational Explosion: "The outcome of an unlimited universe of combinations. With free rein, the number of possible combinations quickly becomes astronomical." (Creativity Encyclopedia, 1999)

Consensual Assessment: "A technique used for the assessment of creativity and other aspects of products, relying on the independent subjective judgments of individuals familiar with the domain in which products are made." (Creativity Encyclopedia, 1999)

Consistency of Creativity across Life Span: "Creative individuals are characterized by distinctive cognitive abilities and personality traits. Studies of adult development have shown that individual differences in both abilities and personality are stable, and that some mental abilities decline with age." (Creativity Encyclopedia, 1999)

Cooperation: "This occurs in such situations of interdependence, when the movement of one participant toward that common goal increases the chances that others will also reach it." (Creativity Encyclopedia, 1999)

Corporate Culture: "As a pattern of shared meanings (concepts, beliefs, and values) that evoke normative thought behavior from organizational actors." (Creativity Encyclopedia, 1999)

Correlation: "A quantitative measure of the degree to which two variables increase or decrease together, ranging from −1.0 (exactly opposite trends) to +1.0 (exactly similar trends)." (Creativity Encyclopedia, 1999)

Creation Myths: Modern conceptions of creativity may derive from culture creation myths. (Sternberg, 1999)

Creative Analysis (subterm found under Models)**:** A language approach to problem solving. (CBIR, 1999)

Creative Activities Checklist: A criterion for evaluating the predictive ability of problem-finding tasks. (Davis, 1998, Index)

Creative Behavior Inventory: Designed to study highly creative individuals and determining their common personality characteristics. (Sternberg, 1999)

Creative Dramatics: Stimulates thinking, imagination, and problem solving. Increases awareness and concentration, strengthen self-confidence, learning to discover, and fostering a sense of humor. (Davis, 1998)

Creative Ecosystem: "The entire system from which creative activity emerges, including three basic elements, the centrally involved creative person(s), the creative product, and the creative environment, as well as the functional relationships which connect them." (Creativity Encyclopedia, 1999)

Creative Education Foundation: Foundation that fosters creativity located in Buffalo, New York. (Davis, 1998)

Creative Environment: "The physical, social, and cultural environment in which creative activity occurs. Creative environments may involve nested environment, for example, a research laboratory nested within a research institute, nested within a university, nested within a particular state or union, nested within a particular time in history. A creative environment is one of three basic elements in a creative ecosystem." (Creativity Encyclopedia, 1999)

Creative License: "The strength and willingness to bend the rules, question assumptions, break with tradition, and act in a unconventional fashion in order to ensure originality." (Creativity Encyclopedia, 1999)

Creative Myths: Modern conceptions of creativity may derive from culture creation myths. (Sternberg, 1999, Index)

Creative Problem Solving Institute (CPSI): One-week creativity program held in Buffalo, New York, each June. (Davis, 1998)

Creative Products: A product that is different from mundane products. (Sternberg, 1999)

Creative Product Analysis Matrix: Offers a balanced approach to systematically looking at creative products. (Isaksen, 1987)

Crystallized Intelligence: "Intellectual skills that accumulate as a result of experience." (Creativity Encyclopedia, 1999)

CPS (subterm found under Models): Creative Problem Solving. A broadly applicable process containing various components and stages to provide a framework for generating and developing new and useful outcomes or actions for a broad range of situations. (CBIR, 1999)

CPS Model: The principles of Creative Problem Solving arranged, grouped, and presented in such a way as to represent or describe the specific six-stage process. (Isaksen et al, 1994, Index)

Creative Altruism: "The active, innovative expression of altruistic feeling and principle." (Creativity Encyclopedia, 1999)

Creative Attitudes: "Dispositions, temperaments, or orientations that influence one's way of feeling or acting in relation to creativity." (Creativity Encyclopedia, 1999)

Creative Achievement: "An estimate of creative productivity accomplished through the use of creativity activity checklists." (Creativity Encyclopedia, 1999)

Creative Problem Solving (CPS): A broadly applicable process containing various components and stages to provide a framework for generating and developing new and useful outcomes or actions for a broad range of situations (Opportunities, challenges, concerns, or problems). CPS can be used by individuals or groups to recognize and act on opportunities, respond to challenges, and overcome concerns. (Isaksen et al, 1994, Index)

Creative Problem Solving: Refers to the general efforts made by any individuals or groups to think creatively in order to solve a problem. Written as "creative problem solving," the lowercase letters are used to describe these "generic" efforts, as opposed to CPS (with uppercase letters), which describes a specific approach or model as just described. (Isaksen et al, 1994, Index)

Creative Product Semantic Scale: A measure developed by Besemer and O'Quin (1989) to represent operationally three dimensions for analyzing creative products and outcomes: novelty (original, germinal), resolution (useful, adequate, valuable), and elaboration and synthesis style. (Isaksen et al, 1994, Index)

Creative Strategic Actions: "Discrete strategic activities that are judged to be differentiated (novel) and legitimate (valuable) by stakeholders representing particular strategic domains." (Creativity Encyclopedia, 1999)

Creative Style: A person's preference for an adaptive or innovative approach to creativity, innovation, and change, based on Kirton's (1976) theory and related instruments and research. (Isaksen et al, 1994, Index)

Creative Thinking: The process of generating ideas, which frequently emphasizes fluency, flexibility, originality, and elaboration in thinking. Treffinger and Isaksen (1992) defined *creative thinking* as "Making and expressing meaningful nee connections; it is a process in which we perceive gaps, paradoxes, challenges, concerns, or opportunities; and then think of many possibilities; think and experience various ways, with different viewpoints; think of varied and unusual possibilities; and extend and elaborate alternatives." (Isaksen et al, 1994, Index)

Creativity (also found as a subterm under Assessment and Theory): A quality of human behavior that has many facets or dimensions and has been defined in a variety of ways. Definitions often emphasize one (or a combination) of factors such as process, personal characteristics or traits, environments, or products. In general or conversational use, creativity often refers to novel ideas that are useful. (CBIR, 1999)

Creativity Complex: "The notion that creativity is a syndrome and is multifaceted." (Creativity Encyclopedia, 1999)

Creativity in the Moral Domain: "Creativity for moral purpose." (Creativity Encyclopedia, 1999)

Creativity Paradox: "The simultaneous coexistence in creativity of psychological elements that seem logically to be mutually contradictory." (Creativity Encyclopedia, 1999)

***Creativity Research Journal*:** Began in 1988, journal that has a research focus. (Sternberg, 1999, Index)

Creatology (subterm found under Models)**:** A framework designed to provide a cross-disciplinary focus on creativity. Initially proposed by Magyari-Beck, Budapest, Hungary. (CBIR, 1999)

Creatology Matrix: "A frame of reference for ordering the main subtopics of the creativity question. The Creatology matrix can also serve both as the registration of the results of investigations into creativity and as a general project for further research." (Creativity Encyclopedia, 1999)

Criteria: Standards used to measure, judge, or evaluate ideas, solutions, or actions; criteria are factors used to screen, select, and support options. (Isaksen et al, 1994, Index)

Critical Thinking (subterm found under Thinking)**:** The process of analyzing, refining, developing, or selecting ideas, including categorizing, comparing and contrasting, examining arguments and assumptions, reaching and evaluating inferences and deductions, setting priorities, and making choices or decisions. (CBIR, 1999)

Cue Usage, Insight Problems: Subjects who "leap" from a problem and needed little information earned success to insight problems. (Sternberg, 1999)

Cultural Blocks: The application or effects of beliefs, morals, traditions, norms, or expectations within a culture in such a way as to interfere with creative problem solving. (Isakson et al, 1994, Index)

Culture: The context within which individuals hold perceptions of their working climate; usually referring to the deeper values and traditions of the organization. Those within the culture do not typically perceive it. (Isakson et al, 1994, Index)

Curiosity: To desire to learn or know about anything; inquisitiveness. (American Collegiate Dictionary, 1970)

D

Dacey's Peak Periods Theory: There are certain peak periods in life during which creative ability can be cultivated most effectively. (Dacey, 1989)

Dark Side of Creativity: "Creativity clearly has a dark side, but the problem lies not alone in the fields of endeavor where it is enlisted (art, science, technology, etc.) but within the creative impulse itself, its narcissistic temptations and our ways of responding to its urging." (Creativity Encyclopedia, 1999)

Data: Data include information, impressions, observations, feelings, and questions. (Isaksen et al, 1994, Index)

Data-Finding (D/F): The second of the six CPS stages in which the problem-solving group considers all possible data to help understand and define a task upon which they are working and then identifies the critical or essential data in order to focus and direct subsequent problem-solving stages. (Isakson et al, 1994, Index)

Daydreams: "Shifts of our thoughts away from concentration on an immediate task to a range of images that may include 'story-like' memories, wishful fantasies, or fantasies of the future realistic or improbable events that are more positive but can be frightening, guilt-ridden, or vengeful." (Creativity Encyclopedia, 1999)

Debate: Examining a question, situation, issue, topic, or challenge from many divers perspectives or viewpoints, including sharing of differing experiences and knowledge; focus on the issues involved, as opposed to conflict, which focuses on the people holding or presenting the beliefs or issues. A dimension of the Climate for Innovation Questionnaire. (Isaksen et al, 1994, Index)

Debriefing: Reflecting on an experience or activity, think about what you observed felt, or learned; commonly involves exchanging those observations, feelings, and learning's with other participants in a group. The second of three stages in an experimental learning model. (Isaksen et al, 1994, Index)

Decision-making (subterm found under Problem Solving and Process): The process of deliberately choosing between alternatives. (CBIR, 1999)

Decision Model (subterm found under Models): A twelve-step model of the decision-making process. (CBIR, 1999)

Deduction: "The process of deriving a valid conclusion from premises, or evaluating whether a given conclusion is valid, that is, whether it must be true if the premises are true." (Creativity Encyclopedia, 1999)

Deferred Judgment: A basic principle of CPS, particularly important in the creative or divergent phases of each stage; emphasizes the need to refrain from evaluation (criticism or praise) of ideas during the process of generating many options. (Isaksen et al, 1994)

Descriptive: An approach to applying CPS that helps match one's needs with an appropriate process pathway; to design, formulate, or invent and then apply strategies, methods, and techniques in ways that are personally, socially, and situationally relevant and useful. (Isaksen et al, 1994, Index)

Designed Cognition: "Cognitive aspects of design thinking and the study of these aspects. Research in design cognition is aimed at how designers think." (Creativity Encyclopedia, 1999)

Developing Solutions: Involves working on promising ideas to analyze, refine, and improve them. (CAPS, 2000)

Developmental Change: Influenced by the natural progression of an entity through a path-dependent sequence of states of stages. (Creativity Encyclopedia, 1999)

Dialectical Thinking: "A specific form of postformal reasoning that involves the coordination or integration of contradictory views or frames of reference." (Creativity Encyclopedia, 1999)

Dictionary Technique: Find an interesting word, and start making associations that are at least remotely related to your problem or technique. (Davis, 1998)

Dimensionality Problem: That a test may measure only some (or none) of the factors in creativity. (Dacey, 1989)

Dimensions of Climate (subtern found under Climate): The specific properties or characteristics found in recurring patterns of behavior that characterize life in the organization. (CBIR, 1999)

Divergent (also Diverging, Diverge, or Divergent Thinking): Generating many possible responses, ideas, options, or alternatives in response to an open-ended question, task, or challenge. Often used casually as equivalent to creative thinking. (Isaksen et al, 1994, Index)

Divergent Thinking Variables: "(Ideational) fluency, flexibility, and originality." (Creativity Encyclopedia, 1999)

Diversity: Variety, unlikeness, and a point of difference. (American Collegiate Dictionary, 1970)

Domain: A territory under rule or influence; a realm. (American Collegiate Dictionary, 1970)

Dunn and Dunn Model: An approach to learning styles for children and adults, with eighteen specific variables in four major categories: environmental, emotional, social, and physical. (Dunn & Dunn, 1978; Dunn & Treffinger, 1992). (Isaksen et al, 1994, Index)

Dyad: A grouping of two people; a pair of people interacting. (Isaksen et al, 1994, Index)

Dynamic Balance: The appropriate use of both divergent and convergent thinking in CPS. (Isaksen et al, 1994, Index)

Dynamism-Liveliness: The eventfulness of the life in an organization, a dimension on the Climate for Innovation Questionnaire. (Isaksen et al, 1994, Index)

E

Eastern Perspective: Less focused on innovative products. Creativity is personal fulfillment and expression of an inner essence or ultimate reality. (Sternberg, 1999)

Eccentrism: "Tendency toward unusual and sometimes outlandish behavior that may contribute to original thinking or may result from it." (Creativity Encyclopedia, 1999)

Ecological (subterm found under Theory): The totality or pattern of relations found between organisms and their environment. The interrelationship among people, desired outcomes, process(es) utilized, situations, and the task at hand. (CBIR, 1999)

Effective Novelty: "The decisive property of ideas, behaviors, or products that involve genuine creativity." (Creativity Encyclopedia, 1999)

Ego-Involved Motivation: "In which action is prompted by an ulterior desire for social approval or a positive self-image." (Creativity Encyclopedia, 1999)

Elaboration: The divergent thinking ability (or option-generation quality) associated with depth and detail; expanding an idea, or exploring and expressing it in a richer and more complete way than it was initially stated. (Isaksen et al, 1994, Index)

Elaboration and Synthesis: One of the three dimensions on the Creative Product Scale developed by Besemer and O'Quinn emphasizing the stylistic attributes of the product including complexity, elegance, attractiveness, and expressiveness. (Isaksen et al, 1994, Index)

Elegant Creative Product: Product is refined and understood. (Dacey, 1989)

Electronic Brainstorming: "Brainstorming conducted within some electronically support system through which intrapersonal and interpersonal idea generation processes are mediated." (Creativity Encyclopedia, 1999)

Emergenic Traits: Highly heritable but do not run in families. (Sternberg, 1999)

Emergent Innovation: "An innovation that arises in the course of a series of activities rather than as a consequence of a preplanned innovation project." (Creativity Encyclopedia, 1999)

Emotional Barriers: "Aspects of personality or 'emotional upset' that interfere with creative thinking; they may result from temporary problems (fear, anger, hate) or more permanent problems of insecurity (anxiety, fear of failure)." (Creativity Encyclopedia, 1999)

Ensemble of Metaphors: The recommendation that the investigator examine all the metaphors in a given text and try to express how, taken together, they represent a field of meaning. (Sternberg, 1999)

Environment (subterm found under Climate and Press)**:** The setting (physical and psychological) in which human behavior takes place. (CBIR, 1999)

Epicyclical Theory: There are three types of periods repeated throughout history: social, economic, and political; good to bad to good again. (Dacey, 1989)

Epistemology (subterm found under Research)**:** The study or a theory of the nature and grounds of knowledge especially with reference to its limitations and validity. (CBIR, 1999)

Eureka Phenomenon: "Takes a vacation" from solving a problem and later finds a full-blown solution to the problem that occurs in a flash. (Dacey, 1989)

EURISCO Program: Program that improves one's own processing style. (Sternberg, 1999)

Evaluation: A deliberate systematic process for analyzing, developing, and refining options and for making and justifying choices and decisions. In CPS, evaluation is regarded as a constructive process, not merely as criticizing or judging the inadequacies of ideas. (Isaksen et al, 1994, Index)

Evaluation Matrix: A technique used when many promising possibilities must be sorted, screened, or selected using a variety of specific criteria; also often described as a criterion matrix or grid. (Isaksen et al, 1994, Index)

Evolutionary Invention: "The idea that all technological advancements have gone through a step by step change from an antecedent. A support of evolutionary invention would state that invention is nothing more than the coming together of known parts into new configurations." (Creativity Encyclopedia, 1999)

Evolutionary/Revolutionary Change: "Influenced by selection and retention processes in the task environment that determine the viability of specific variations." (Creativity Encyclopedia, 1999)

Excursion: A technique designed to help an individual or a group attain "distance" from a problem context, or look at a problem in a new way or from a different perspective, in order to stimulate freshness or originality in their thinking. (Isaksen et al, 1994, Index)

Experimental Approach: Focus on the cognitive processes involved in solving creativity problems. (Sternberg, 1999)

Expert Systems (subterm found under Computer Applications): Computer program that contains much of the knowledge used by an expert in a specific field and assists nonexperts. (CBIR, 1999)

Explicit Theories: "Opinions and views held by scientists. They are explicit in the sense that they are shared with other scientists and testable." (Creativity Encyclopedia, 1999)

Exploratory-Transformational Creativity: Creativity grounded in a richly structured conceptual space. (Sternberg, 1999)

Extended Effort: The concept of investing the sustained time and energy necessary to increase the likelihood of obtaining the novelty you want. (CAPS, 2000)

Extrinsic (subterm found under Motivation): Originating from or on the outside; especially originating outside an art and acting upon part as a whole, external. (CBIR, 1999)

Extrinsic Motivation: The achievement of a creative solution is a means to an ulterior end, rather than the end in itself. (Sternberg, 1999)

Extroversion: In the Myers-Briggs Type Indicator (Myers & McCaully, 1895). A description of the preference of people who are activated and energized by interactions with the outer world of people and things, a preference of working with others. (Isaksen et al, 1994, Index)

F

Facilitation: The process through which a group carries out and monitors its progress in applying CPS methods and techniques during a group meeting or working session. (Isaksen et al, 1994, Index)

Facilitative Leadership: Focuses on service—helping, developing, and strengthening others in ways that inspire motivation and shared commitment. (CAPS, 2000)

Facilitator: The person charged with the major responsibility of providing the process expertise for a CPS session; usually someone with some special knowledge, ability, and skill dealing with methods and techniques of CPS. (Isaksen et al, 1994, Index)

Family Studies: Research shows that creativity does not run in families. (Sternberg, 1999)

Fear of Failure: Deterrent to creative thinking, or at least to public exposure of products of creative efforts. (Sternberg, 1999)

Feedforward: "Information about the general properties of highly valued creative work which is provided before creative work is undertaken." (Creativity Encyclopedia, 1999)

Feeling-of-Warmth (FOW) Judgments: "Method for studying problem solving. Subjects are asked to indicate how near they believe they are to a solution." (Creativity Encyclopedia, 1999)

Firstborns: Galton (1874) was the first behavior scientist to suggest that creative achievement may be related to the firstborn. (Sternberg, 1999)

Five Factor Model: "There are 5 fundamental bipolar dimensions to personality: openness, neuroticism, extraversion, agreeableness, and conscientiousness." (Creativity Encyclopedia, 1999)

Five W's and an H: The six key words (Who, What, When, Where, Why, and How) that are useful during Data and Acceptance-Finding activities. (Isaksen et al, 1994, Index)

Fixation on Ideas: Not being able to get closer to a solution and an inability to free oneself from fixation. (Sternberg, 1999)

Fixity, Functional (Dacey, 1989, Index): Makes original thinking very difficult. (Sternberg, 1999)

Flex (subterm found under Styles): To change one's thinking. (CBIR, 1999)

Flexibility: The divergent ability (or option-generating quality) associated with producing varied ideas, emphasizes examining a situation from different or varied perspectives or viewpoints. (Isaksen et al, 1994, Index)

Flexibility of Thought: Research found that creative and eminent scientists are more flexible in thought. (Sternberg, 1999)

Flow: "Intense absorption in a task, a state associated with peak performance, often of a creative kind." (Creativity Encyclopedia, 1999)

Fluency: The divergent thinking ability (or option-generating quality) associated with producing many ideas. (Isaksen et al, 1994, Index)

Focusing Phase: More emphasis on focusing where the need is primarily for analysis, evaluation, and improvement. (CAPS, 2000)

Forcing Relationships: A category of tools that deliberately triggers a new flow of options using novel stimuli. (Isaksen et al, 1994, Index)

Formal Operational Learning Stage: The characteristics of the maturing adolescent's intellectual development. (Isaksen, 1987)

Fourth Grade Slump: "The drop in original thinking and behavior that occurs for many children around the age of 9." (Creativity Encyclopedia, 1999)

Freedom: The independence in behavior by the people of an organization. A dimension of the Climate for Innovation Questionnaire. (Isaksen et al, 1994, Index)

Freewheel: To encourage all ideas, including those that might appear to be wild or silly possibilities. One of the four ground rules for idea generation. (Isaksen et al, 1994, Index)

Fromm's Theory: Creativity is largely a matter of having the right set of attitudes. (Dacey, 1989)

Frontal-Lobe Activation: Creative people have a lower level of frontal-lobe activation, which is involved with the inhibition of activities. (Sternberg, 1999)

Fun (subterm found under Process): What provides amusement or enjoyment: specifically playful, often boisterous action or speech. A mood for finding or making amusements. (CBIR, 1999)

Functional Commissurotomy: Uncreative persons having problems being imaginative. This is not a result of surgery. (Sternberg, 1999)

Functional Fixedness: "A category of cognitive set or mental structuring that manifests in rigidly or lack of flexibility in dis-embedding components from a given field." (Creativity Encyclopedia, 1999)

Fundamental Attribution Error: "Applies to creativity when the potential creator focuses on the context to explain his or her own original actions." (Creativity Encyclopedia, 1999)

Future Problem Solving (subterm found under problem solving): Students are empowered to become change agents and tackle controversial issues of the future, set goals, create visions, offer solutions to real problems and explore the impact of those solutions on the quality of life. (CBIR, 1999)

Fuzzy: Used to describe how one might initially view or define a problem, situation, or challenge before working to attain clarity or direction; an "ill-defined" challenge or mess. (Isaksen et al, 1994, Index)

G

Garbage Can Problem-Solving Model: Input flows consisting of problems, participants, solutions, and choice opportunities. They all mix together in the organizational environment. (Sternberg, 1999)

Gardner's Intelligence Theory: Intelligence is not a unitary entity but rather a collection of eight distinct intelligences. (Sternberg, 1999)

Gauss's Motivation: "One is externally motivated when one considers one's involvement in some activity to be under someone else's control." (Creativity Encyclopedia, 1999)

Gender Differences: These have no significant difference except possibly in certain activities. (Sternberg, 1999)

Generating Ideas: One of the three major components of the CPS model in which ideas are produced to respond to a specific concern or problem. It concludes the Idea Finding stage of the CPS process. (Isaksen et al, 1994, Index)

Generative Cognition: Involves (a) imagination, (b) sense of domain relevance, and (c) intrapersonal intelligence. (Sternberg, 1999)

Generativity Theory: Applies to human behaviors as being novel, fluid, and problemistic. (Sternberg, 1999)

Genius: Genius was original, manifested in someone seemingly coming out of nowhere, out of reach. (Sternberg, 1999)

Geography of Creativity: "A phrase calling attention to the fact that many forms of creativity are unevenly distributed around the world due in large part to variations in cultural values and economic wealth." (Creativity Encyclopedia, 1999)

Germinal: Likely to suggest highly creative products. (Dacey, 1989)

Gestalt (subterm found under Theory): Creative thinking begins by meeting a problematic situation; the thinker aims to restore the equilibrium of the whole. (CBIR, 1999)

Gifted and Talented (subterm found under Education and Models): Refers to someone who demonstrates outstanding performance or potential in a given area over a substantial period of time. (CBIR, 1999) Giftedness: talent, endowed with natural gifts. (American Collegiate Dictionary, 1970)

Goal-Oriented Creativity: Creative insights normally arise when people are focused on particular problems. (Sternberg, 1999)

Group Development (subterm found under Groups): The act, process, or result of group evolution. (CBIR, 1999)

Group Dynamics (subterm found under Groups): The interacting forces within a small human group. (CBIR, 1999)

Group Problem Solving (subterm found under Groups): (1) A group execution of an action. (2) Something accomplished by a group. (3) The group manner of reacting to stimuli. (CBIR, 1999)

Group Process (subterm found under Groups): The group process of identifying solutions to a situation. (CBIR, 1999)

Groups: A number of assembled individuals together or having some unifying relationship. (CBIR, 1999)

Growth Theory of Creativity: Self-actualized approach to creativity; since one grows, creativity grows. (Davis, 1998)

Guided Imagery: A technique in which a facilitator guides individuals in developing mental pictures of the problem situation, various actions, options, and desired outcomes for their CPS efforts; generally in a relaxing or reflective approach. (Isaksen et al, 1994, Index)

Guidelines for Generating: The four guidelines are defer judgment, strive for quantity, freewheel, and seek combinations. (CAPS, 2000)

Guilford's Model: There are three basic dimensions of intelligence: (1) operations, (2) content, and (3) products. (Sternberg, 1999)

Guilford's Theory: Also known as the Structure of Intellect Theory, including cognition, memory, convergent thinking, divergent thinking, and evaluation. (Dacey, 1989)

H

H-Creativity (Historical creativity): Having a historical novel idea. (Sternberg, 1999)

Handedness: Research shows that left-handers who use their right side of the brain tend to be more creative. (Sternberg, 1999)

Heavy (or "Strong") Convergence: The diligent application of affirmative judgment and critical thinking used in solution finding; the emphasis used in the choice of techniques used to come to consensus to narrow down a set of options, or to analyze and evaluate options. (Isaksen et al, 1994, Index)

Hemispheric Asymmetry: Creative people rely more on the right hemisphere than on the left only during the creative process. (Sternberg, 1999)

Heritability: Emergenic traits can be highly heritable but do not run in families. (Sternberg, 1999)

Heuristics: "Generally taken to mean discovery processes." (Creativity Encyclopedia, 1999)

Hidden Assumptions: Searching for inconsistencies can fire up creative thinking. (Dacey, 1989)

Highlighting: A convergent thinking technique used to compress the number of options down to a workable size for more thorough convergence. It consists of finding hits, clusters, and restatement. (Isaksen et al, 1994, Index)

Hits: The options in a list of options that are selected by the client as having promise or potential. (Isakson et al, 1994, Index)

HM (How might . . .): An invitational stem or opening phrase at the beginning of a problem statement used to invite ideas. (Isaksen et al, 1994, Index)

Hot Spots: Several hits in a list of ideas that share common attributes or dimensions or themes; hits that form a logical group or cluster. (Isaksen et al, 1994, Index)

H2 (How to . . .): An invitational stem at the beginning of a problem statement used to invite ideas. (CAPS)

Humanistic Motivation: Self-actualized creativity; was not motivated by a desire for achievement. (Sternberg, 1999)

Hypnagogic: Images that are sources of creative ideas. (Davis, 1998)

Hypothesis: A provisional explanation of phenomena devised with the intention of testing its adequacy. (Creativity Encyclopedia, 1999)

I

Idea: In general use, a thought or a specific result of cognitive activity; more specifically, options, directions, or possibilities generated during the Idea-Finding stage in CPS. (Isaksen et al, 1994, Index)

Idea-Finding (I/F): The stage of the CPS process in which many ideas are generated for a specific problem statement, after which most promising ideas are selected for further refinement and development. (Isaksen et al, 1994, Index)

Idea-Finding Potential: The phrase used to describe the characteristics of a problem statement that invites ideas, states the essence of the issue for which you want ideas, is concise, locates ownership, and is free of criteria. (Isaksen et al, 1994, Index)

Idea Flow: The speed at which ideas are produced and recorded in a brainstorming session. A rapid, continuous flow can be managed through a variety of recording techniques such as the use of flip charts, storyboards, or Post-It™ notes or by increasing the number of recorders per group. (Isaksen et al, 1994, Index)

Idea Support: The degree to which new ideas are treated in a positive and encouraging manner. A dimension of the Climate for Innovation Questionnaire. (Isaksen et al, 1994, Index)

Idea Time: The amount of time people can use (and do use) for generating, developing, or elaborating new ideas. A dimension of the Climate for Innovation Questionnaire. (Isakson et al, 1994, Index)

Ideational Fluency: "The total number of ideas given on any one divergent thinking exercise." (Creativity Encyclopedia, 1999)

Ideational Pools: These are constructed for each examinee or respondent and contain each of that individual ideas. Judges can evaluate the pools rather than individual's ideas. (Sternberg, 1999)

I.D.E.A.L. (acronym): Identify the problem, Define and represent the problem, Explore possible strategies, Act on the strategies, and Look back and evaluate the effects of your activities. (Sternberg, 1999)

Idea Processor: "A computer program which assists the process of ideation." (Creativity Encyclopedia, 1999)

Ideational Flexibility: "The number of themes or categories within an examinee or respondent's ideation." (Creativity Encyclopedia, 1999)

Ideational Fluency: a.k.a. Ideation, key component of the creative process. (Sternberg, 1999)

Ideational Originality: "The unusualness or uniqueness of an examinee or respondent's ideas." (Creativity Encyclopedia, 1999)

Ill Defined Challenge: A challenge that is not yet formulated or developed to the extent or degree of specifying actions and responsibilities to be taken by an individual or a group. (Isaksen et al, 1994, Index)

Illumination: The appearance of the "happy idea." (CAPS, 2000) When suddenly a new idea, solution, or new relationship emerges. (Dacey, 1989)

Imagery: Plays a central role in creative functioning. (Sternberg, 1999)

Imagery Trek: Involves taking a journey far from the challenge and developing novel relationships as a result. (CAPS, 2000)

Imagination: The ability of the mind to develop and use images. For CPS, the degree to which novelty is needed for a particular outcome or obstacle. One of the three "I's" of ownership. (Isaksen et al, 1994, Index)

Imagineering: Letting your imagination soar, then engineering it down to earth. (Applied Imagination, 1957)

Implementation: The point at which one or more promising or possible solutions are ready to be carried out. In CPS, the intended outcome(s) for the Plan of Action. (Isaksen et al, 1994, Index)

Implicit Criteria: Unspoken and internal criteria you can use without specific awareness or attention. (CAPS, 2000)

Implicit Theories: Folk conceptions of creativity and intelligence. (Sternberg, 1999)

Improvisation: "A music or theatre performance in which the performers are not following script or score, but are spontaneously creating their material as it is performed." (Creativity Encyclopedia, 1999)

Incremental Improvement: A process of change that relies on making a series of small or detailed refinements within a given problem definition or accepted system. The style preference of Adaptors. (Isaksen et al, 1994, Index)

Incubation: A general phenomenon in the creative process, during which one's mind may continue to explore ideas when one is not consciously thinking about the challenge or concern. (Isaksen et al, 1994, Index)

Inductive Reasoning: "The process of drawing out or making inferences or conclusions based on facts and observations." (Creativity Encyclopedia, 1999)

Influence: The degree to which you have the ability to make decisions and to take action to create change. One of the three "I's" of ownership. (Isaksen et al, 1994, Index)

Innovation: The result of creativity that emphasizes the product or outcome. (Isaksen et al, 1994, Index)

Innovator (or "I"): Represents the Innovative style of creativity described by Kirton (1976). (Isaksen et al, 1994, Index)

Insight: "The ability to see and understand clearly the inner nature of things especially by intuition." (Creativity Encyclopedia, 1999)

Institute of Personality Assessment and Research: Their objective was the development and use of psychological assessment techniques. (Sternberg, 1999) "It is known as the place where the study of creative personality emerged as a major topic in the 1950's." (Creativity Encyclopedia, 1999)

Integrated Discovery System (IDS): Can create hierarchical taxonomies and qualitative and quantitative laws, and take surprising results to form new hypotheses. (Sternberg, 1999)

Intelligence: "The ability to purposively adapt to, shape, and select environments." (Creativity Encyclopedia, 1999)

Intelligence Threshold: "An IQ score beyond which creativity is thought to become independent of intelligence." (Creativity Encyclopedia, 1999)

Intentional Change: "Influenced by goal formulation and decision processes that lead to the purposeful enactment of variations." (Creativity Encyclopedia, 1999)

Interactive Group Brainstorming: "Brainstorming in groups whose members interact during brainstorming to enrich ideas." (Creativity Encyclopedia, 1999)

Interest: The degree to which you have desire or motivation to work on a particular challenge. One of the three "I's" of ownership. (Isaksen et al, 1994, Index)

Intrapersonal Intelligence (from Howard Gardner): This capacity helps in making subtle distinctions among cognitive and emotional processes, as one means of understanding and guiding one's own creative behavior. (Sternberg, 1999)

Intrinsic Motivation: Pursuing a task for the interest or enjoyment afforded by the task or the effort itself, rather than for the potential promise of some external reward. (Isaksen et al, 1994, Index)

Introversion: A description used in the Myers-Briggs Type Indicator (MBTI; Myers and McCaully, 1985); people who are more comfortable focusing their attention and energy on the inner world of ideas and experience and engaging in reflection and quiet study before discussion with others. (Isaksen et al, 1994, Index)

Intuition: Trusting and following one's own inner sense, experiences, and hunches without requiring explicit or logical support and evidence; anticipating what might be, rather than attending only to what is directly present or experienced through these senses. (Isaksen et al, 1994, Index)

Investment Theory of Creativity: "The creative individual takes a buy low, sell high approach to ideas. In buying low, the creator initially sees the hidden potential of ideas that are presumed by others to have little value. Once the idea has been developed and its value is recognized, the creator then sells high, moving on to other pursuits and looking for the hidden potential in other undervalued ideas." (Creativity Encyclopedia, 1999)

Invitational Stem: One of the four elements of a problem statement that is designed to encourage the flow of ideas; initial phrases in a problem statement such as: In What Ways Might . . ." or " How to. . . ." (Isaksen et al, 1994, Index)

IWWM. . . : Shorthand for "In What Ways Might. . . ." Constructive ways to word the invitational stem or format of a problem statement. (Isakson et al, 1994, Index)

J

James's Theory: Creativity was the result of both rich associations and avoidance of commonplace ideas. (Dacey, 1989)

Janusian Processes: Simultaneously looking in diametrically opposite directions. (Sternberg, 1999)

Judicial Thinking Style: Evaluating systems, rules, and people. (Sternberg, 1999)

Jung's Theory: The unconscious plays a vital role in high-level creativity. Great ideas come from a greater source. (Dacey, 1989)

K

KAI: Kirton-Adaption-Innovation Inventory, a psychological instrument by Kirton (1976) to measure an individual style of creativity. (Isaksen et al, 1994, Index)

Kaizen: "A production culture based on continuous improvement in both products and processes." (Creativity Encyclopedia, 1999)

Kent-Rosanoff Word Association Test: "Psychological test usually composed of 100 stimulus words and requiring a response, usually timed, of the first word that comes to mind on exposure to each a stimulus word." (Creativity Encyclopedia, 1999)

Kepner-Tregoe Model: "Widely used and contains a deliberate stage called situation appraisal. This stage includes efforts to bring order and clarity to a complex situation and to determine priorities and actions to resolve each concern." (Creativity Encyclopedia, 1999)

Kohler's Theory: The concept of instantaneous insight. (Dacey, 1989)

Kris' Theory: Asserts that another defense mechanism, regression, is also often involved in the creative act. (Dacey, 1989)

L

Ladder of Abstraction: A divergent thinking technique used for generating many, varied, and unusual problem statements. Asking "Why?" produces more global or general statements, while asking "How?" produces more specific and concrete statements. (Isaksen et al, 1994, Index)

Laying-Aside Technique: Enhances creative productivity by temporarily resting an idea. (Sternberg, 1999)

Leadership: A process through which a person guides a group in participating or applying CPS methods, taking into account the nature of the task, the socioemotional relationships, the needs of group members, and the developmental level of the participants for their task. (Isaksen et al, 1994, Index)

Leadership Style: The way a leader, formally or informally, influences co-workers. (Sternberg, 1999)

Learning Style: A person's consistent or stable preferences for dealing with a wide variety of different tasks or situations. There are theoretical models and

instruments for assessing various aspects of learning style. These can be used for self-understanding, for improving teamwork and effective group participation, and for understanding the working dynamics of CPS within a group. (Isaksen et al, 1994, Index)

Left-handedness: Research shows that people who are left-handed pose more creativity by using their right brain. (Sternberg, 1999)

Left Hemisphere: Carries out verbal, sequential, and analytical processes. (Sternberg, 1999)

Legislative Thinking Style: Greater tendency to formulate problems and create new and often global perspectives and systems of rules. (Sternberg, 1999)

Let It Happen Strategies: "Tactics that involve leaving the problem for a time, allowing incubation and the like to contribute to the problem solving effort." (Creativity Encyclopedia, 1999)

Level of Creativity: A person's capacity or ability to produce many, varied, or unusual ideas that are useful or to elaborate on possibilities already generated; responds to the question, "How creative are you?" Contrasted with Style of Creativity or Creative Style. (Isaksen et al, 1994, Index)

Life Span Developmental Model: "Creativity does not increase or decline but rather changes in quality across the life span." (Creativity Encyclopedia, 1999)

"Light" Convergence: An informal expression describing the critical thinking required to narrow options such as applying the hits or hot spots techniques. (Isaksen et al, 1994, Index)

Linguistic Creativity: "The fact that natural languages are open-ended in a sense that new meanings can be given to already existing words, the new words can be created as required and novel word combinations formed." (Creativity Encyclopedia, 1999)

"Little c" Creativity: The type of creativity that all of us evince in our daily lives. (Sternberg, 1999)

Logic: The science of valid inferences based on both formal systems of proof ("proof theory") and their accompanying semantics (or "model theory"). (Creativity Encyclopedia, 1999)

Logical Thinking: Involved with clarifying the problem, figuring out the solution requirements, and implementing the solution. (Davis, 1998)

M

Macroevolution: Evolutionary change, long periods of little or no change, with shorter bursts of evolutionary innovation. (Sternberg, 1999)

Mad: "Suffering from or manifesting severe mental disorder; insane; psychotic; wildly foolish; or rash." (Creativity Encyclopedia, 1999)

Maker: An individual who, whatever his or her mastery of the current domains, is driven by compulsion to challenge current domain practices and, ultimately, to create new domains or subdomains. (Sternberg, 1999)

Maslow's Theory: Humans have the basic instincts, which manifest themselves as needs. (Dacey, 1989)

Maze Metaphor: The creative problem is represented as a maze, with various exits representing successful solutions to the problem. (Sternberg, 1999)

MBTI: An acronym for the Myers-Briggs Type Indicator, which is a psychological assessment toll used to examine one's preference for dealing with other people and situations (Extroversion-Introversion), gathering data (Sensing-Intuition), and dealing with the outside world (Judging-Perceiving). Based on Jung's theory of psychological types, it is often used to help understand individual preferences or styles as well as diversity in groups. (Myers & McCaully, 1985). (Isaksen et al, 1994, Index)

Mental Journey: You follow where the images lead you. (CAPS, 2000)

Mess: A term used to describe a challenge or an opportunity that exists within a task domain, that has not yet been focused or carefully examined; messes are broad, ill-defined goals, stated briefly or concisely, and expressed beneficially (i.e., with emphasis on a constructive direction for creative efforts). (Isaksen et al, 1994, Index)

Mess-Finding (M/F): One of the six stages in the CPS process in which many general goals or starting points for problem solving are considered. In a CPS session, one mess is usually defined as a broad area of concern on which to focus further problem-solving efforts. (Isaksen et al, 1994, Index)

Meta-analysis: "A review of the empirical literature that quantifies and averages results of all relevant studies to obtain an index of overall effect size." (Creativity Encyclopedia, 1999)

Metacognitive Processing: As your operating system, it is continuously monitoring and managing what you are doing and thinking about. (CAPS, 2000)

Metaphor: Understanding and experiencing one event, experience, or thing but describing it as another concept, usually from a different realm, which is related to it in several specific ways. In a metaphor, you describe one thing as another, without using the word "like" (which is used as a simile). Metaphors are used in CPS to gain new perspectives for dealing with problems or challenges. (Often referred to as metaphorical thinking; see also Synectics.) (Isaksen et al, 1994, Index)

Milestones: Goals along the action plan. (CAPS, 2000)

Mindfulness: Captures the idea that good thinking depends on habitual tendency to approach problems in a thoughtful and nonimpulsive way. (Sternberg, 1999)

Mindmap: "A graphic technique which facilitates recording thoughts and associations through a connected nodal structure." (Creativity Encyclopedia, 1999)

Modification: The ideas generated involve a structural (or more significant) change from the traditional ideas. (CAPS, 2000)

Mood as Input: "The paradigm in which individuals are given different stop rules or processing goals as they perform a task. Positive mood states have been reliably shown to be more creative on a range of tasks than are individuals in other mood states." (Creativity Encyclopedia, 1999)

Motivation: Motivation for creative results consists of a need for order, a need for achievement, and other motives. (Sternberg, 1999)

Multidimensional Interactive Creative Imagination Imagery Model (M.I.C.I.I.M.): Consists of three main dimensions: environment, individual, and cosmic. (Isaksen, 1987)

Multiple Discovery: "Typically defined as when two or more scientists or inventors simultaneously give expression to a similar theory, form, model, or invention." (Creativity Encyclopedia, 1999)

Multiple Intelligences Theory (Gardner, 1983): Intelligence is not a unitary entity but rather a collection of eight distinct types of intelligence: linguistic, logical-mathematical, spatial, musical, bodily kinesthetic, intrapersonal, and interpersonal. (Sternberg, 1999)

Musts/Wants Tool: Sorts options based on importance. (CAPS, 2000)

Myths: Widely held opinions or beliefs that are based on false premises or are the result of flawed or illogical reasoning. Three principal myths historically associated with creativity have been "mystery, magic, and madness." (Isaksen et al, 1994, Index)

N

Negative Creative Traits: Childish, absentminded, hyperactive, impulsive, argumentative, and neurotic. (Davis, 1998)

Negative Transfer: The amount of past experience in the situation; expertise turns out to be a disadvantage. (Sternberg, 1999)

Niche Audiences: "Relatively small audiences with specialized interests, tastes, and backgrounds. Many important forms of social creativity are of direct interest only to niche audiences." (Creativity Encyclopedia, 1999)

Nominal Group Brainstorming (NGB): "Brainstorming within which the participants do not interact, but generate their ideas in isolation." (Creativity Encyclopedia, 1999)

Nonabsolute Thinking: "A form of higher order thinking that is operationally defined as multiple-frame operations on ill-defined problems and is associated with a non-absolute worldview. It is considered a commonality underlying some of the most representative models of post-formal reasoning." (Creativity Encyclopedia, 1999)

Norms: In measurement, the distribution of scores on a particular variable or instrument within a sample with which the scores of other individuals or groups can be compared. In relation to group development and group process, the term is also used to describe an expectation, a standard, or a principle for establishing and guiding appropriate action. (Isaksen et al, 1994, Index)

Novelty: Newness, unusualness, or originality; the statistical infrequency of an idea or option. (Isaksen et al, 1994, Index)

Novelty Dimension: Examines the amount of newness or originality contained in a product. (CAPS, 2000)

Nutshell: The brief introduction or overview at the beginning of a chapter in this book on the three CPS components. It describes the purpose, input, process, output, and specific language, as well as the tools examined within the component. (Isaksen et al, 1994, Index)

O

Obstacles: Situations that represent areas of concern, discomfort, or dissatisfaction for an individual; may serve as starting points for CPS. (Isaksen et al, 1994, Index)

Old Age Style: Unexpected changes in the late life works of creative artists over age 60, one of the several phenomena that characterizes old artists. (Creativity Encyclopedia, 1999)

Openness: When there is a high degree of trust, individuals can be genuinely open and frank with one another. People count on each other for professional and personal support. (CAPS, 2000)

Operational Definition of Creativity: "A product or response is considered creative to the extent that appropriate observers independently agree it is creative. Appropriate observers are those familiar with the domain in which the product was created or the response articulated." (Creativity Encyclopedia, 1999)

Options: A broad term that refers to available choices or possibilities or beneficial desired outcome for using CPS. (Isaksen et al, 1994, Index)

Opportunity: Identified using a mess statement, it provides a positive or beneficial desired outcome for using CPS. (Isaksen et al, 1994, Index)

Organic Creative Product: It has a central core of meaning around which the whole of the product is organized. (Dacey, 1989)

Organizational Climate: "Recurrent patterns of behavior, attitudes, and feelings that characterize life in an organization." (Creativity Encyclopedia, 1999)

Organizational Creativity: "The processes generating new and valued ideas within a coherent organization, and rated as new and valued by members of that organization according to shared organizational values." (Creativity Encyclopedia, 1999)

Organizational Settings: Achieve a balance between thinking and performing so that creative ideas are available and cultivated within the organizational setting. (Isaksen et al, 1994, Index)

Originality: The divergent thinking variable or dimension (or idea-generating quality) associated with producing unique, novel, or unusual responses (options or ideas) that are statistically infrequent in relation to an appropriate comparison sample or group. (Isaksen et al, 1994, Index)

Original Genius: "As opposed to mere talent, this refers to the ability to create fundamentally new and highly valuable ideas and products." (Creativity Encyclopedia, 1999)

Outcomes: Positive opportunities or challenges upon which individuals work; also used to describe the desired results or intended action steps that emerge from a CPS session. (Isaksen et al, 1994, Index)

Output: The term used to describe the results of activity from any of the three CPS components. These outputs are process related such as locating yourself elsewhere on the CPS framework, or a need to recycle or exit CPS. (Isaksen et al, 1994, Index)

Ownership: An essential element in problem solving; personal involvement or investment in a task, characterized by influence (the ability to take action), interest (caring or motivation to work on issue), and imagination (need for novel or new options). (Isaksen et al, 1994, Index)

P

Paired Comparison Analysis: Prioritizes options by comparing them against each other, a pair at a time. (CAPS, 2000)

Paradigm: A set of rules, guidelines, or beliefs adhered to consistently to guide or direct one's behavior or thinking; a stable pattern of operating or thinking. (Isaksen et al, 1994, Index)

Paraphrase: A converging technique in which the client describes, in his or her own words, the principal or essential attributes or dimensions common to the options chosen from a larger set of possibilities. (Isaksen et al, 1994, Index)

Peak Experience: A momentary flash of insight that brings with it a great joy and gratitude for being alive. A self-forgetful, a moment of unselfish ecstasy. (Dacey, 1989)

Perceptual Barriers: A set of obstacles or factors that inhibit creative thinking based on how information is gathered, organized, and processed; obstacles that arise from failure to observe carefully or challenge assumptions. (Isaksen et al, 1994, Index)

Performance: Behavior ranked with the respect to quality, quantity, or both. (Creativity Encyclopedia, 1999)

Performance-Oriented Creativity: Some works can only be apprehended in performance, and the creativity inheres chiefly in the particular characteristics of the specific performance.

Personality Assessment: "A method for the psychological evaluation of individuals that involves testing and observation in a group setting with a variety of tests and procedures by a number of staff members. The staff members pool test scores and subjective impressions to formulate psychodynamic descriptions of the individual that enable predictions to be made of future behavior in areas of special interest." (Creativity Encyclopedia, 1999)

Personality: "The historical conception of the person in psychology, usually involving the study of both character and temperament." (Creativity Encyclopedia, 1999)

Person-Environment Fit: "Refers to the fact that no single environment best suits all creative people and that the degree of good 'fit' between creative people and their working environment can influence creative productivity." (Creative Encyclopedia, 1999)

Phase: Either the divergent or the convergent thinking that occurs during any or all stages of CPS. (Isaksen et al, 1994, Index)

Physical Resources: Include space, supplies, technology, and other tangible resources that will be necessary to carry out the work. (CAPS, 2000)

Piggybacking: One idea can lead to another, connecting one option to another. (CAPS, 2000)

Plan of Action (POA): Specific steps and commitments that emerge from the Acceptance-Finding stage of CPS. (Isaksen et al, 1994, Index)

Planning Approach: Involves keeping track of your thinking while it is occurring to ensure that you are moving in the direction that you want to go. (CAPS, 2000)

Planning for Action: One of three major components of the CPS model in which the major focus involves examining, analyzing, and developing potential solutions, as well as formulating a specific plan to gain acceptance and support implementation. (Isaksen et al, 1994, Index)

Playfulness and Humor: The extent to which spontaneity and ease are displayed in an organization and individuals feel free to generate and share unusual or unlikely possibilities. A dimension of the Climate for Innovation Questionnaire. (Isaksen et al, 1994, Index)

Preconscious: Between conscious and unconscious, which is where creativity takes place. (Davis, 1998)

Preference for Disorder: Disorder is more interesting to the creative person. (Dacey, 1989)

Preparing for Action: To translate interesting and promising ideas into useful, acceptable, and implementable actions. The end result of your work in this component is a plan of action carrying out the redefined and developed situation. The Preparing for Action component involves two stages: Developing Solutions and Building Acceptance. (CAPS, 2000)

Press: The climate, environment, or situation in which creativity takes place or is inhibited. (Isaksen et al, 1994, Index)

Prescriptive: A rigid approach to problem solving in which individuals or groups follow a fixed or predetermined set of steps or apply specific strategies regardless of the specific demands or requirements of the task, the group, or the setting. (Isaksen et al, 1994, Index)

Private Creativity: "An act of creativity which is a direct value only to the person(s) who initiated it." (Creativity Encyclopedia, 1999)

Proactive Creativity: "The process characterized by intrinsic motivation, positive affect, spreading activation, and focused self-discipline, which produces new, effective products that tend to be of enduring value." (Creativity Encyclopedia, 1999)

Problem: Any situation for which we need new ideas or a plan for using or implementing new solutions successfully; the gap between where you are and where you want to be. For CPS, a problem can be viewed as an opportunity for change. (Isaksen et al, 1994, Index)

Problem-Finding (P/F): One of the six stages in the CPS model, during which many different ways of stating a problem are generated and considered, leading to the selection or construction of a problem statement for which the group will subsequently generate ideas. (Isaksen et al, 1994, Index)

Problem Space: "The space of all possible solutions to an invention problem. The problem space contains all the restrictions that must be filled by the new creation." (Creativity Encyclopedia, 1999)

Problem Statement: A question that can be used to generate many, varied, and novel ideas; expressed in a concise form that includes an invitational stem, a statement of ownership, a constructive verb, and a goal or objective. (Isaksen et al, 1994, Index)

Process: A bounded group of interrelated work activities providing output of greater value than inputs by means of one or more transformations. (Iskasen et al, 1994, Index)

Process Diagnosis: Deliberately selecting an appropriate CPS component, stage, or tool to use for a certain task and their approach to creative problem solving. (Isaksen et al, 1994, Index)

Process-Entailed Needs: "Needs generated by a creative product which must be met if the product is to be completed successfully." (Creativity Encyclopedia, 1999)

Process Language: The terminology known and used by the members of a group to communicate effectively and efficiently about their task and their approach to creative problem solving. (Isaksen et al, 1994, Index)

Prodigiousness: Ability for achieving original creativity. (Dacey, 1989)

Prodigy: "A child, before the age of 10, performs at the level of a highly trained adult in a cognitively demanding domain." (Creativity Encyclopedia, 1999)

Productive Thinking: "Problem solving that requires the invention of a new solution method." (Creativity Encyclopedia, 1999)

Productivity Environmental Preference Survey (PEPS): A measure of eighteen dimensions of learning style for adults based on the Dunn and Dunn model. (Isaksen et al, 1994, Index)

Products of Creativity: Can be both tangible and intangible. They may be concrete or "touchable" like an invention or marketable product. Other creative outcomes can be tangible such as learning and personal development, the development of a new service or improvement of an existing one, social technology, or the design of a new process or methodology. (CAPS, 2000)

Projective Test: "A test that requires subjects to respond not in terms of preselected alternatives but in terms of their imagination, individual motivations, and perceptual or cognitive style." (Creativity Encyclopedia, 1999)

Pseudocreativity: "Behavior that is stereotypical thought to indicate creativity, although it does not." (Creativity Encyclopedia, 1999)

Psychic Censor: Prevents material from coming to awareness. (Dacey, 1989)

Psychological Climate: "The individual's perception of the organizational climate." (Creativity Encyclopedia, 1999)

Q

Q-Sort Procedure: "A set of rules for the scaling of a group of personality descriptors (Q items) as applied to an individual, so that the order of the Q items expresses the judge's formulation of the personality of the individual." (Creativity Encyclopedia, 1999)

Qualitative Methods: "Research techniques in the social sciences, such as one-on-one interviews, that normally do not involve numerical quantification." (Creativity Encyclopedia, 1999)

Quality of Options: The quality of the available options can influence the approach you take to focusing. Generally, the more novel your options are, the more you will need to be affirmative or developmental in your approach. (CAPS, 2000)

Quantity of Options: Quantity often breeds quality, in that the more options you generate, the greater the possibility is that at least some of them will be original and promising for you. (CAPS, 2000)

Questionnaires, Creativity: These instruments are based on research on the characteristics typically possessed by creative people. (Dacey, 1989)

R

Rank's Theory: People are born without a will of their own. (Dacey, 1989)

Reactive Creativity: "The process characterized by extrinsic motivation, negative affect, limited mental associations, and desperate problem solving, which produces new, effective products that solve only a short term problem." (Creativity Encyclopedia, 1999)

Reasoning: "The process of deriving conclusions from premises. The two principal sorts of reasoning are deduction and induction." (Creativity Encyclopedia, 1999)

Reflective Thinking: The art of thought resulting in many different attempts to describe the best thinking that humans could develop. (CAPS, 2000)

Remote Associates Test: Assesses mental abilities, an index of both creativity and intelligence. (Sternberg, 1999)

Reproductive Thinking: "Problem solving that requires applying an already known procedure to a problem." (Creativity Encyclopedia, 1999)

Resistor: In Acceptance-Finding, resistors are possible sources of difficulty or obstacles that might inhibit or prevent implementation of a solution (including people, places, resources, times, and reasons). (Isaksen et al, 1994, Index)

Resolution: "A product's value or usefulness, or the extent to which it solves a problem." (Creativity Encyclopedia, 1999)

Resource Group: A group of approximately four to eight people who participate in a CPS session in order to assist a client in solving a problem. The resource group may be involved in all aspects of the CPS process but plays a particularly important role in the divergent phases of each stage. (Isaksen et al, 1994, Index)

Resources: "Abilities, skills, traits, and/or dispositions that are useful for creativity; often used as a synonym for components." (Creativity Encyclopedia, 1999)

Respond to Change: People need to better understand the dynamics associated with dealing effectively with change in order to increase productivity and enhance competitive position in the marketplace. (CAPS, 2000)

Responsive Creativity: "Audiences which derive or create value from the novel acts or products in which they come in contact, thereby completing the fundamental cycle of social creativity." (Creativity Encyclopedia, 1999)

Reverse Brainstorming: Ideas are found by turning around the basic problem and listing in reality what is really happening. (Davis, 1998)

Revolutionary Change: Often called step change, radical breakthrough, or "out of the box" thinking. This kind of change focuses on doing things differently with a total departure from the current approach or way of operating. (CAPS, 2000)

Risk Taking: The tolerance of uncertainty permitted in an organization. A dimension of the Climate for Innovation Questionnaire. (Isaksen et al, 1994, Index)

Roger's Theory: There are three inner conditions of the creative person: openness to experience, ability to evaluate situations, and ability to experiment and accept the unstable. (Dacey, 1989)

Roles: "There are three main roles in a facilitation—(1) client: person who is responsible for the task itself, (2) resource group: help of others in providing you with alternatives and energy for getting you task accomplished, and (3) facilitator: will be responsible for leading the process." (Creativity Encyclopedia, 1999)

S

S.C.A.M.P.E.R.: An acronym for a list of idea-spurring words (e.g., Substitute, Combine, Adapt, Modify, Put to other uses, Eliminate, Reverse, Rearrange) than can be used as a technique to enhance or stimulate idea generation. (Isaksen et al, 1994, Index)

Schema: "Concepts employed in a cognitive psychology to represent organized mental structures for storing information efficiently using various categories or definitions." (Creativity Encyclopedia, 1999)

Scope of Application: Linking your need to the CPS process tells you what parts of the CPS to use; designing your scope of application helps you estimate how long and how often you will use CPS on the task. (CAPS, 2000)

Searching for Success Zones: A convergent-thinking technique used to sort options based on their level of importance and probability of success. (Isaksen et al, 1994, Index)

Secondary Creativity: "Creativity involving novel application of the already known (contrast with "primary creativity" that involves a genuine breakthrough." (Creativity Encyclopedia, 1999)

Selecting Hits Tool: Identifies and selects promising options using personal experience and judgment. (CAPS, 2000)

Self-actualization: "Spontaneous expression of the person whose mere basic needs have been satisfied." (Sternberg, 1999)

Self-Actualized Creativity: "A general form of creativeness, a lifestyle; it includes mental health and growth toward self-realization." (Creativity Encyclopedia, 1999)

Self-Image Barriers: A set of blocks to creative thinking emphasizing a low confidence in one's own ability to think creatively and solve problems, and the inability to identify and use resources effectively. (Isaksen et al, 1994, Index)

Sensation (Thrill) Seeking: Explanation of why some are creative and some are not. (Davis, 1998)

Semantic: "Meanings that refer to objects and occurrences that can be pointed to." (Creativity Encyclopedia, 1999)

Sensory Search for Relationships: A category of tools that uses the five senses to identify observations, impressions, reactions, and memories to stimulate novel connections. (Isaksen et al, 1994, Index)

Serendipity: "The act of discovering something genuinely valuable." (Creativity Encyclopedia, 1999)

Sequencing Action Steps: The goal is to organize the actions into short-, medium-, and long-term items. (CAPS, 2000)

Session: A single event or meeting designed to use CPS to help accomplish a specific goal or objective related to a task. (CAPS, 2000)

Situational Outlook for Creativity: The concern for, or consideration of, a complex set of factors within one person's situation that has a powerful impact on creativity. (Isaksen et al, 1994, Index)

Social Creativity: "An act of creativity which is a direct value to someone other than who initiated it. Acts of social creativity always involve an audience." (Creativity Encyclopedia, 1999)

Sociocultural Validation: "The acceptance by the social environment that a product is creative." (Creativity Encyclopedia, 1999)

Socio-Drama: A group creative problem-solving technique emphasizing the use of role-playing, set in a dramatic context. (Isaksen et al, 1994, Index)

Solution-Finding (S/F): One of the six stages in the CPS model, in which ideas are selected, analyzed, developed, or supported through the use of many possible criteria and the application of such tools as ALUo, Paired Comparison Analysis, or a Criterion Matrix. (Isaksen et al, 1994, Index)

Special Talent Creativity: "High, perhaps, recognized, creative productivity in a special area; it may or may not include mental health." (Creativity Encyclopedia, 1999)

Spontaneity: Freedom from constraint, embarrassment, or awkwardness. (Isaksen et al, 1994, Index)

Stage: Any of the six major elements of the CPS model (Mess-Finding, Data-Finding, Problem-Finding, Idea-Finding, Solution-Finding, or Acceptance-Finding). (Isakson et al., 1994, Index)

Stakeholders: "People who can significantly affect or are significantly affected by the actions of an individual, group, or organization." (Creativity Encyclopedia, 1999)

Star Models, Tanenbaum's: Reviews factors needed to achieve creative excellence. (Davis, 1998)

Stem: A specialized word, sentence, or phrase used to guide or focus your thinking in a particular way during different CPS activities. (Isaksen et al, 1994, Index)

Sternberg's Three-Facet Model: Includes intelligence, cognitive style, and personality motivation. (Davis, 1998)

Stimulus Freedom: Creative people will bend the rules to their needs when given a situation that interferes with creativity. (Dacey, 1989)

Stimulants to Creativity: Freedom, encouragement, challenge, atmosphere, appropriate recognition and rewards, open to trying something different, ability to disagree about issues without penalizing them, and important, worthwhile, or meaningful projects or tasks to work on. (CAPS, 2000)

Stop-and-Go Brainstorming: These are ten-minute periods of brainstorming, interrupted by brief evaluations. (Davis, 1998)

Strategic Barriers: Blocks to creative thinking emphasizing flexibility in the use of problem-solving strategies. (Isaksen et al, 1994, Index)

Strategic Creativity: "Actions or processes used intentionally to increase the likelihood of creative behavior." (Creativity Encyclopedia, 1999)

Strategy: "A general plan of action in which the sequence of solution activities is laid down." (Creativity Encyclopedia, 1999)

Structure of the Intellect Test: Measures and diagnosis weakness in divergent thinking. (Sternberg, 1999)

Structure of Intellect Model (S.O.I. model): I.Q. represents only those abilities concerned with cognition. (*Journal of Creative Behavior*, 1973)

Structure of Intellect: "J.P. Guilford's model, with 180 different kinds of intellectual processes and skills." (Creativity Encyclopedia, 1999)

Style Dimension: Focuses on the extent that a product extends beyond the basic requirements needed to solve a problem. (CAPS, 2000)

Style of Creativity: An individual's preferences or predisposition to deal with people or situations in consistent ways, and to use particular methods for gathering data, making decisions, and interacting with the environment. Deals with how individuals express and make best use of their creativity ("How are you creative"), not with how creative they are. (Contrast with Level of Creativity.) (Isaksen et al, 1994, Index)

Sublime Creativity: "Creativity leading to great works, major discoveries, etc." (Creativity Encyclopedia, 1999)

Supplementary Idea Generation: Ideas generated involve a new use, application, or "build" on the traditional ideas. (CAPS, 2000)

Supra-Rational Creativity: Higher type of creativity involves unusual levels of insight, intuition, and revelation. (Dacey, 1989)

Symbolic Analogy: Synectics technique. (Davis, 1998)

Synchronicity: "Is the simultaneous or near simultaneous happening of coincidental events that have no cause." (Creativity Encyclopedia, 1999)

Synectics: An approach to creative problem solving stressing the use of analogy and metaphor, in an effort to make novel connections between seemingly unrelated stimuli, drawing particularly on the work of W.J.J. Gordon, T. Poze, or G. Prince. (Isaksen et al, 1994, Index)

Synesthesia: "The involuntary union of the senses in a single common experience." (Creativity Encyclopedia, 1999) Ability to use your senses to help foster creativity. (Davis, 1998)

Synthetic Ability: The ability to generate ideas that are novel, high in quality, and task appropriate. (Sternberg, 1999)

Systems Approach: Creativity can only be observed at the intersection where individuals, domains, and fields interact. (Sternberg, 1999)

Systems Theory: "Theory describing the behavior of composite entities composed of changing, interacting, and interconnected parts whose functioning emerges from the mutual influences of the parts." (Creativity Encyclopedia, 1999)

T

"Tabletop" System: Nondeterministic processor combining a multitude of competitive bottom-up processes with top-down influences. (Sternberg, 1999)

Talent: "Superior aptitude or ability in any worthwhile line of human endeavor." (Creativity Encyclopedia, 1999)

Tangential Idea Generation: Ideas involve entirely different uses or applications than those from other categories; a real "shift" in perspective. (CAPS, 2000)

Targeted Innovation Model: Predictable goal model for targeting CPS. (Isaksen, 1987)

Task: A particular job, piece of work, assignment or effort that needs attention and energy. (Isaksen et al, 1994, Index)

Task Appraisal: Identifying the important and relevant dimensions of a task to determine your approach and appropriateness for using CPS. (Isaksen et al, 1994, Index)

Task Expertise: The extent to which people bring appropriate knowledge, information, and experience to the job at hand. (CAPS, 2000)

Task-Involved Motivation: "In which action is prompted by an intrinsic interest in the task itself." (Creativity Encyclopedia, 1999)

Task Specificity: "A theory that argues that the skills, traits, or knowledge that underlie successful (or creative) performance in different microdomains within the same more general domain are different and largely unrelated." (Creativity Encyclopedia, 1999)

Task Summary: Includes a statement of the need being addressed, the key background information associated with the task, and a statement of the desired outcomes. (CAPS, 2000)

Team: "Two or more individuals who join together to perform a certain task." (Creativity Encyclopedia, 1999)

Technique(s): A specific algorithm, procedure, or strategy for generating options or ideas, or for analyzing them; often used as a synonym for tools. (Isaksen et al, 1994, Index)

Temporal Consistency: Personality traits of creative people tend to be rather stable from early childhood to adulthood and on. (Sternberg, 1999)

Theory: "A broadly explanatory, mature hypothesis that has been repeatedly challenged by skeptical thinking, the predictions of which continue to be validated without yielding contradictory results or significant anomalies." (Creativity Encyclopedia, 1999)

Thinking Aloud Methodology: "Respondents are asked to verbalize their thoughts as they work on a problem. The method is used for studying processes involved in problem solving and thinking." (Creativity Encyclopedia, 1999)

Thinking Styles: There are three different types of thinking styles: synthetic, analytical, and practical. (Sternberg, 1999)

Thought Sampling: "An important method for studying how imagination emerges in our normal stream of consciousness." (Creativity Encyclopedia, 1999)

Three-Ring Model: "Joseph Renzulli has proposed a three-ring model whereby giftedness is at the intersection among above-average ability (as measured in the conventional ways), creativity, and task commitment. The circles for ability and creativity thus overlap." (Creativity Encyclopedia, 1999)

Threshold Theory: A minimum of intelligence is required for an individual to exhibit creative problem-solving behaviors. (Sternberg, 1999)

Tolerance: "Seeing the value in behaviors or ideas even though they are deviant." (Creativity Encyclopedia, 1999)

Tools: Specific techniques that can be named, learned, practices, and applied to increase the ease, efficiency, and effectiveness with which we generate or analyze options. (Isaksen et al, 1994, Index)

Toolbox: A collection of techniques used for divergent and convergent thinking in the CPS process. (Isaksen et al, 1994, Index)

Torrance Test of Creative Thinking: The most commonly used test of divergent thinking. (Sternberg, 1999)

Total quality Management: An effort to increase the productivity of organizations. (Sternberg, 1999)

Totem Poles, Multiple Talent: All of the students process skills and talents of some variety. (Davis, 1998)

Training: Anyone with normal cognitive abilities can reasonably aspire to produce creative work. (Sternberg, 1999)

Traits, Creative: Fluency, flexibility, originality, elaboration, openness, capacity to make chaos into order, high energy, risk-taking, curiosity, complexity, imaginative, independent, tolerance of ambiguity, and playfulness. (CAPS, 2000)

Transformational Creativity: To alter some relatively fundamental aspect of creativity. (Sternberg, 1999)

Transliminal Chamber: "The center of the creative energy." (Davis, 1998)

Trialability: The plan can be experimented with; (1) Can the plan be tried out or tested? (2) Can the uncertainty be reduced? (3) Can we begin with a few parts of the plan? (4) How might others be encouraged to try out the plan? and (5) Can the plan be modified by you or others? (Sternberg, 1999)

Tri-level Matching theory: "(This) theory predicts that persons, groups, and organizations with different preferences and abilities, knowledge, and work arrangements will best match the character of particular problems." (CRJ, 1998 v.3)

Trust and Openness: The emotional safety in relationships displayed in an organization. A dimension of the Climate for Innovation Questionnaire. (Isaksen et al, 1994, Index)

TUITs: "Task-unrelated images and thoughts, which are measures used in experiments to capture the ways that our daydreams or fantasies intrude in our consciousness even while we are actively concentrating on performing a demanding signal-detection task." (Creativity Encyclopedia, 1999)

Two-Stage Analysis of Creative Process: Includes the big idea stage and an elaboration stage. (Davis, 1989)

U

Unconscious Factors: Creativity maybe motivated by the need to atone for unconscious aggressive or destructive impulses. (Sternberg, 1999)

Understanding the Problem: One of the three major components of the CPS process framework in which the challenge or concern is more clearly defined. This component includes the Mess-Finding, Data-Finding, and Problem-Finding stages of the CPS model. (Isaksen et al, 1994, Index)

Unique Qualities: Help you to understand how the method differs from other methods and how the method might be helpful in ways that other methods cannot and under what conditions. (CAPS, 2000)

Universal Creativity Skills: Many have proposed that there are broad creativity skills that can be acquired and applied across many types of problems and situations. (Sternberg, 1999)

Unusual Uses Test: An examinee thinks of as many uses for a common object as possible. (Sternberg, 1999)

Utopian Thinking: "As a dynamic process, utopianism can be a feature of creativity. All creators themselves license to imagine their work in perfect conditions—whether that be a frictionless engine or an exquisitely receptive audience. In particular, social utopianism as a process can be key to the creative approach to social problems." (Creativity Encyclopedia, 1999)

V

Validity: The degree to which a test or an instrument measures what it purports to measure. (Isaksen et al, 1994, Index)

Valuation: "This process is selective rather than divergent, but not critical, nor evaluative. The focus of valuation can be originality. When it is, ideas are selected not because they are correct or conventional, but because they are original." (Creativity Encyclopedia, 1999)

Value Barriers: The blocks to creative thinking in which values, beliefs, ethics, or principles of conduct are held or applied so rigidly as to unduly influence problem-solving behavior. (Isaksen et al, 1994, Index)

Verbal Creativity: Verbal processes can be manipulated with verbal instructions and informational manipulations. (Sternberg, 1999)

Verification: The idea is new, but does it work? (Dacey, 1989)

Vertical Thinking, Lateral Thinking: Vertical thinking is selective, while lateral thinking is generative. (Dacey, 1989)

VID: An abbreviation for "Very Important Data." It can be used during convergent Data-Finding to identify the key or most important data. (Isaksen et al, 1994, Index)

Vision: The image of a desired future state; answers the question, "What are the results you wish to create?" Visions are compelling or inspiring, and, although they refer to the future, are usually stated in the present tense. (Isaksen et al, 1994, Index)

Visually Identifying Relationships (VIR): A specific sensory search for relationships tool identified in the forcing relationships category. It relies upon the use of pictures to provide the random stimuli for promoting novel or original ideas or connections. (Isaksen et al, 1994, Index)

W

Well-Crafted Creative Product: Worked and reworked with care. (Dacey, 1989)

Wertheimer's Theory: Creative thinking is the formation and alteration of mental patterns or forms. (Dacey, 1989)

Whole Brain Theory: Strong in all identified brain processes. (Davis, 1998)

WIBAI . . . (Wouldn't It Be Awful If . . .): One form of an invitational stem used to explore or generate possible mess statements. (Isaksen et al, 1994, Index)

WIBNI . . . (Wouldn't It Be Nice If . . .): Another form of an invitational stem used to explore or generate possible mess statements. (Isaksen et al, 1994, Index)

Word Association Tests: Students who are more original in their word associations score higher on tests of anxiety. (Sternberg, 1999)

Work Ethic: Value is placed on being active and productive, which fosters creativity. (Sternberg, 1999)

Work Preference Inventory: Provides scores related to workers' perceptions of climate conditions that stimulate creativity. (Sternberg, 1999)

Y

Yogic Sponge Position: Putting the problem out of your mind and deciding you are going to relax. Think about movement and clear the mind to reach solutions. (Dacey, 1989)

Z

Zeitgeist: Societal paradigm (loose zeitgeist, acceptance occurs; hard zeitgeist, idea rejected). (Sternberg, 1999)

Zen: "A Japanese sect of Mahayana Buddhism that aims at enlightenment by direct intuition through meditation." (Creativity Encyclopedia, 1999)

Zones of Concentration and Absorption: "Times and places where people can become deeply absorbed in their creative work and where they can achieve levels of concentration not achievable in other settings." (Creativity Encyclopedia, 1999)

References

Im, S., & Workman, J. P. (2004). Market orientation, creativity and new product performance in high-technology firms. *Journal of Marketing, 68*, 114–132.

Puccio, G. J., Burnett, C., Acar, S., Cabra, J. F., Yudess, J., & Holinger, M. (2018). Impact of creativity training on idea generation, creativity, and leadership effectiveness in groups. *Journal of Creative Behavior.* Advance online publication. doi:10.1002/jocb.381

O'Quin, K., & Besemer, S. P. (2006). Using the creative product semantic scale as a metric for results-oriented business. *Creativity and Innovation Management, 15*(1), 34–44.

Index

A

Acceptance-finding, 135
Adaptors, 86, 89, 90
Affective processes, 115
Affective thinking skills,
 for CPM-TSM, 139
 and cognitive thinking
 skills, 140
 definitions for, 141
Affirmative judgment, 125
Altshuller, Genrich, 123
Amabile, T. M., 59
 Consensual Assessment,
 240–244
 research on CAT,
 244–246
Amabile's model. *See*
 Creative behavior
Ambiguity, tolerance
 for, 47
Assisters, 148
Authoritarian culture, 208

B

Barron, Frank, 42
Behavioral processes, 115
Besemer, S., 237–239
Billy Budd, 55
Black Hat, 124
Blocks to creativity, 72–82
Blue Hat, 124

Brain hemisphericity,
 114–115
Brainstorming, 150,
 159–165
 development of,
 150–153
 guidelines for, 160
 invention of, 159
 with Post-Its, 164–165
Brainwriting, 165
"Buffalo Technique, The", 2
Burns, George, 210
Business and
 industry, rapid
 developments in,
 28–29

C

Card sort, 173–174
Center for Studies in
 Creativity, 2
Change leader
 development
 model, 142
Clarifier, 99–100
Climate
 and corporate culture,
 202–210
 establishing, 197–199
 leadership determining,
 204–210

Clustering, 172–173
Cognitive processes, 115
Cognitive skills, 127
Cognitive styles,
 parameters for,
 84–85
Cognitive thinking skills,
 for CPM-TSM
 and affective thinking
 skills, 139
 definitions for, 140
Commitment, 56
Communication, 106–107
Component model. *See*
 Plain Language
 Model
Conscious mind vs.
 unconscious mind,
 118–119
Consensual Assessment
 Technique (CAT),
 240–244
 basic steps for, 241–242
 research on, 244–246
Convergent thinking,
 171–172
Convergent tools
 card sort, 173–174
 highlighting, 172–173
 hits, 172
 PPCo, 174–175

Convergent tools
 (*continued*)
 wheelbarrow story,
 175–177
Corporate culture and
 climate, 202–210
 leadership determining
 climate, 204–210
"Create the Perfect
 Bathtub", 151
Creative behavior, 65–67
 creativity-relevant
 skills, 65
 domain-relevant
 skills, 65
 task-motivation, 65–66
Creative Classroom, The,
 188–189
Creative Climate
 Questionnaire
 (CCQ), 192
Creative Education
 Foundation, 1, 2
Creative learning model,
 179–182
Creative person
 characteristics of, 42–58
 ambiguity, tolerance
 for, 47
 assumptions,
 willingness to
 testing, 49
 capacity to making
 order from chaos,
 51–52
 commitment, 56
 concentration, 48–49
 curiosity, 54
 elaboration, 47
 flexibility, 44–46
 flow, 58
 fluency, 44
 humor, 55

 imagery, ability to
 using, 52–53
 impulsiveness, 57
 independence, 55–56
 intrinsic motivation,
 53–54
 judgment, ability to
 deferring, 47–48
 objectivity, 57–58
 openness to ideas,
 49–50
 optimism, 54–55
 originality, 46
 persistence, 55
 problems and ideas,
 ability to toy
 around with, 52
 problems, defining, 51
 risk taking,
 willingness to,
 50–51
 self-awareness, 56
 self-confidence, 51
 self-discipline, 56–57
 creative behavior, 65–67
 creativity-relevant
 skills, 66
 domain-relevant
 skills, 65
 task-motivation, 65–66
 creativity killers. *See*
 Creativity killers
 creativity style. *See*
 Creativity, style of
 creativity vs.
 productivity,
 58–59
 fourth-grade slump,
 71–72
 habits and blocks to
 creativity, 72–82
 intrinsic motivation, 60
 introduction to, 39–42

 intuition, in decision
 making, 67–68
 development of,
 68–71
 IQ and creativity, 42
 Kirton Adaption-
 Innovation
 Inventory, 86–90
 Puccio's FourSight
 Instrument,
 96–105
 team building and style
 communication,
 106–107
 diversity, 106
 interpersonal
 relationships,
 107–112
Creative press
 classifications of
 organizational
 culture, 208–209
 climate, establishing,
 197–199
 closing thoughts on, 231
 corporate culture and
 climate, 202–210
 leadership
 determining
 climate, 204–210
 external environment,
 210–215
 internal environment,
 215–226
 introduction, 185–186
 negative press, effects
 of, 205
 physical press, 186–191
 seven attributes for
 creative climate,
 226–229
 social-psychological
 press

external social-
psychological
press, 191–192
internal
psychological
press, 199–202
trust, 229–230
Creative problem solving
(CPS) model, 124
background, philosophy,
and history
of, 131
cognitive and affective
thinking skills
for, 139
creative learning model,
179–182
descriptive process, 130
development of,
132–140
flowsheet, 136
with FourSight
instrument, 96–99
fundamental
principles, 131
opportunities and
challenges
with, 132
Osborn-Parnes Model,
135–136
Plain Language Model,
136
stages of, 133–136
Thinking Skills Model
(TSM), 136–140
Creative Problem Solving
Institute, 37
Creative process, 113
brain hemisphericity,
114–115
brainstorming
development,
150–153

creative learning model,
179–182
creative problem
solving (CPS)
model. See
Creative problem
solving (CPS)
model
creative thinking skills,
124–125
defined, 122–124
desired future state
model, 182–183
explicit and implicit
views of, 125–128
illumination, 133
incubation, 119–122, 133
leadership and
creativity, 140–144
preparation, 133
problem, definition of,
149–150
problem-solving models,
prescriptive and
descriptive process
of, 128–130
terminology, 118–119
Thinking Skills Model
(TSM), 145–149
toolbox. See Toolbox
verification, 133
workings of, 115–118
Creative product, 233
basic steps for, 241–242
bedrock of creativity,
246–248
Consensual Assessment
Technique (CAT),
240–244
Creative Product
Semantic Scale,
237–239
evaluating, 235

explicit criteria for,
236–237
Global Judgment,
251–254
Measures of
Eminence, 250
Peer and Teacher
Nominations,
249–250
research on, 244–246,
248–254
Self-Reported Creative
Activities and
Achievements, 251
Creative Product
Semantic Scale,
237–239
Creative Studies
Department, 2, 3
Creative teaching, 190
Creative thinking skills,
124–125
Creativity. See also
Creative person;
Creative press;
Creative process;
and Creative
product
4 P's of, 18–25
4 P's of, 4–6
conceptions of, 6–14
defining, 15–18
habits and blocks to
cultural barriers,
78–80
emotional barriers,
80–82
learning and habit
barriers, 72–74
perceptual barriers,
76–78
rules and traditions,
74–75

Creativity (*continued*)
history, background, and development of, 1–2
and leadership, 140–144
person, process, product, and press, framework of, 4–6
reasons for studying, 26
business and industry, rapid developments in, 28–29
disciplines, builds on, 32–33
growing body of interest, 35–37
human potential beyond I.Q., 26–28
human resources, effective use of, 29–30
knowledge, builds on, 33
leadership, contributes to effective, 30–31
learning process, enhancing, 34–35
mental health, important aspect of, 34
natural human phenomenon, 33
society development, 32
solving problems, discover new and better ways to, 31
vs. innovation, 233–235
vs. productivity, 58–59
reativity killers, 60–65
competition, 62–63

expected evaluation, 60–61
extrinsic orientation, 63–65
restricted choice, 63
reward, 61–62
surveillance, 61
Creativity-relevant skills, 65
Creativity, style of, 82–85
cognitive styles, 84
parameters for, 84–85
views of, 86–105
job requirements, matching to, 93–94
level and style, confusing, 90–96
organizational needs, matching to, 92–93
training, 94–96
Critique questions, 178–179
Cultural barriers, 78–80
Culture and climate, 202–210
Curiosity, 54

D

Descriptive process, 130
Desired future state model, 182–183
Developer, 102–103
Dewey model, 122
Disciplines, creativity builds on, 32–33
Divergent thinking, guidelines for, 153
Divergent tools
brainstorming, 159–165
brainwriting, 165
forcing connections, 165–166

morphological matrix, 166–169
SCAMPER, 170–171
Diversity, 106
Domain-relevant skills, 65
Dynamic balance, 124–125, 136

E

Ekvall's ten dimensions, 192–197
Elaboration, 47
Emotional barriers, 80–82
Entrepreneurial culture, 208
External environment, in creative press, 210–215
External social-psychological press, 191–192
challenge, 192–193
conflicts, 196–197
debates, 195–196
dynamism and liveliness, 193
freedom, 193
idea support, 195
idea time, 194
playfulness and humor, 194–195
risk-taking, 196
trust and openness, 193–194
Extraconscious process, 120

F

Fact-finding, 135
Flexibility, 44–46
Flexing skills, 85, 95
Flow, 58
Fluency, 44

Forcing connections, 165–166
4 P's of creativity, 4–6, 18–25
FourSight instrument, 96–105
Fourth-grade slump, 71–72

G
Global Judgments, 251–254
Green Hat, 124
Greenhouse culture. *See* Relations and cooperation culture
Growing body of interest, 35–37
Guilford, J. P., 10

H
Hallmark Innovation Center, The, 189–191
Hennessey, 244–246
Highlighting tool, 172–173
Himes, Gary, 226–229
Hits, 172
Human potential beyond I.Q., 26–28
Human resources, effective use of, 29–30
Humane culture, 208
Humor, 55

I
Idea-finding, 135
Ideational fluency. *See* Fluency
Ideator, 100–102

Illumination
concept of, 20
creative process, 122, 133
Imagery, ability to using, 52–53
Implementer, 103–105
Impulsiveness, 57
Incubation, 119–122
concept of, 20
creative process, 122, 133
Independence, 55–56
Individual creativity, 21–23
Innovation, 143
Innovators, 86, 89, 90
Institute of Personality Assessment and Research (IPAR), 41
Internal environment, in creative press categories of, 215–226
Internal psychological press, 199–202
International Center for Studies in Creativity, 3, 7, 20
Interpersonal relationships, 107
conflicts, open confrontation of, 110–111
cooperation, spirit of, 109–110
defensiveness, lack of, 111–112
deviant behavior and ideas, acceptance of, 107–108
friendliness toward one another, 108–109

group members, attempts to including, 112
idea, encouraging expression of, 110
interpersonal trust, 107
respect for each other's feelings, 111
willingness to listen, 108
Intrinsic motivation, 53–54, 60
Intuition, 42
in decision making, 67
development of, 68–71

K
Kirton Adaption-Innovation Inventory, 59, 86–90
Knowledge, creativity builds on, 33

L
Leadership. *See also* external environment, in creative press
contributes to effective, 30–31
and creativity, 140–144
determining climate, 204–210
establishing climate, 197–199
Learning and habit barriers, 72–74
Learning process, enhancing, 34–35

M

MacKinnon, Donald W., 236–237

The Manifesto for Children, 36

McGinnis, William, 68

Measures of Eminence, 250

Mental health, important aspect of, 34

Mess finding, 135

Middles, characteristics of, 86, 89–90

Morphological matrix, 166–169

Myth
concepts of, 6–10
of madness, 14
of magic, 11–13
of merriment, 14
of mystery, 10–11

N

Natural human phenomenon, 33

Negative press, effects of, 205

Noller, Ruth, 15

Novelty, 18, 238

O

Objective finding. *See* Mess finding

Objectivity, 57–58

Optimism, 54–55

Originality, 46

Osborn, Alex, 1, 2

Osborn, Alexander Faickney, 159

Osborn-Parnes Model, 135–136

P

Page, David, 16

Pauling, Linus, 44

Peer and Teacher Nominations, 249–250

Perceptual barrier, 22

Perceptual barriers, 76–78

Perkins, David, 128

Persistence, 55

Person, process, product, and press framework. *See* 4 P's of creativity

Personal creativity, 17

Physical press, 186–191

Plain Language Model, 136

PPCo (Pluses, Potentials, Concerns, and overcoming the key concerns), 174–175
universal tool of, 177

Preconscious, concept of, 119

Preparation
concept of, 20
creative process, 122, 133

Prescriptive process, 129

Press, 231

Problem, definition of, 51, 149–150

Problem-finding, 135

Problem-solving models
prescriptive and descriptive process, 128–130

Problems and ideas, ability to toy around with, 52

Productivity vs. creativity, 58–59

"Project Zero", 41

Psychological Abstracts, 24

Puccio's FourSight instrument. *See* FourSight instrument

R

Recognized creativity, 18

Red Hat, 124

Relations and cooperation culture, 208–209

Resisters, 148

Resolution, 238

Rules and traditions, 74–76

S

SCAMPER (Substitute, Combine, Adapt, Modify, Put to other uses, Eliminate, and Rearrange) tool, 170–171

Self-awareness, 56

Self-confidence, 51

Self-discipline, 56–57

Self-image barriers, 23

Self-Reported Creative Activities and Achievements, 251

Social-psychological press
external social-psychological press, 191–192
internal psychological press, 199–202

Society development, 32

Solution-finding, 135

Solving problems, discovering new and better ways to, 31
Strategic barriers, 21
Style, 238
Subliminal messages, concept of, 122
Synectics™, 123

T
Task-motivation, 65–66
Thinking Skills Model (TSM)
 acceptance, exploring, 148
 challenges, formulating, 146–147
 creative problem solving, 136–140
 ideas, exploring, 147
 plan, formulating, 149
 situation, assessing, 145
 solutions, formulating, 147–148

vision, exploring, 145–146
Tide™, 249
Toolbox
 convergent thinking, 171–172
 convergent tools. *See* Convergent tools
 critique questions, 178–179
 divergent thinking, guidelines for, 158
 divergent tools. *See* Divergent tools
Torrance, E. Paul, 36
Torrance Test of Creative Thinking (TTCT), 43
 elaboration, 47
 flexibility, 44–46
 fluency, 44
 fourth-grade slump measured by, 71–72
 originality, 46

Transformative creativity, 18
TRIZ™, 123
Trust, 229–230

U
Usefulness, 18

V
Value barriers, 21–22
VanGundy, 210–226
Verification
 concept of, 20
 creative process, 122, 133

W
Wheelbarrow story, 175–177
White Hat, 124

Y
Yellow Hat, 124